"Art is about life,
the art market is about
money." — Damien Hirst

COLLECTING CONTEMPORARY ART

Adam Lindemann

TASCHEN

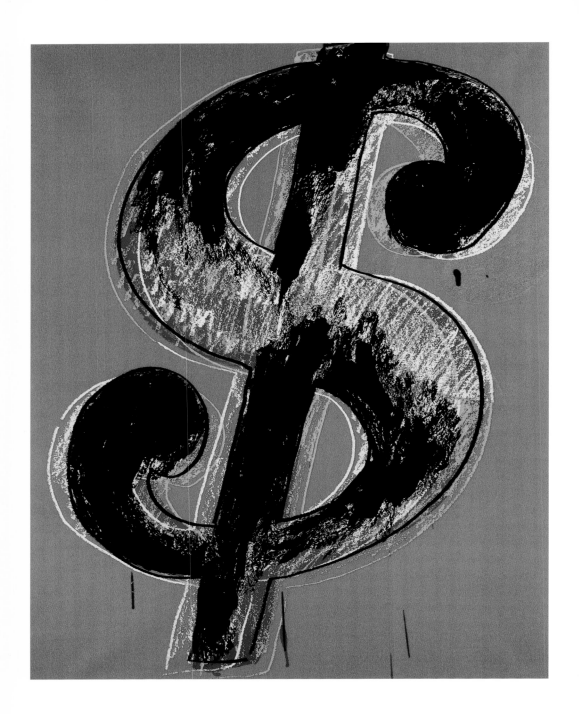

Contents

Preface

Recently, the soaring prices and the excitement surrounding the Contemporary Art market hit the front pages of *The New York Times* and *The Wall Street Journal*. This sort of mainstream journalistic attention suggests that perhaps we are in the midst of an historic shift in the history of the art market, if not art history itself. Certainly there had been a major boom and bust only a decade ago in the Contemporary Art world, when artists like Julian Schnabel, Eric Fischl and David Salle had waiting lists a mile long; however, never before had a painting that sold for well under $ 100 000 (e.g. John Currin's *Fishermen* [2002]) been flipped for more than $ 1.5 million in only two or three years.

Even more remarkable is the fact that auction records for individual artists are being broken on a regular basis. Maurizio Cattelan's *Not Afraid of Love* (2000) – a life-sized elephant covered by a sheet – was sold by his dealer Marian Goodman for about $ 350 000–$ 500 000; within a year it was flipped at Christie's for $ 2.75 million. These types of returns would be spectacular in any business, but are even more so when we consider that collecting art is supposed to be about things like culture and beauty, not speculation and monster profits.

What comes with the allure of making ten times your investment buying and selling Contemporary Art? People who were merely collecting before are now turbocharging their art-buying activity, and people who would never spend thousands on art are now rethinking their bias. Why? Because art now looks like an investment, not just an indulgence; at least seven new art funds are out there raising money at this very moment, recommending that investors put up to ten percent of their assets into this new asset class.

Must this bubble burst? If so, when? It's impossible to predict with any certainty. Nonetheless, the fact that prices for Impressionist Art have been sinking while Contemporary Art soars leads us to believe that today's art buyer wants to tap into what's new and exciting and is willing to take a few risks to get it. Certainly the $ 8.3 million paid for Damien Hirst's *The Physical Impossibility of Death in the Mind of Someone Living* (1991) – a shark preserved in formaldehyde, suspended within a giant tank – is staggering. On the other hand, if one believes that it is the iconic art object of the Nineties, then it looks like an appropriate sum for a unique and historic cultural trophy.

If you are currently collecting art or just thinking about it, you must try to understand the various types of people who promote, sell, and collect these works. *Collecting Contemporary Art* is not a "who's who", and certainly not a guide on what to buy or sell, but it is a selection of 40 representative interviews offering a broad range of opinions on the subject. Over one hundred hours of conversation, explanation, and insider tips with some of the art world's leading figures have been reduced to a few easy-to-read pages; their words will give you powerful insights into the inner mechanisms of today's art market.

Adam Lindemann
Spring 2006

Opposite title
Martin Kippenberger
Ohne Titel, 1992, oil on canvas, 71 x 59 in. (180 x 150 cm)

p. 4
Andy Warhol
8, 1981, acrylic and silkscreen ink on canvas, 90 x 70 in. (229 x 178 cm)

Introduction

by Adam Lindemann

Last year I visited Dharamsala, India, home of the Dalai Lama, with my friend and former professor, Robert Thurman, a renowned Indo-Tibetan scholar. While surrounded by monks and Westerners striving to attain happiness through Eastern teachings and meditations, it suddenly occurred to me that all I could think about was collecting art. Call it what you will, a sickness, a crass materialism, an obsession or a passion – there are many more like me who may never attain spiritual enlightenment but will continue to seek out great, and not so great, art objects that provide us with a meditative field of bliss, that transcendent feeling you get in front of a true masterpiece. Art was always a part of my life, but I didn't really look at works as collectibles or investments, it was just another part of my upbringing.

Growing up next to the Guggenheim, many of my childhood friends were the sons of artists like Leon Golub or art dealers like Allen Frumkin. In my early twenties, I spent quality time at Studio 54 where I was introduced to "Andy's world" by my girlfriend. On my first visit to the Factory, Warhol tried to introduce us to a young artist named Jean-Michel Basquiat, with whom he had just completed a series of collaborative paintings. The work looked somewhat random to me at the time, and I was a bit put off by the fact that Basquiat was crashed out on a sofa and wouldn't wake up. Later, when we all went to see Michael Jackson's "Victory Tour" at Madison Square Garden, Jean-Michel smoked a spliff the size of a corncob. Like so many of my generation, I was mesmerized by Michael's presence – the signature glove and hat, the famous moonwalk. I also was caught up in the heady atmosphere of the Eighties art world, a world in which Andy and Jean-Michel were personas no less compelling than the King of Pop. I've often wondered what I could have bought from Warhol and Basquiat in those days. Instead, all I have to show from the experience is a T-shirt that Andy signed and gave to me for my birthday. Years later, I found it, framed it, and proudly hung it in the bathroom.

I started collecting seriously much later, after being introduced to tribal and Oceanic art at Yale by my friend Bernard de Grunne. He was getting his doctorate in African art, and later went on to run the African and Oceanic Art department at Sotheby's. With his

advice, I began to collect great African masterpieces such as works from the Fang and Songye tribes, especially the fetishes and fearsome "power figures". I loved the work, particularly the pieces from the Congo, objects straight out of Joseph Conrad's *Heart of Darkness*. But it wasn't enough; something was lacking: I still missed the excitement of the art and artists of my time.

My hard-core Contemporary Art collecting habit began when Peter Brant, the magazine publisher and a master collector, introduced me to Julian Schnabel, who was then raising money to jump-start his second film, *Before Night Falls*, and he offered me one of his "greatest masterpieces" for a fraction of its real value: a mere $400 000. I liked the work, but couldn't even conceive of spending that kind of money, so I did what all new collectors do: I asked someone for an opinion. This time it was a friend of my father's, an excellent collector of Modern art (from Abstract Expressionism through Minimalism and Pop). His response: "Schnabel, you must be joking, don't touch it!" Naturally, I got a

little scared, so I looked up Schnabel's auction record and any fool could see that his market had virtually dried up. Nonetheless, Julian held firm on his price. I decided to buy a smaller, later work from him; quite a nice painting that I enjoy to this day. I do like Schnabel's work and it may very well make a comeback. As a matter of fact, right now it looks charismatic, decorative and a bit nostalgic. One day perhaps even the Eighties' stars will be hot again. The experience provided me with an invaluable lesson: in the art market, opinions are constantly changing; today's genius could be tomorrow's embarrassment. So if you buy it, buy it because you enjoy it.

The next lesson came to me as I timidly entered the Warhol market, buying a painting here and there when visiting the Warhol estate with former Warhol film actress, Baby Jane Holzer. My brother George was interested only in emerging artists and discovering the next art star; on the other hand, I was convinced that if one were spending "real money", then one should buy real

art. That often means art produced by people who are now deceased, i.e. we know what it is, how many were made, and what the historical importance is. No sooner had I bought one or two Warhols than I began to take advice, frequently from people who had their own personal agendas and vested interests inextricably woven into each comment. "Oh, that market's too hot, can't go up any more," or "Forget it, he made 300 of those, it can't be worth $75000!" I ended up buying about half of the works I had wanted, and usually the ones that cost less – mistake! The old saying *de gustibus et coloris non est disputandum* (taste is not a subject of debate) still holds true; not everyone is going to like what you like. On the other hand, if you ever want to sell your beloved painting, all you need is one other person who likes that particular work, so you can be right and the person who doesn't like the picture can be right, too.

Previous page
Christopher Wool
Untitled (P 363), 2001, Enamel on linen, 108 x 72 in. (274 x 183 cm)

My art collecting became increasingly satisfying the more I learned; my hobby grew into an obsession. One day when I was talking to Philippe Segalot, former head of Christie's Contemporary and a powerful art consultant, I had an epiphany. Segalot suggested that I sell several smaller Warhols in order to buy one big Warhol *Rorschach* painting that I had been eyeing. He was right. Why own a bunch of tchotchkes, albeit very classy ones, when you can have a masterpiece? But then again, what I really wanted was a *Car Crash*, a *Race Riot*, and the entire series of *Most Wanted Men*, which I had just seen at the Berlin Warhol retrospective. Unfortunately, these works were not available and my self-imposed budget would not permit me to buy them even if they were. Conclusion: sell everything!

"If you're looking for the right colour painting to match your wallpaper, stop reading here."

I realized that I had to change my focus to Contemporary so I could collect the best work of whomever I could afford, within my budget. Thus I began collecting Contemporary Art by living, new, exciting artists. (P.S. every single Warhol I didn't buy because it seemed too expensive, including a small *Car Crash*, a small *Last Supper* and an *Electric Chair*, doubled in value within two years; I should have followed my nose, not my pocketbook.)

What is it that makes owning art exciting, inviting and sexy? Is it watching that 1964 *Jackie* on the wall go from $65000 to over $200000 in a couple of years? For me the answer is NO and, of course, YES. What is exciting is that opportunity to enjoy the work on a daily basis, the ego trip of possession (the "look what I've got" factor) and, perhaps most important, the act of selecting and purchasing, making a personal aesthetic decision which defines your own individuality and personality within the entire context of art history. Meanwhile, the money does matter. Regardless of your budget, no one wants to pick a loser, and if the appraisal value of that work keeps rising, it helps remind you that your choice was a smart one, you picked a winner, and even if you never want to sell, the picture always looks better when someone offers you two, three or ten times the return on your investment.

Albert Oehlen
Scatman's World, 1997,
Oil on canvas, 114 x 86 ½ in. (290 x 220 cm)

Mark Grotjahn
Untitled (Angry Flower Female
Big Nose Baby Moose # 3), 2006,
Sock and oil on cardboard, mounted on linen,
72 x 54 x 6 in. (183 x 137 x 15.2 cm)

So that's how I got here, not because Contemporary Art is where it's at, not because I don't appreciate a great Jackson Pollock, but because this is where I stand the best chance of getting a masterpiece, a work of art that makes you feel like you're talking to the Dalai Lama. Next step: Make a plan, figure out a strategy, and stick to it. Now I'm ready to attack the Contemporary market, but where and how do I begin?

Getting started

You've decided you want to jump in and collect your first pieces of Contemporary Art, but before you do you want some advice. Whether it is a $15000 assume vivid astro focus (aka Eli Sudbrack) piece you just saw in the Whitney Biennial or a shiny new Jeff Koons sculpture offered by Sonnabend Gallery for $650000, you want to get an informed opinion. Remember, everyone will have a different opinion, and because it is Contemporary Art, the consensus is just forming and always changing. Keep that in mind before you ask the question that no one can answer for you: Is it worth buying?

When I began to look around for younger art, I was attracted to a Japanese artist who was gaining momentum: Takashi Murakami. I felt Murakami was the ticket; his work was unlike anything I had ever seen. It was two-dimensional or, as he says, "superflat", and it looked like he could produce enough high-caliber work to set the world on fire (his factory and much of his art practice is modeled on Warhol's). His manga- and anime-inspired cartoon world was a synthesis of everything I loved about Andy Warhol, Jeff Koons and Damien Hirst, with a uniquely Japanese apocalyptic twist. But as a newcomer to collecting younger artists, I was having trouble getting hold of good work. I got lucky when I met Amalia Dayan, an expert at the auction house Phillips de Pury Luxembourg, who later went on to work at Gagosian Gallery before striking out on her own. She helped me gain access to works of the highest quality and introduced me to many fabulous opportunities, both aesthetic and financial.

As Murakami's work began to heat up in the auction houses, selling for $500000 to $600000, I remember one of the most respected collectors complaining, "Don't like it, too easy, it's just no good." Soon, the expert dealers who hadn't touched the work were grumbling, "The bubble will burst," and the collectors who had shunned it fell silent. For the record, his market exploded, and he will have a mid-career retrospective at the Los Angeles Museum of Contemporary Art in 2007. The point is that there is no consensus on younger artists, and that's the wonderful thing about the Contemporary market: your decision to buy that object becomes part of the artist's potential place in the history of art.

The Basics

Before hearing from the experts, let us understand some basic terminology and have a clear understanding of the four types of art purchases. It's better not to look too foolish from the start; there will be plenty of time for that later.

1. Buying on the primary market

Contrary to what you may be thinking, your best buy will NOT be at auction. In the Contemporary world, we want to buy on the primary market, which means buying directly from the artist's primary dealer(s) – usually the gallerist. (A subtle but important distinction: many dealers who represent artists exclusively or partially prefer the title "gallerist" to the more bluntly commercial "dealer", with the implication that they're not in the business just for the money.) Why? First of all we want the fresh stuff, the new art, the work someone is not already looking to flip, and more important, it's cheaper. The dealer must keep primary prices lower than auction prices because he's got to sell 365 days a year, therefore the primary sale price is generally the lowest. Simple, right? Well, not really. Every hot artist will have the dreaded waiting list, which means that you'll get one piece a year, or two, of your desired artist, if no one better comes around – a bigger collector, a major institution, or a better client of the gallery. Now let's say you get that call, the one telling you that the insane Matthew Barney vitrine, or that sexy Lisa Yuskavage painting, can now be yours as long as you sign a simple resale agreement. You can have the work, but only if you promise to offer the work first back to the gallery if you decide to sell it (i.e. you can't just "flog" it at auction). So you just bought a co-op instead of a condo, and if you don't understand that, call a real estate broker; I can't help you!

A dealer generally asks collectors to sign resale contracts to protect his artist from becoming a casualty at auction, but also to retain control over the artist's market and to make sure that all secondary sales go back through the gallery. If you're buying a piece with no intention of selling it, go ahead and sign it. But if you are more of a speculator, the contract should be more carefully inspected (some of these agreements might not have any legal weight). Or if you are buying the work with the intention of eventually donating it to a museum, the dealer won't require that you sign the agreement. Plus, any dealer loves to hear that one of their artists' works is going to end up at a prominent museum, even if half the time that doesn't happen.

2. Buying on the secondary market

If you missed the gallery show of an artist you're hot for and the dealer has no new works to sell you, but you really want to collect the artist's work, ask the dealer if he or she has a piece on resale (these could be works brought back to the dealer after signing the above-mentioned resale agreement). Be careful, the particular work could be a dog. However, it could be something really good, but this time you're going to pay full retail. If the work is what you are looking for, you're in luck, and there are no strings attached. You are free to sell it anywhere and to whomever you wish, although you may still want to offer it back to the primary dealer, just to make sure you remain in line for future works!

3. Buying at auction

If you missed it primary and you can't find it secondary, you've got to get it at auction. There's no real choice in the matter: great works will come up at auction and they sell to the highest bidder.

Beatriz Milhazes
Popeye, 2008, Acrylic on canvas,
78 ¾ x 54 ¾ in. (198 x 137 cm)

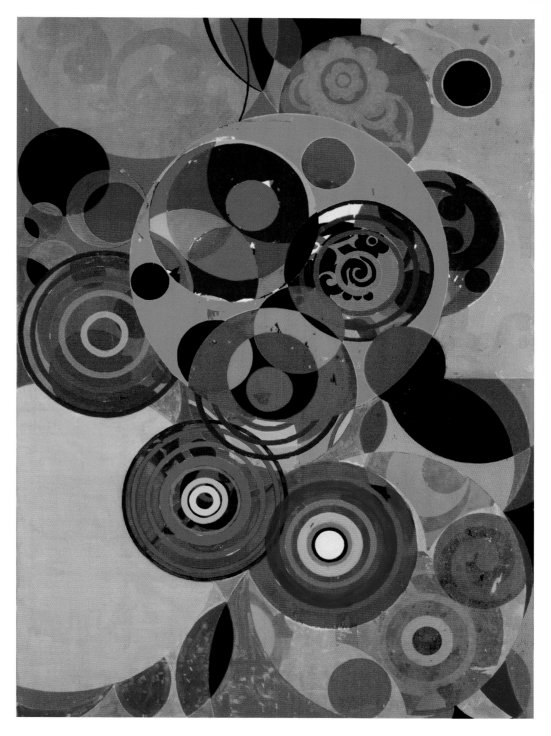

Here there will be no more ten-percent discounts from galleries. At auction you'll pay Sotheby's, Christie's or Phillips a twenty-percent premium on the first $200 000, twelve-percent thereafter. No matter, if the works are five years old or more, it could be your last chance to get a good early piece by the artist.

The catalogues are published usually a few weeks prior to the sale; be sure to sub-scribe or set up an account with the auction houses so that you can do your homework and get background information on the works that interest you. It's also good to talk to colleagues (other collectors, dealers, consultants, etc.) and find out who else is interest-ed in bidding on the piece(s) that you're interested in. Often, dealers will bid on their own artist's work for "inventory" and many times, collectors and dealers will try to con-trol the bidding of certain works. Make sure you get a condition report on the works you're looking at. A condition report provides essential information on the work's ma-terial condition: obviously a crucial consideration, especially with high-dollar works by famous artists. Then talk to the artist's primary dealer to see if the work has been shopped around before you decide to bid on the sale. If possible, with artworks that have been resold more than once, try to get the inside scoop on the piece you're eyeing. Although this requires some research and probably insider tips, you may learn that the 1966 Donald Judd Plexiglas sculpture you've set your heart on suffers from hidden struc-tural flaws – something that an otherwise scrupulous condition report may omit. Spend some quality time at the previews; this is an excellent opportunity to garner information and opinion … or mere scuttlebutt. Once you're at the actual auction, you'll get a feel for the room, its energy, and a final chance to make up your mind. Try to avoid bidding over the phone (unless you are in the room on your cell phone), and definitely don't just leave them an "order". Auction prices can be manipulated, and what sells one day for $150 000 may only make $100 000 another day, so do your homework, lest you end up spending big unnecessarily.

4. Buying at an art fair

It may seem strange to include art fair buying as its own separate category, but indeed it is. Both the density of works available and the frenetic pace make the fairs an altogether different experience. The huge boom in the business done at the major art fairs (including Art Basel, Art Basel Miami Beach, the Armory Show in New York and the Frieze Art Fair in London), as well as the crowds they draw, have put pressure on all the galleries to show a few tempting pieces by their top artists at each fair. Warning: When you get to the fair and find that most top picks are gone, this is why: they were all sold in advance. At first this seems to make no sense, but after some reflection we discover that the role of the art fair is not only for selling but also for advertising. The gallery will typically bring one or two "plums" that are pre-sold or quickly routed to influential or "preferred" clients. These pieces usually serve as window-dressing to draw you to the gallery's booth. Inside, you may find whatever second-rate merchandise that was left in the gallery's inventory the day before the fair opened.

The top fair in the world is in Basel, Switzerland, held every summer, and the second best is Art Basel Miami Beach that takes place in December.

5. Your homework

If you just want to buy art only because you like it, or you are decorating your home, or you're looking for the right colour painting to match your wallpaper, stop reading here. If, on the other hand, you want to collect seriously you will have to do your homework before you buy.

First of all, buy whatever books or museum catalogues of the artist that you can find. Carefully examine every image and pay attention to who owns which pieces. Next, read the essays. You don't have to agree with everything that's said about an artist, but you need to know what the artist is about, and how the work is discussed and presented in the museum and critical contexts. It's also a good idea to talk to the artist's primary dealer to learn more about the artist's work and his or her market. Read the art magazines (*Artforum*, *frieze*, *Art in America*, *Parkett*, *Art + Auction*, *The Art Newspaper*, *Flash Art* ...) and research the galleries and museums that show works by the artist. The internet can provide a lot of interesting information on an artist and his or her career and market. *Artnet* features an extensive Price Database, which you can consult to see auction prices and images from worldwide auction results (this is not a free service; you must register and pay a subscription fee).

If the artist has never sold at auction, figure out why: either the artist is too new, or the dealer is such a control freak that nothing ever makes it to auction. Generally, it is better to find that there have been several previous trades, most of them at a premium to the current primary prices for the artist. Auction results, however, do not tell the whole story; you will still have to consider the quality, the condition, and the hype. If you happen to see that many of the works get "bought in" (when an artwork doesn't meet the seller's reserve price, it is bought in by the auction house), this is a warning; although not everything breaks a record in the early years of an artist's career, some artworks are liquid, others are not.

6. The social life/the art scene

There is no doubt that a large part of the Contemporary Art world is the art scene, and this is mostly a good thing. The number of people showing up at auction previews and art fairs grows and grows. Most of them have money but buy nothing. Why? – because they are lacking any knowledge of art or connoisseurship, so therefore they are afraid to buy. They know little and are afraid to reveal their ignorance, so they feign indifference. Why are they all here? The Contemporary Art world is fast becoming a major social event, and people are there to see and be seen, as much as to look at and perhaps buy art. This phenomenon is particular to Contemporary Art alone; if you start collecting antiquities, tribal art or even Impressionist works, you will never find the excitement, the number of events and the overall buzz of the art scene today. Historically, this was not the case; at a Peggy Guggenheim opening in the 1940s featuring Jackson Pollock or Willem de Kooning, only the select cognoscenti would show up. At a recent Damien Hirst opening at Gagosian Gallery's massive 15 000-square-foot Chelsea space, the line was out the door and the place was so packed you couldn't even see the art.

Richard Phillips
Free Base, 2007, oil on linen,
114 ⁹⁄₁₆ x 136 ¾ in. (290 x 347.3 cm)

With auction preview parties, countless gallery openings and dinners, as well as the festivities in Venice, London, Basel and Miami, the art scene will fill your calendar if you let it, and introduce you to lots of new people, places and ideas. The social scene is made up of different layers of insiders and outsiders, and before you schmooze it is best to distinguish the various characters you will meet.

You will first of all find the slick secondary-market dealers. They look good in Prada suits, they are entertaining and international, and they can help secure dinners at hot restaurants and private parties. They make sure you're having fun. Next, you will encounter the hardcore primary dealers. They don't really have time for you, they are too busy being "serious" about art, or they have to run off to deal with an artist, an installation or some other excuse. Some of these gallerists are virtually artists in their own right, and can be more exciting and creative than the artists they represent. The late, great Colin de Land, for example, always had a "scene" going in his space, American Fine Arts, Co., that was as exciting as his shows. He is reported to have been engaging, charismatic, insane and visionary all at once. More recently, Gavin Brown has

amassed a young roster of artists with several "breakout" stars like Elizabeth Peyton, Peter Doig, Urs Fischer, and Franz Ackermann. The whole thing turned into a scene at his gallery and at Passerby, the bar he opened next door, which was frequented by his artists, his friends and a generous dose of hangers-on.

Last but not least, you will encounter the collectors' scene, and this one is more welcoming and will have fewer strings attached. The good thing about meeting other collectors in a social setting is that you instantly have plenty to talk about, and comparing notes on who bought what can quickly and easily create new friendships. Typically, this occurs with museum patronage, joining the many museum boards, or just buying a couple of seats at an art benefit.

In summary, the art scene is filled with fascinating if somewhat mercenary characters and this scene needs your money to sustain itself. It is somewhat shocking to experience how spending some money, or making believe you will, can suddenly bring so many people to your doorstep. Enjoy them!

THE SEV
TYPES O
ART MA
PLAYER

After you've done your research and have immersed yourself in the social life of the art world, you may get to the point where you find an artwork that you simply *must have*. Advice will come from several different types of people, although many of them can wear two, three, or all hats at the same time. For the sake of method (the Dalai Lama said that "wisdom without method is confinement"), I have divided this world into seven user-friendly categories: Artists, Art Critics, Art Dealers, Art

EN
F
RKET
S

Consultants, Auction House Experts, Art Collectors, and Museum Professionals (directors and curators). By interviewing several experts in each field, young and old, I hope to arm you with some relevant information before you write the cheque. Please keep in mind that these roles very often intersect: You may encounter dealer/consultants, collector/dealers and many other variations.

THE
ARTI

Ironically, I've chosen not to interview any artists for this book, despite the fact that the artist is the central figure in collecting Contemporary Art. This is a sensitive topic because every dealer will of course tell you that his or her artist is "amazing". Naturally, you'll want to meet this art-world celebrity and, if you are serious about the work, you will.

Like everyone else, I always like to meet and get to know the artist whose work I am collecting; the fact is, though, I don't believe it does any good. After all, *the work* is what we are after. The work must speak for itself; the object must communicate that blissful liberation that every masterpiece conveys. Whether the artist is polite, polished, or tortured, after the cocktails are over, you are living with the art, not the artist.

What can be dangerous here is that the artist will tell you that a certain piece is the best he or she has made (usually one that hasn't sold yet), or make the classic comment that always scares me:

ST

"My new work is going to be my best." The artist must have faith in order to continue to develop his or her personal vision, but you don't, and neither does the art market. I doubt that Jeff Koons knew, when he made his 1986 "Statuary" series, that the stainless-steel bunny (*Rabbit*, 1986) would be the iconic work of the decade. Maybe he thought that his *Italian Woman* (1985) or his *Louis XIV* (1986) pieces were equal to it or even better. The fact is that the art market, not the artist, chose the bunny, and that piece is now worth more than the other two combined, somewhere between $ 5 and $ 8 million, at least.

Everything is relative, as the Dalai Lama – not to mention Einstein – says, and Koons' "Bunny" remains an extraordinary signature work from that era. So in conclusion, go ahead and meet the artists, ask your questions, but remember, they won't have an answer for you; they are looking for their own answers.

THE A
CRIT

The Rodney Dangerfield of the art world, "He gets no respect!" It is an interesting intellectual challenge to understand exactly why these sophisticated people no longer influence the prices of art in the marketplace. In the 1940s, Fifties, and early Sixties, a review by the great (and much despised) Clement Greenberg could make or break an artist's show; today, no critic has that power. Recently,

ART
C

David Rimanelli (26)

shows by Jeff Koons and Damien Hirst were panned in the art press … too late, they were already sold out! Reading art criticism probably can't teach you how to pick a winner, but this information will ultimately save you money by highlighting market hype and derivative copycatting, and potentially alerting you to work that is simply gimmicky or passé.

David Rimanelli

Art Critic, New York

David Rimanelli is a contributing editor of a leading art magazine, *Artforum*, and teaches Contemporary Art at New York University. What better way to define the role of the art critic in today's art market than to ask an expert?

On the relevance of the great French poet Charles Baudelaire to the art market

Baudelaire has no real significance with respect to the market, but he remains the paradigm of the great art critic. Baudelaire in the mid-nineteenth century, and of course Denis Diderot a century before, were really the most influential art critics before the twentieth century, not in terms of reviews in a magazine, but in terms of intellectual stands and positions that had a much more far-reaching effect on the visual arts, poetry, theatre, etc. Diderot wrote his famous *Salons* for his fellow Encyclopedist Melchior Grimm's *Correspondance Littéraire*, which had a circulation of, say, fifteen. Fifteen people were subscribers to the *Correspondance Littéraire,* and when reading Diderot's *Salons*, they read about artworks that they most likely could not see, but which nonetheless they might be influenced to purchase. The circulation was limited to, among others, Catherine the Great, and various other, typically German princes and aristocrats. Intellectuals within the Enlightenment circles of the *Encyclopédie* might also have access. Scarcely *Art News*. When Diderot was doing his *Salons* for the *Correspondance Littéraire,* most people couldn't read and most of the people who could read were not interested in reading about paintings and sculptures for the most part, hence a very limited audience.

Baudelaire had a much wider readership, as he published in newspapers or *feuilletons*, and there were many other critics, and many of them responded publicly to his *Salons*. He said that art criticism must be passionate, polemical and political. I don't know if he meant political in the way that word is bandied about today, but I think it had something to do with taking a stance. This is the period when France is still in the midst of constant revolutions and *coups d'état*, and it's like the critic is at the barricades with the artists. Baudelaire was the main champion of Romanticism against Neoclassicism. His paragon of artists was Eugène Delacroix; then he was associated with Gustave Courbet's realism. You would think his most celebrated essay, "The Painter of Modern Life", would have

been about Edouard Manet, with whom he was also closely associated, but in fact he wrote it on the very fine illustrator, Constantin Guys. But you know, "The Painter of Modern Life" is about abandoning the ossified, academic salon schools of painting. No more simpering nudes and idealized Venuses, no more vacuous crucifixions, no more dead, dead history paintings. Instead, the heroism of modern life would be to paint the Parisian streets, or the concerts, you know, industry, leisure, as it's happening in contemporary life, be it that of the 1850s or of our own time.

The beginning of art criticism

Baudelaire is not the beginning of art criticism, but he represents the beginning of *our* sense of art criticism. In antiquity we have art criticism. Pliny the Elder, in his history of Greek art, wrote *Deinde cessavit ars* – "Then art stopped." He was referring to Greek sculpture after the death of Lysippus. You know, in the Renaissance there were people doing art criticism, sometimes, but in different veins. For one thing, these never were addressed to a mass public. Art criticism, as we know it, is something that coincides with modernity, and with the advent of photography. At the same time, photography is sort of rendering useless, seemingly, the conventional roles of painting. Hence painting has to do something else to be alive and the avant-garde is born, no longer an art of depiction but an art that still, to remain vital, has to invent radically new forms.

Why is Clement Greenberg important?

Well, perhaps most significantly he championed Jackson Pollock. He saw Pollock's first exhibition at Peggy Guggenheim's Art of This Century Gallery, and he immediately, in just a paragraph or part of a paragraph of a review of a group show at the Guggenheim gallery, singled out Pollock. Then he followed Pollock through all of his progressions up to the kind of watershed development of the all-over dripped, poured paintings – like *Number One* in the Museum of Modern Art, for example, or *Autumn Rhythm* in the Metropolitan Museum of Art. When you think of a Pollock painting, those are *the* Pollock paintings, the archetypes. He didn't totally discover Pollock, I guess Peggy Guggenheim discovered him, or actually her assistant, Howard Putzel, did. But in terms of publication and championship critically, he really did it. He was also incredibly influential for a lot of artists. He wrote rhapsodically about Willem de Kooning's first solo show in 1948. He subsequently lost interest in de Kooning when de Kooning went back to representation. For him, "it" was all about abstraction, and that's what the New York School was to him, not about pouring out your soul in splatters of paint on canvas and certainly not about any kind of coded figuration. It was about a pure abstract art that was unlike the abstraction of the school of Paris (Picasso, Braque, Matisse, Miró). That's where the term, the New York School, comes from, although Greenberg himself usually avoided labels.

> "The critic is not irrelevant, even if most criticism is."

The influence of Clement Greenberg on the art market of his time

Initially, no, there was no market for this art. There were hardly any viewers. There were

hardly any galleries willing to show it, and when you went to these galleries, the same people basically showed up for every opening, and there were maybe a few dozen of them at most. However, Pollock *did* eventually become a star in his own lifetime.

Greenberg certainly developed ties to all the important museums, big collectors like the Rockefellers, etc. They bought what he said was the right art to buy. Go to the museums of America and there are Kenneth Nolands, Morris Louises, Anthony Caros, Helen Frankenthalers and lesser artists, by far, whom he also championed. Big collectors were buying what Greenberg said because he had a kind of authority that no one else achieved.

The role of the art critic today

I'm not sure because I'm very sceptical and pessimistic about the role of the art critic today. I know there are people who publish very fine works in *Artforum*, which I've been affiliated with since 1988, and there's been a lot of brilliant writing elsewhere too, but overall I don't think most art criticism is particularly cogent. I think mostly, if you get a certain art critic behind you, it's like a marketing tool. Like "Roberta [Smith] loved my show" or "Jerry [Saltz] came to my studio." Or, for example, although I don't think of myself as in any way a famous person, people whom I don't know, know who I am and they want to know me, and they want me to come to their studios, and they're very direct about it.

Who was David Sylvester?

David Sylvester was *the* pre-eminent British art critic in the second half of the twentieth century. He died in 2001. He was very close to Francis Bacon for a long time, and he's the great champion of Bacon. Sylvester did his famous interviews with Bacon, which really solidified their connection for posterity. He had some role in the continued dissemination of Bacon's work. He unstintingly supported Bacon, and found new contexts in which to show and represent Bacon as an artist who's always going to be viable and vital, like Picasso.

He kept that artist going as a subject of interest and I think that could have a role in terms of the market. I don't know if he created Bacon's market but I think when he first hooked up with Bacon, Bacon didn't have a market and Sylvester didn't have a pot to piss in. Well no, maybe he did, but he was not wealthy by any means. Early on in Francis Bacon's career, before he made his name with the *Three Studies for Figures at the Base of a Crucifixion* in the mid-Fourties, Sylvester would schlepp around London trying to sell paintings for him for £50. That's dedication. Bacon gave him a painting. Many years later, David Sylvester said to Francis: "Do you mind if I sell this?" Francis said, "Do whatever you want," and he sold it for a lot of money. He bought a fancy house in Notting Hill, I believe, *filled* with some very fancy things. He was also a friend of de Kooning's, and he had works by him, drawings inscribed to him by Bill. He was the first vociferous champion of American Abstract Expressionism, writing about it in a very public venue, *The Sunday Times* magazine, when few in Britain took the movement seriously.

David didn't write about people he didn't love. He wasn't cynical in that way, but he wanted something in return, more than the tuppence a critic would normally receive. And many artists gave him works. Maybe he'd say to himself, or behind the artist's

back, "I want a drawing … I want a watercolour … I want something." The point is he valued himself and his work and felt that he should be recompensed in one way or another.

Whether today's critics need to earn more

Why shouldn't critics make more money? Why shouldn't they *ask* for more money? Why would intelligent and talented writers choose a career that pays nothing? I think that this is one of the reasons why, in our kind of art economy as opposed to the economy of the Fourties or the Fifties or the Sixties, the critic is so debased, although still an essential part of the art system. The critic is not irrelevant, even if most criticism is.

Ugo Rondinone
SIEBENUNDZWANZIGSTERJUNIZWEITAUSENDUNDZWEI,
2002, acrylic mural painting, ∅ 157 ½ in. (400 cm),
IF THERE WERE ANYWHERE BUT DESERT. TUESDAY,
2002, fibreglass, paint, clothing, 20 ⅛ x 65 ¾ x 46 ½ in.
(51 x 167 x 118 cm)

THE
ART
DEAL

Art dealers are fascinating people – their egos are often bigger than those of their artists – but they have to be. It takes balls to open an expensive retail store that sells stuff that nobody actually needs and that nobody may want to buy. You may find the price high, but if it's what you want, make an offer. You may not like the fact that you are now on a waiting list for a painting that you'll probably never get, but that's how an artist's market is formed. The dealer is trying to manage his or her portfolio of artists for *profit*, and they've got bills to pay: 50 percent to the artist (or more for superstars), overheads, dinner parties, openings, catalogues, magazine ads, museum patronage, etc. Sometimes it's beneficial to explore the gallery's other artists. If you can't get a piece by the artist that you're fixating on, you can build a relationship and trust with a dealer by supporting his or her entire programme.

You want to take a risk and buy one work; the dealer's risk is that an entire show doesn't sell. So relax, find what *you* want and go for it. You've persevered, you're committed, now it's time to buy. Just keep in mind a few things. Most dealers will offer a ten-percent discount on any primary work, so if you like to negotiate, remember, 15 percent is the maximum you can realistically expect. On secondary material, prices should be much more negotiable; the dealer is fishing, so make an offer and wait. If you have agreed on a price, demand an invoice immediately; if not, the work could "mistakenly" fall into some other client's quicker hands. And pay as fast as you can; dealers love this, and a little good will can go a long way. One last hint: Don't look for bargains; great works sell for a premium, and they *are* worth it.

Marianne Boesky

Art Dealer, New York

Marianne Boesky has built an exceptional young programme over the last ten years. She is best known for her art-business savvy and for developing the career of art-market star Lisa Yuskavage, a painter of provocative and disturbing female nudes. Although Yuskavage's prices have lagged behind those of her close friend and contemporary, John Currin, her large paintings are now in high demand, firmly establishing her among the top stars of her generation. In late 2005, Yuskavage joined the star-studded programme of David Zwirner's gallery. Marianne also represents art-market phenomenon Takashi Murakami, and she has shrewdly built the careers of several newcomers like Liz Craft and Barnaby Furnas.

Trends and changes in the art market over the past three to five years

There are a lot more collectors competing for work and the market is global in a way that it wasn't six or eight years ago. With the Internet, people all over the world can view gallery exhibitions and buy works from an image on their computers. Art buying has increased to a much broader base of people. You've got a younger group of active collectors who are looking at art made by artists in their thirties and forties. You also have a real dearth of material in the Impressionist area because most of the great works are already owned by museums, institutions and collectors who rarely sell. In the Contemporary market you can pay anywhere from $2000 to $2 million for a young, emerging artist, so if you have the access, you can get a lot more work for your money. When our parents became successful, they bought a Renoir because they wanted to show that they had arrived. When *our* generation looks at a Renoir of a pretty girl with a parasol by the river, it doesn't connect to us at all. The demand for a young artist like Jeff Koons is so much higher than it is for a mediocre Renoir at auction.

I also think part of what has fired up the market for Contemporary Art is the process of acquiring. This younger generation of collectors comes into the art world, wants to collect and realizes that there are barriers. They have to develop the relationships to ultimately give them access to great work. There are ways of competing, be it that you're going to promise to donate to a museum, or you've built a collection that is just too good for a dealer to pass up having their artist included. I think it's part of the personality of the new collector to enjoy the process of having to compete a bit and to want to win. It's

doubly impressive to your neighbours if you have that Damien Hirst: a) you scored it from the dealer, and b) you can afford it. So people all of a sudden think they know what you're worth, somehow.

There are many collectors who are genuinely moved by art and who aren't interested in the financial aspects of it at all, but there is also a huge crop of people who are very interested in the value. Art has now become an alternative product to invest in, an asset that can be put into a portfolio. With the auctions and the art fairs all year round now, you have these markers six or seven times a year, where you can re-evaluate your holdings. You're not going to get institutions investing in art funds yet, but eventually you will, because the numbers are there, and the returns on art – if it's bought well – tick fast.

If you can buy something at $60000 and sell it for $600000 two years later, everyone wants in. I think that's also what's been fuelling the market, making it that much more sexy.

Takashi Murakami
Flower Ball (3D), 2002, acrylic on canvas mounted on board, 98⅜ x 98⅜ x 2⅜ in. (250 x 250 x 6 cm)

Takashi Murakami
Planet 66: Summer Vacation, 2004, lithograph,
edition of 50, 21 ⅝ x 21 ⅝ in. (55 x 55 cm)

In terms of art making, there was a shift away from painting for many years, and now I think there's been a shift back towards painting. Also, materials have become more sophisticated, and you have super-high production costs that put a lot of pressure on the galleries and the artists to realize their ideas, and that also raise the price-points for the collectors.

On building a gallery stable

There are definitely criteria that I look for when I'm looking at an artist's work. I'm always looking for a level of skill; I'm looking for someone who has a really deep knowledge of art history that is reflected in their work; and you can see that they're taking from what they know and what they've mined and researched, and incorporated that into the work, even though they have their own unique voice. Those are two really important aspects, for me. The third is commitment – that they're an artist by birth, not by choice, and whether there was a gallery or not, they would be toiling away doing their thing.

I want every artist who is in my stable to have longevity. If you come to me as a collector and there's something on my walls and in my gallery, I want you to know that I believe in this for the long term, it's not a one-shot deal.

What makes a great collector

A great collector is a risk-taker. I think the greatest collectors don't solely rely on consultants working for them; they actually do a lot of the looking themselves and they take risks on things. They'll buy established, known great things, they'll buy totally off-the-cuff, young, emerging things, and ultimately you'll see a thread that weaves them all together and defines that collector's vision and aesthetic. The best collections are the ones that are self-made, but of course this also requires good help: meeting with dealers, advisers, and talking, and thinking, for sure, but the best collections are not made by giving someone a list of names to go out and purchase.

It's important that collectors come up with certain rules for themselves, at least at the beginning, whether it's a budgetary rule, or the collection is just going to be works on paper, or it's going to focus on twenty-five artists in depth. You can always change those rules and bend them.

New collectors should start by being referred to gallerists or to a well-connected curator/adviser in their field of choice by somebody they trust. When they come into the gallery, we'll pull out all these books with overviews of Contemporary Art. We'll give them a

couple of packs of post-its and have them sit and mark whatever they like. Then, I'll go through the materials with them and discuss those artists that they like, and then I'll send them on their way to begin looking. You do need somebody to tell you which galleries are legitimate. There are over four hundred galleries in New York City, and I think that new collectors should carefully choose not only the artists they buy, but also the dealers they buy from. Because you want to be able to know that in two years, if you've outgrown something, you can come back and that dealer's still there and still behind that artist, and knows where the market is to resell it.

Tastes will change and grow, and the things that a collector initially reacts to are going to be things that are familiar. Like when you first started collecting, you might have been more attracted to Basquiat and Warhol because you understood them, they were familiar in your collective consciousness. Perhaps soon after, you wanted something more challenging and different that not everybody knew already, so you became the person who is the knowledgeable source on that artist. Then all of a sudden, those other artists that everyone knows aren't so interesting to you any more. You've sort of raised the bar for yourself over time … but you have to start somewhere.

On buying

Let's say in the next Barnaby Furnas show we have six paintings available, and we have sixty people who want them – anyone who is willing to donate to a museum that wants the work will get priority. Nobody is required to donate anything to a museum, but if they do, they're going to get priority. After that's done, then we'll go to people who've been waiting for a long time and who have been especially supportive of the gallery over time. The reason we want it to go to a museum is because it's like building fundamentals in an undervalued company: it raises the profile and prestige of the artist, and it will be taken care of and exhibited to the public, on and off, for eternity, hopefully.

"Art has now become an alternative product to invest in, an asset that can be put into a portfolio."

Should a new collector hook up with a museum and give fractional gifts?

I think that's asking a lot, especially for a new collector who's in his thirties or forties and has no idea of what his financial situation might be when he is in his sixties, and might need to sell his art collection. There are also other incentives to give. If you buy, say, a Murakami for $50000 and all of a sudden it's worth $500000 two years later, if you hold the work for a year and a day and then donate it, you can take a tax deduction for the full fair-market value, not the cost basis – you're basically making a chunk of money, if you have a tax issue that year. There are other incentives to donating, and people do it for all sorts of reasons.

A good buy

A good buy is always something you love to live with, and it shouldn't be about buying and selling. It should be about buying and holding. I don't think anyone should buy art

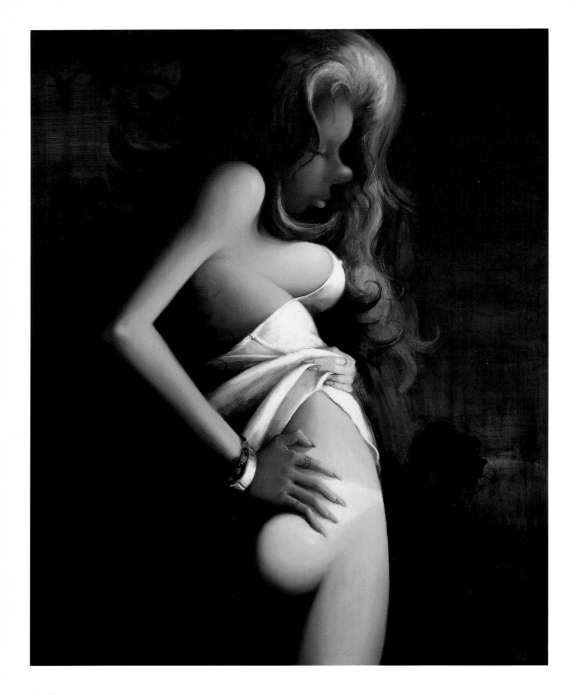

Lisa Yuskavage
Night, 1999–2000, oil on linen,
77 x 62 in. (195.58 x 157.48 cm)

who can't afford to buy art, and who can't afford to lose every dime that they spend on it. The number one thing is that they really enjoy whatever they're taking home with them. I assume that beginner-collectors are actually going to live with everything they buy at first, until they grow out of their space and begin sending pieces down the road to storage. You have to love whatever it is you are buying. If it's something that you love and it goes from $1000 to zero but you still love looking at it, you've made a really good buy.

If you want to make a good buy in terms of value over time, probably the point in the market to do that is when the price hits a certain amount. One collector I know buys only when the price hits $100000, but that's not at the top of the market. He waits for ten shows to have happened, the market to establish itself, the secondary market to be firm and in place, and then he'll set a record price for something which will ultimately be one tenth of what the price will be three years later. His whole collection consists of artists who are already established, but not at their peak. He buys them when they've made it to a certain point, and then they only go up from there.

"A good buy is always something you love to live with."

If you want to have a sure, great investment, then you should watch the market until the artist hits about $100000 and you still believe that there's huge upside there. That's one way of doing it – but it requires substantial means. I'd say that if you only have $5000 to spend and you want to buy some art, you have choices; I would recommend buying unique works by emerging artists over prints by established artists.

On selling

The auction market is hugely important because of the third-party, "free-market" price confirmation. The artist's work needs to have a life of its own away from the artist and the gallery, ultimately, to survive history. There are unwritten rules on how to act in the art world, and selling at auction is a perfectly fine thing to do if you've reached that decision the right way. If you buy something on the secondary market, you're free to sell it on the secondary market. If the gallery has given you priority, as somebody who is trusted and special, and you buy something and then decide to sell it, you should have a conversation with the gallerist before you take it to the auction house.

If you bring a work back to the gallery, and the gallery can get you just as good a price as the auction house, then the gallery knows where it's going, the gallery gets a commission, the artist often gets a kick-back and everybody's happy. The auctions certainly do a seller a positive service if the artist is in demand. However, if the artist is suffering and a work goes to auction, it can be a public embarrassment for the artist and for everybody. The galleries can't buy back everything: if you have a Takashi Murakami that you bought from me that is worth $800000 today and you have a resale agreement with me, I'm not going to be able to buy it back from you for $800000. I'm going to let it go. Then it will go to auction, and that will be good for the artist and for everyone.

Bruno Brunnet and Nicole Hackert

Art Dealers, Berlin

Bruno Brunnet and Nicole Hackert founded Contemporary Fine Arts in 1992 in a chic Berlin neighbourhood and several years later, joined the mass migration of galleries to Berlin-Mitte, the bustling "hip" centre of the city. Their high-octane artist roster includes several international stars (Chris Ofili, Sarah Lucas) as well as important German artists like Jörg Immendorff, Daniel Richter, and the inimitable Jonathan Meese.

On becoming art dealers

Bruno: I was tired of being a waiter, so I decided to become an art dealer. I founded Bruno Brunnet Fine Arts in 1992.

Nicole: I had more or less a traditional art historian university education and started to gain experience when I was still studying, via internships in museums, *Kunstvereine* and galleries. While I was working at Bruno Brunnet Fine Arts, I saw that as an art dealer, your access to the artists is definitely the most direct. Museums are just for showing the art and you do not experience artists on a day-to-day level. But that's what I wanted – to be hanging out and learning from artists. At the same time, I also enjoy hanging out with (some selected) art collectors.

Anyhow, when I finished university, Bruno asked me if I wanted to become his partner. I agreed and we founded Contemporary Fine Arts in 1992.

> "Art doesn't produce itself in this way; an artist is not an unlimited resource."

What they enjoy

What stimulates us are those moments when the exhibition is installed. You light a cigarette, turn on the music, have a glass of champagne and thank the artist. It's very stimulating if you manage to bring to a collector your enthusiasm for an art piece even if you can't find the right words.

Dana Schutz
Vertical Life Support, 2005, oil on canvas,
61 x 36 in. (155 x 91.5 cm)

We love it when subsequently the collectors get to have confidence in us. Of course we enjoy selling.

Changes in the art market over the past five years

It has speeded up. It has allowed a lot of people with the most superficial knowledge to become members of what was, originally, an exclusive club of the Contemporary Art scene. This is the first time ever that the auction results for Contemporary Art can compete with, say, Impressionism. A lot of glamour and money have gotten involved.

On choosing artists to represent

Most often, it is the other artists who recommend new artists to us. When we choose an artist, there's a lot of chemistry involved. Not only do we look at the work, but it's the person sending out signals. For instance, we offered Jonathan Meese a show after meeting him for 15 minutes, and before we had seen a single piece of art, only because we both felt that somebody very special with an incredibly rare talent had crossed our way. Also, you've got to get along with an artist on a personal level. This doesn't mean that he or she must be polite, well-behaved and share all your views. It is, as mentioned, a more "chemical" thing and it definitely has to do with sharing the same sense of humour and fears.

Advice for the new collector

For a start, find a gallery that he or she trusts – galleries are incredibly important for a beginner. Yet, there always comes a point in the collector's career where he or she wants to be more autonomous, and that's okay.

Impact of art fairs on the market

Art fairs are one of the reasons why the market has speeded up. They have caused this unhealthy attitude among collectors in that they expect something, or somebody, new every three months. Art doesn't produce itself in this way; an artist is not an unlimited resource.

Art as an investment

Yes – but not only for money. If you invest in art, you also invest in a different attitude, a new way to look at things. It's an investment that enriches your way of life.

CFA artists who have yet to achieve the recognition they deserve

They have all achieved (or will eventually) the recognition they deserve. At least for now.

How auction prices affect their business

It would be a lie if we stated that they have no effect. They do, of course, affect the price policy.

Chris Ofili
Siren Two, 2005, pastel on paper, 16 x 25 in. (40.6 x 63.6 cm)

Differences between dealing from New York or Berlin

In Berlin, we don't have auctions on Contemporary Art; if we did, they would obviously also vitalize the local art market, and bring in more people from the international crowd. Furthermore, one obviously cannot compare Berlin with New York when it comes to the number of local collectors, so dealing from Berlin is done much more via email and internet than – presumably – is the case in New York.

How to attract great artists and build their markets

We do it pretty much the old school way. Every show, every artist gets a catalogue. Every single art piece that leaves the studio gets inventoried, photographed by one of the best art photographers in the world (Jochen Littkemann) and framed, if necessary. The artists we work with exclusively can always come up with the wish to have a catalogue raisonné, and it would be there. We manage them – if they wish – in almost every aspect of their lives. We do fairs, we communicate (never enough) with the international crowd. We encourage our artists to interact with other media. We have good parties.

On gaining access to good work for the new collector

The new collector should be loyal to a gallery. They should not sell through auctions without informing the gallery from which they purchased the work, but rather give them a chance to buy it back. Sometimes, they should go for a work before they entirely understand it.

To buy from a gallery or at auction

As a beginner, buy art at galleries; try to collect in depth; try not to collect too many artists and then fill in the gaps with auctions; do not build up a collection solely by buying at auctions.

What makes a great collection?

Cecily Brown, Peter Doig, Angus Fairhurst, Jörg Immendorff, Sarah Lucas, Jonathan Meese, Chris Ofili, Raymond Pettibon, Tal R, Daniel Richter, Dana Schutz, Norbert Schwontkowski.

On defining a great collector

He or she is a person who doesn't believe the hype; who helps to make artists big; who collects in depth, not with bits and pieces from everybody; who is crazy sometimes. It is someone who lets the collection reflect himself or herself rather than what was at the latest Frieze.

> "Sometimes, new collectors should go for a work before they entirely understand it."

Jonathan Meese
Mama Johnny (Noel Coward is Back), 2005, bronze, performance in the installation at the Tate Modern, London, February 25, 2006, 86 ⅝ x 59 x 51 ⅛ in. (220 x 150 x 130 cm)

Sadie Coles

Art Dealer, London

Sadie Coles opened her gallery in 1997 in central London with exhibitions of new paintings by John Currin and an installation by Young British Artist star Sarah Lucas, after having worked for years for the powerful gallerist Anthony d'Offay. Soon after, she started organizing "gallery swaps", a programme of exchanging her exhibits with galleries in other locales such as Berlin, Los Angeles, Istanbul and Tel Aviv. She has become one of London's leading gallerists and taste-makers. She was recently wedded to the artist/fashion photographer Juergen Teller.

Getting started as an art dealer

As far as my original interest in art goes, I blame my mother. Later, after art history at university, I worked for a museum until I was recruited by Anthony d'Offay who turned out to be an exceptional trainer of future art dealers. I worked there for five years, then started a project programme for d'Offay exhibiting younger artists. Once I had started programming I felt ready for independence, although I wasn't set on opening my own gallery at that time. I was a bit afraid of the business side of things, as essentially I had always worked with artists on programming and producing, not selling. But eventually I realized that I just had to jump in, and for that, I blame Sarah Lucas and the other artists who waited for me to get it together.

What do you enjoy about your profession?

The artists and their ideas – I think that a million times a day. And the fact that there is so much more art to see and learn about, it is never-ending. Not that I don't get a thrill from the rest of it, which is talking about art in order to facilitate the commerce that repays the artists and supports them in what they want to achieve. I like that all the people I am in touch with every day – the artists, curators, collectors, writers and fellow art dealers – share the same extremely charged passion. We have all got a lot to talk about all the time!

On changes in the art market over the past five years

The size and speed of it has increased tenfold. There are now so many more people

Sarah Lucas
Christ You Know It Ain't Easy, 2003, fibreglass, cigarettes,
77 x 72 x 16 in. (195.6 x 182.9 x 40.6 cm)

involved on all levels. When I started at d'Offay there was no internet, no email and only occasional faxing. Selling was an elegant, long-winded process with couriered transparencies and eloquently written letters. The internet is partially responsible for the increase in the volume of business and the speed with which business is now done. In a positive way, it has made art dealers more accessible to a wider audience and encouraged a boom in new business. The downside of this is that the newer, bigger market needs more and more product, so quality control becomes more and more important. And, depressingly, there are occasions when the trading side of things – the market – sometimes seems to be the main event, with art getting less attention. At times it feels like parallel universes.

How to choose an artist to represent

It is a gut feeling both about the work and the artist, and recognizing that my own desire for their work can be communicated to others. It is also important to feel that I can do something for the artist, and that he or she feels this way too. It is vital from the first moment that you are on an adventure together. And because the success of that adventure is going to require spending a lot of time together, with a lot of ideas and trust and effort on both sides, I need to feel a connection with the artist from the outset. When you are running a primary market gallery, you intend to have close, long-term relationships with the artists you represent, so you need to choose carefully.

> "... in New York you have cocktails early and in London we have digestives late."

Getting started as a new collector

See as much art as you can and read, and read, and read. After about forty years of that, I would identify a few primary galleries that you share an aesthetic with and develop a relationship with the dealers in question. Many great collections are built through close relationships with a relatively small number of dealers. Actually, I really can only speak from my own experience, which is that you get a passion, and the desire to develop it grows and grows and is the most rewarding and exciting thing you can imagine.

How art fairs have changed the market

The art world used to be event-led in terms of international museum openings, and this has changed somewhat. The events that lead are now the big fairs and the auctions. Art fairs can lead to a tendency for super-consumable material within this kind of market. Good fairs control quality carefully through the editing of the galleries, old and new, that are represented; they also come up with the ideas to ensure that a wide range of good, challenging and ambitious work is shown. I miss the feeling that everyone is flying in from somewhere in order to look at art rather than at the art market.

Jim Lambie
The Kinks, Turner Prize 2005, installation at Tate Britain, London. *Four to the Floor* (left), *The Kinks* (Black Kestrel, Septaptych Rorschach) (right), *Chromatic* (floor)

On art as an investment

Art *is* an investment of course – of ideas and

money. We invest in culture to work out intellectual and emotional dilemmas. Art is a fantastic investment of intellect that pays back big time. Obviously, when you are working with contemporary culture you are in some way gambling on, investing in, the future. That is what makes it so exciting. In money terms, of course, you can cynically play the art market in the same way that you can play cotton or something. But if you are in it for that reason, you are short-changing yourself – give it some rope, for God's sake! What's more, any analysis of the Contemporary Art market will always defy reason, because crazy belief can throw it all off and up.

> "When you are running a primary market gallery, you intend to have close, long-term relationships with the artists you represent, so you need to choose carefully."

Artists in your programme who have yet to achieve the recognition they deserve

Since I am a primary dealer, I would recognize that all the artists I work with have greater things to achieve, because if you talk to artists they are almost universally interested in their new work, and in the future. If they weren't, there would be nothing for me to do.

Effect of auction prices on the art dealer's business

You watch them, consider them, calculate them, participate in them, and then set your primary prices in relation to them. But the one thing you can't do is control the auctions; they are the predatory beast you cannot tame, because there are always people out there you don't know. It is irresponsible to ignore auction prices because the artist doesn't want to feel they are being undersold on the primary market. So the gap between primary and secondary has to feel comfortable, not ridiculous, in either direction.

On differences dealing in New York or London

It is easier to move around Europe from London, but everything in New York is cheaper! London has been a trading place for cultural objects for hundreds of years and has that in its blood. It acts as a unique conduit between America and Europe but crucially, over the last decade and a half, has displayed an energetic belief in Contemporary Art that is now bearing fruit. London has also learned to hustle like the best of them, rather than sitting complacently on the arse of its past. But it doesn't rival New York in either scale or location, and the strength of London as a European centre for Contemporary Art is its similarity to New York, not its differences. Both places have strong galleries, good auction houses, a committed audience with the support of local artists, curators and writers, great museums, the same language, and, importantly, an intrinsic understanding of international business. But in New York you have cocktails early and in London we have digestives late.

Urs Fischer
A Place Called Novosibirsk, 2004, cast aluminium, acrylic paint, iron rod, string, epoxy resin, 98 x 30 ½ x 41 ⅜ in. (249 x 77.5 x 105 cm)

Jeffrey Deitch
Art Dealer, New York

Jeffrey Deitch's unique gallery, Deitch Projects, specializes in producing eclectic and ambitious projects by Contemporary artists, as well as exploring the boundaries between art, music and fashion within his Soho spaces. After spending ten years working for Citibank Art Advisory, he launched Deitch Projects in 1996 and is credited with representing and steadfastly supporting monster talent Jeff Koons, as well as developing the careers of Mariko Mori, Barry McGee, Vanessa Beecroft and assume vivid astro focus. Deitch's effervescent and enigmatic programme is always fresh, and a visit to his gallery or to an exhibition he has curated will dependably deliver the unexpected.

Getting started in the art business

I have been in the art business my entire adult life. I remember the day after graduation, I drove down to 420 West Broadway and I walked up to Leo Castelli's reception desk and asked for a job. Of course, there was a snooty secretary there and she looked at me, horrified, but I wasn't fazed. I just walked upstairs to John Weber. Their receptionist had just quit and they had nobody. The only problem was that John Weber would in no way accept a man. He had to have a pretty girl as the secretary. I said, "I want to get the experience. Just let me work for free for a week, and if I'm good, maybe you can give me a good recommendation after the owner gets back." The director said, "I can't say no to that deal. We need help," so I worked for free. John comes back a week later and sees this guy there at the desk and, of course, he's furious and he calls the director into his office and shuts the door and starts yelling, "Who's that guy sitting there!" I really owe so much to her, the director. She convinced him.

After that, I was too young to open my own gallery, so I went to the Harvard Business School and while I was there, I cooked up this idea of going to a bank or investment firm to start an art investment programme, an art advisory programme. I went to Citibank and I had an amazing experience there. I didn't know much about art connoisseurship, particularly about Modern Art. I had a very good salary, unlimited travel budget, almost unlimited access, and I spent ten years there and taught myself art connoisseurship. I opened a gallery only ten years ago. This is basically my retirement.

Trends in the market over the past three to five years

There are artistic trends and there are economic trends. To have a lively art market you need to have something positive on both sides. Let's start with the artistic: Contemporary Art, in particular, is very collectable again. There was a lengthy period, from the late Eighties up to the late Nineties, when the most talked about, influential art was installation art, performance art and video art – not too easy to collect. Now we have a revival in figurative painting, figurative sculpture, art that embraces the popular culture. There is a lot of excellent art that is very immediately accessible and – if you go deeper – also very intellectually satisfying. That's important. Without that, you cannot have the same kind of life in the art market.

In terms of economics, it has been up and down, but now it's basically a very prosperous period. What happened in the stock market after the peak in 2000 gave a lot of people the confidence that art was a good place to have some money, that art did not go down in the same way that certain stocks went down. It held its value and, if anything, would go up.

At that time, I think that a lot of stocks were in a bubble. The art market is very solid – most parts of it are not in a bubble. Conceivably, there are

Barry McGee
The Buddy System (detail), 1999, mixed media, installation at Deitch Projects, New York

Mariko Mori
Pure Land, 1997–1998, glass with photo interlayer,
5 panels, 120 x 240 x ⅞ in. each (304.8 x 609.6 x 2.16 cm)

certain Contemporary artists who were super-popular, who were in a bubble. But prices for the major New York school of Pop Art have seen very solid gains with collectors, not speculators.

The art market starts getting dangerous when speculators come in, when there's undisciplined lending of money to buy art. In the late Eighties, you had speculators and sketchy financiers who convinced lenders – not even banks – to give them money to buy at auction, to give them 100 percent. All that put together is just a recipe for eventual collapse, because most of the art was not going on the walls of people's homes, it was going to warehouses. When it goes on the walls of people's homes, that's a solid market.

On building a gallery programme

I have a personal vision and that's what this gallery is all about. The most important thing is that I'm optimistic. You don't find it depressing here. I'm also looking for an artist who creates his or her own aesthetic world, as opposed to an artist who's just making a nice object. There are a lot of artists who make very nice objects, but you can't really say that there is a whole vision of the world that you can grasp in their work. Somebody like Mariko Mori, though, has this fascinating fusion of traditional Japan, and Zen Buddhism, and Japanese pop culture, and futuristic UFOs. She has kind of an amazing vision of the world, and you see it through the work.

There are two directions that I'm particularly interested in. One of them is the art that's inspired by street culture: Barry McGee and Keith Haring and Jean-Michel Basquiat. I'm ex-

"The kind of person who drives us crazy is trying to get a discount on a $ 1000 drawing."

cited about how things come out of the culture of the streets into the galleries. I also love performance that relates to painting and sculpture. Vanessa Beecroft and Mariko Mori – that's the kind of art that was first being explored in a big way in the Seventies, when I came into the field. I loved it then and it's still one of the things that motivate me.

Where Deitch's artists will be in ten years

I am unusual in the gallery business in that a number of artists whom we present here are not the artists I will represent on an ongoing basis. Almost every other gallery operates on a conventional system – an artist signs up, they represent him, they have a show every year-and-a-half or so, you go into the back room and you see things hanging. I run a kind of private ICA. I want to keep the programme exciting.

The artists I really make a commitment to, where I give them a stipend or give them production money, am really involved to the point where I want to buy a work for my own collection, those artists I do represent – there are only about a half dozen of them – I think they are here for the next decade and more. I also *do* want to show work where I'm not sure where it will be in the next decade, so it gives me a lot of freedom. There are a number of things I've shown where I don't know if, ten years from now, I'd still want to show them, or if there's still something very Contemporary about them that I'd want to get involved with.

On the longevity of an artist's career and the market

There's something very cruel when you look at the auctions, particularly the evening sales, and how many Eighties-generation artists they allow in there. Then you look at the day sale, which is larger, and there are twenty of them. The cruel reality is that out of a whole generation of a thousand artists who had serious shows in New York in the Eighties, it comes down to fifteen people who even have a secondary market.

When I came into the market, auctions were much less important. There was much less of the consciousness about who's going to last in the secondary market. Now people feel they want to refine it. If there's something that's not an "A", you should get rid of it. They want to subject it to rigorous tests. I think that's unhealthy. Collecting should be much more broad, and you should not subject each art work to this testing: Is it going to be here in ten years? If you like it, if it's interesting, if this person is making a contribution to art culture, break the habit. It's great to support them.

I understand the reality, and this is basically a product of the auction situation – it has changed things a lot. I hope that it broadens a little bit, so that it opens up again. But for now, if you are talking with inside dealer-collector types, they are very, very conscious of this.

I feel it's unnecessarily tough on the process of creation, it weighs on the market. I'd rather take a different approach. You can get a few artists where your investment will more than pay for itself in time, but be broad – that's how I would look at it. Other people would go on with this new market gospel, you know, be really tough, get rid of things. My perspective is different.

What makes a good client?

Basically, I want to deal with people who are serious, and who are stimulating for me to work with. I want to work with someone who is fun to talk to. I want to be involved with people who make my life more interesting, who come to our events, show interest, start buying small. The kind of person who drives us crazy is trying to get a discount on a $ 1000 drawing. I'm happy to give you a discount of ten percent, or give you the frame, free, but I'm not going beyond that, it's a waste of time. We don't want to deal with some-one like that.

On clients who buy primary and sell at auction

I don't like it. There's a way to play the game, and I have to deal with people who under-stand how to play the game. How not to play the game is to buy something from me, and not pay for it, not pick it up, and then a cheque arrives a year later from Sotheby's with a note to please release this work to Sotheby's next week, "we're sending a truck".

Sometimes they're good friends of mine – a year after buying something, I open up a Sotheby's or Christie's catalogue and there it is. In one case, I called the client up and said, "Listen, this is not how you play the game," and they withdrew it from auction. It was still in the catalogue, but it wasn't very good, because if that goes on, I'm going to lose the artist. The artist says, "What do I need you for? I should just put the thing right into the auction for double what I got." So people have to respect that there's a way to play the game.

About resale agreements

I believe in property rights. If I sell this to you, it's yours, and I should only sell to people I respect. I believe that they understand these unwritten rules, and that will help our cause.

What makes a great collector?

I've been privileged to work closely with a number of major collectors. They are all very different people; it's a thing where you can be yourself and can follow your personality.

"When it goes on the walls of people's homes, that's a solid market."

Some collectors approach it in a very intuitive, un-intellectual way. If they like something and don't even get into the analysis, they can have a great collection just because they bring their emotion and their intuition into it. Others are really analytical, and they want to get every record and book and analyze things backwards and forwards, and that can also be a great collection. Of course, both of those approaches can end up with a terrible collection.

If you look at people like Norman Braman and Dakis Joannou, they have a lot of self-confidence and, luckily, I've maintained rewarding relationships with them. They like me and trust me, and they ask a lot. Ultimately, they have great collections because they have super-confidence in their own vision. You can get lots of different opinions but, ultimately, you have to make the decision. It's a confidence created when your eye and your background converge, and you say, "That's it."

Also, you have to have a sense of value. You need to have confidence to build a great collection in order to be ahead of the market. If anything by Jeff Koons comes up for sale and it's an unprecedented price, way beyond the primary market, something like this has never come up for secondary, you have to have the confidence to say, "This is great. I have to pay the price." To take the collection up to another level, you have to be able to do that.

Vanessa Beecroft
VB52, Castello di Rivoli, Turin, 2003

Márcia Fortes

Art Dealer, São Paulo

Based in São Paulo, Márcia Fortes graduated from New York University. She worked first as an art critic and cultural correspondent for *Jornal do Brasil* as well as several art magzines including *frieze*. In 2000 she became director of Galeria Camargo Vilaça. The following year, she founded Fortes Vilaça with her partner, Alessandra d'Aloia. She is best known for promoting Brazilian artists like Ernesto Neto and Beatriz Milhazes out of the Latin American art market into the much broader international Contemporary Art world.

Beginnings of a gallery

It was more by providence than by choice that I came to the gallery. In the Nineties I worked as a freelance New York-based writer/curator, when I developed a great friendship with Marcantonio Vilaça, the best art dealer Brazil has ever had. He had founded Galeria Camargo Vilaça with partner Karla Camargo back in early 1992; together they led the Brazilian Contemporary Art scene locally and abroad. Marcantonio was smart, bold, at once aggressive and sweet. Like many of us, he lived hard on the fast lane. On January 1, 2000, he died of a heart attack, a very sad morning. After that many events unfolded, I relocated to São Paulo and worked as director of Galeria Camargo Vilaça for a year until Karla Camargo, who had been heroic about holding things together in her partner's absence, decided to quit. But the main point is: in a convoluted roundabout way, the gallery project has survived after a huge makeover ministered by my current partner, Alessandra d'Aloia, and myself. Now we run a new enterprise under a new name and with new artists, Galeria Fortes Vilaça, but we carry the institutional and emotional heritage of Marcantonio. It's something I'm very proud of.

Recent changes in the art market

We're all deeply contaminated by the various "cancers" that have befallen our circuit – the wild proliferation of art fairs and biennales which end up becoming more or less the same thing: hectic festivals of fragmented artistic languages populated by an ever-hungry herd of dealers and collectors and curators trotting about like mad, me included. This madness has intensified so much in the past five years that I believe (or want to believe) a backlash is on its way, and everyone will tire of travelling the globe after each fair and

biennale. Overall, the speed of things, which had been fast for many years, has now become vertiginous.

Choosing gallery artists

Many of them we have taken on from the late Galeria Camargo Vilaça, perhaps half of our team. The other half was freshly picked over the past five years, generally after we saw a sequence of appealing works in various shows, or because I happened to know the artist from his/her student days and trusted his/her sheer talent. I like it either way: taking on an artist who has already developed his/her "style" because I've always felt drawn to the work, and then become part of his/her creative process, or starting completely from the beginning with a young unknown person, helping him/her build a body of work and then working really hard on bringing that artist to the attention of my gallery audience. One gives me immediate pleasure, and the other, the thrill of a challenge which I revel in.

How a new collector should start

He/she should start by purchasing something he/she really likes. Intuition is one of the best assets when it comes to art. It's also crucial to study art, past and present, and to consult with professionals in the field, keeping up with new trends in the circuit. Having a curator can also be very fruitful (though sometimes contriving). A new collector should also be prepared to get it wrong in the beginning. Few never do.

Ernesto Neto
Ora Bolas ... Alguma coisa acontece no mergulho do corpo, no horizonte, na gravidade, 2005, cotton fabric net, plastic balls, rubber balls, hook, foam, cotton fabric and metal banister, height 159 ½ x Ø 262 in. (405 x 665 cm)

On art fairs

On the sunny side, an art fair is a great opportunity to see top quality works concentrated in a single place. I mean really fresh, Contemporary

works which haven't been placed in the museums yet. Art fairs are also amazing platforms for encounters with every type of art-world professional, an incredibly fertile ground.

On the other hand, it's all become so aggressive and competitive in a very unhealthy way. The art fairs generate heavy pressure on the dealers, an art-fair booth is a gallerist's "solo show", so the dealers in turn put a lot of pressure on the artists to produce work and the artists' work can suffer from that. Then, art fairs also place a lot of pressure on the collectors and museum curators, who need to rush in order to guarantee the acquisition of the best work available. Sometimes, thirty minutes is already too late. Nobody wants to hold anything. The market has become ruthless this way.

Adriana Varejão
O Chinês (The Chinese), 2005, oil on canvas, 110¼ x 154 in. (280 x 391 cm)

Previous spread
Beatriz Milhazes
O Beijo, 1995, acrylic on canvas, 76 x 118 in. (193 x 299.7 cm)

Art as an investment
Art could definitely be considered an investment, but a difficult one; it's also much more than just that.

Artists in her programme who have not yet received the recognition they deserve
I actually think that all of them deserve more recognition. Because we happen to be located outside the usual Northwestern grid, we never get the attention that is bestowed on artists from the United States or Germany. For example, any Yale graduate who makes a somewhat interesting painting will soon get an *Artforum, Flash Art* or *frieze* magazine cover article, but it will take decades for someone as mature as Beatriz Milhazes or Ernesto Neto to earn one. There has never been a book by a major art publishing

house on either, for instance. Then, you have someone as competent and established as Adriana Varejão, who has been experiencing great demand from collections and support from critics/curators but still needs to be further recognized. Not to mention the other twenty artists I represent who are undoubted talents, who have participated in a couple of biennales, but remain relatively unknown to the broader art audience. José Damasceno, for one, has just participated in the Biennale di Venezia and will soon take part in the Sydney Biennial, but there has never been an international review of his work.

Some people still think in the old prejudicial way, "I don't follow Latin American art." That makes me cringe, as this limiting category has no place in the world today except as a geographic standpoint. I think that Latin American art is as vague an expression as World Music, a category that defines whatever happens outside the Northwestern grid, but that in terms of artistic style is widely diverse. It is an expression that has lost its meaning. Of course, there's globalization and then there's a deep sense of identity, this is the paradox we all live today. There is an evident articulation between the local cultural identity, an information flux that is global and the personal interest of each artist, just like it happens everywhere. I see Contemporary Art from Brazil as part of the mainstream art world. Luckily, many museum curators and collectors see it the same way, but we still have to get through to the majority.

On differences in dealing between New York and Brazil

It makes all the difference. Just ask how many art-world people have travelled south of the Equator. It means half the globe, but most people have never even been here. So we can't sit on our bottoms and expect people to walk into the gallery. Even though we can count on a tight supporting group of local curators and collectors of Contemporary Art, it is still a limited group and not half as widespread as the Contemporary Art audience in New York. We need to resort to participating in the international art fairs (alas, there again!), publicizing in the specialized magazines, sending newsletters, widening our mailing list, sending out packages of material, talking on the phone and emailing constantly. We work harder.

> "I see Contemporary Art from Brazil as part of the mainstream art world."

Also, we work on two different calendars: winter season in New York is summer in the Southern Hemisphere, so instead of vacationing in February (which would be our August), we're at full speed because of the art world at large; and during the summer season in New York we're in the midst of winter and plunged in work down in São Paulo, since July and August are our domestic high season. We do work harder.

What makes a great collection

A great collection has a certain focus, personality or distinction, because it's rather boring to see many collectors striving to build the same collection with the same household names. But above all, great work – no collection can get around that.

Larry Gagosian

Art Dealer, New York – Los Angeles – London

Born in Los Angeles, Larry Gagosian is known for his style, his charisma, his aesthetic bravura and for programming more gallery space than any other dealer in the world today. The Gagosian empire includes a staggering list of superstar living artists (e. g. Cy Twombly, Richard Serra, Chris Burden, Damien Hirst, Jeff Koons and Mike Kelley). Gagosian also represents several major estates: Willem de Kooning's, David Smith's and now, in the United States, that of the immensely influential Martin Kippenberger. Gagosian is perhaps the only gallery in the world where you can walk in to buy a Franz West or even a Cy Twombly (*if* you can get one) and, if you are not careful, you may walk out with a Picasso. With two impressive galleries in New York, one in Los Angeles, and two more in London, Larry is without a doubt the most talked about art dealer in the world, often praised for his ambitious shows and the financial risks he takes (such as Richard Serra's *Torqued Ellipses*). He is known for being a tough businessman, for taking artists from other galleries, and for living better than most of his clients, much in the style of Joseph Duveen, the great art dealer of the last century who seeded the collections of America's rich with the great masterpieces of old Europe.

On the art market

The market seems to be much broader than it has been at any time since I've been an art dealer. I think the biggest change is that there's a much broader appreciation of art, and it has become, for lack of a better word, a great hobby for a lot of people to collect art. A greater percentage of the people who have the means to do it seem to be interested in collecting art than at any time since I've been in business.

If you go back ten years, you realize how incredibly thin the market was. There were a few extraordinarily rich people who, basically, did almost all of the collecting. Now we have a completely different kind of collecting environment, because there are many people who think about buying a painting when they buy a loft, or when they buy a house.

I don't think we're in a bubble. I think it's a fairly healthy market. Can prices go down? Yes. A real bubble bursting happened in 1990. We saw a cycle coming out of this internet crash in 2001 when the NASDAQ tanked, but it was not a bubble burst. Rather, there

was a little bit of softening at auction, a little less volume, meaning the market slowed down a little. That is more likely to happen the next time, based on what I've seen. Now, if things get really, really overheated and there's a lot of speculation, that's when you have a bubble, it's just a matter of time before it bursts. But they never burst the same way, and they never form the same way.

I think there's always a certain amount of speculation in the market. That has been the case in a slow market as well, because even then, people see it as a buying opportunity. If somebody has a lot of money, and that person wants to buy an artist in depth because he or she thinks the work might be more valuable in the future, that's not the same as somebody buying work with the sole intention of selling it for a profit.

During the speculative bubble of the Eighties, there were collectors investing in art, strictly, almost like a financial instrument. They were buying art because they thought that in six months, or a year, or two years, they could make a serious profit. I don't know many people who are doing that now. The people I see buying art are not buying with time horizons and three-year limits in mind. There are

Cecily Brown
Black Painting No. 6, 2004, oil on linen, 48 x 50 in. (121.9 x 127 cm)

degrees of speculation, and the kind of speculation that I think is really volatile, and that you have to be careful of, I have not seen appear in any substantial way.

"... an art investment can also be a bad investment."

Getting started collecting Contemporary Art

The most important thing that a collector should do is to buy. Of course, that may seem like a self-serving answer from an art dealer, but I mean it seriously. You run into these collectors who are so paralysed that they can't buy anything; it's, "I don't know, I don't need it." You *never* know, really, until you start living with things and making commitments. Obviously, you should buy things that you like, that you can afford, that you feel like you're getting a fair deal on, but there's this paralysis, particularly when people are starting to collect. That's understandable up to a point, because the person is entering an area that is kind of a murky world for an outsider, or for an initiate into collecting. There are things about it that are hard to read unless you've had some familiarity with art galleries and dealers. On the other hand, if you're dealing with a reputable gallery, I think you have to *buy*.

At times, they'll ask you, "How do I know I'll like this in five years?" Well, you *don't* know. It's a process. You have to get in there and start living with art and seeing how it changes your thinking and your perceptions. It's rare that somebody will buy pictures, initially, that, ten years down the road, they will find as compelling and interesting to live with. They either outgrow them economically – sometimes they can afford better, whatever that is; you have to be careful with that, because money doesn't always make better – or their taste totally changes. They start with Impressionism and they end with Minimalism or Pop. You don't know where your taste is going to go, or how fast it will evolve. So you have to start just buying things. Collecting is to buy, to make commitments. If you're not buying, the process doesn't work.

Chris Burden
Curved Bridge, 2003, stainless steel reproduction, Mysto Type I Erector parts and wood bases, edition 1/3, 98⅜ x 389¾ x 106¼ in. (2.5 x 9.9 x 2.7 m)

Art as investment

It can be. But an art investment can also be a bad investment.

On resale agreements

I don't like them. I think things have to find their own way. I don't think you can restrict people. I'm proud that very few of our living young artists, the ones we sell, end up at auction. Collectors should have the right to sell a work of art if they want to, for whatever reason they wish.

At the same time, the seller should know that there is a certain protocol. I'd rather know the people I'm dealing with, and know what their intentions are, and trust that they're going to do the right thing, and that if they have to sell something, they are going to call the gallery. The need to sell something, or wanting to sell something, doesn't always arise out of pressure; things may change, they don't want an artist any longer, they want something else. It doesn't make them bad collectors or bad people. But if they respect the relationship with the gallery, and if they respect the potential fragility of any artist's career, and they behave correctly, then why shouldn't a person be allowed to sell? The sale doesn't even have to be back through the gallery, but at least we'd like to be given the first call. And I'd rather keep that informal. That's just my style.

Previous spread
Martin Kippenberger
Ohne Titel (from the series "Lieber Maler, male mir"), 1981, acrylic on canvas, 78¾ x 118 in. (200 x 300 cm)

Richard Serra
Torqued Ellipses, installation view, Dia Center for the Arts, New York, September 25, 1997 – June 14, 1998

Barbara Gladstone

Art Dealer, New York

Barbara Gladstone is a powerful figure in today's Contemporary Art world, having opened her gallery in 1980. She is highly respected for her success in building the formidable career of American Art star Matthew Barney, a reclusive filmmaker and sculptor who has directed several lavish art films and is perhaps best described as a Contemporary surrealist. Barbara is usually dressed in black and is always stylish, if somewhat intimidating. She has been loyal to her gallery's vision, and her confidence in the remarkable talent of artist Richard Prince, despite his earlier lack of acceptance in the marketplace, has finally borne fruit. He is today one of the most respected and sought-after veterans of the art market.

What makes an art dealer

There is no course, no one way to become an art dealer. A dealer can be whatever he or she chooses. You can be perfectly yourself. Think of all the art dealers working – they're all totally different. You know what a good lawyer is, what a good banker is, what a good doctor is, there's a certain protocol. But art dealers could be tie-less, with their feet on the desk, coming in at noon and leaving at four, or working 24 hours a day. It can be done however, and no one will ever criticize, because there's no industry standard for success. Success is much more about the gallery programme and working well with the artists.

The difference between a gallerist and a dealer

A gallerist supports a programme of artists over the long term, represents artists – it's what I do. There is a distinction between that and the secondary market or private dealers.

I represent artists and work for them as an agent. It is my job to think beyond selling this particular work, to five, ten, fifteen years from now. Where will the artist be then, and what will do them the most good now in building their careers for the future. This includes who should buy their work, what collections they should be in.

On the other hand, when a private dealer has a work by an artist for sale, he doesn't have the same responsibility to take care of the artist because it's not an ongoing relationship. There is an obligation to this object, to place it for the most money – which is perfectly legitimate, but it's a very different situation. I feel totally responsible for the artists because they trust me.

On young artists today

I always think it takes years to see more than just the promise. Looking back, for instance, at the Eighties, it is more or less clear who emerged strongly from that decade, and who didn't. The very big danger at the moment – which is the same danger that there was in the Eighties – is the tendency to look for younger and younger artists because the market is so active and so many things are sold. Many young artists may not be able to take the pressure of producing work in the full light of exhibitions all the time. It used to be that they never really bloomed until they were almost thirty, and so they had time to develop. There is not that luxury anymore. Critics, collectors, and gallerists go into graduate schools, or undergraduate schools,

Matthew Barney
Cremaster 5, 1997, production still

and artists start having shows at a very, very young age. Few will be able to last with that kind of pressure on them, to produce exhibitions and works for sale. It may take close to twenty years to know who has made it.

On an artist's longevity

I believe that the careers of artists are long term. I assume that the kind of artist who's going to come to me, as opposed to some other gallery, is that kind of artist who knows that I'm going to start working and I'm going to continue working for the long haul. I'm serious about them, and they are serious about me – we both deserve it. I also very much like to work with artists who I feel are experienced and a little bit under the radar. Sometimes, it's like the tortoise and the hare in terms of the artist's trajectory. Many times I have felt that it would just get better.

"There is ... no one way to become an art dealer. A dealer can be whatever he or she chooses."

The art adviser; to hire or not to hire

I think it's fine and can be important for a beginning collector. I don't like every art adviser, but I think certain advisers are very, very useful. If a relationship is successful, at a certain point, the collector may be ready to go out on his or her own. But for a few years, it's a very good thing to do. In some cases, it's a marriage made in heaven and they just continue working, which is great. But people should be careful to choose good advisers, professional ones.

New collectors should understand the art world and familiarize themselves with it before they do anything. They should subscribe to art magazines and join museums. The junior committee of a museum is always a good way to meet people who have common interests. Museums are vitally interested in the next generation of people who will support them. The curators of those museums are very open to talking to people because they also enjoy the dialogue. I think it's always nice, when someone starts to collect, to give something to his or her local museum – that's a way to get noticed immediately.

Finding good work

Do a lot of research. You have to know, for instance, that in an artist's career, there can be some pieces which are better than others – because they're more complete, part of a special series, or from an especially strong period for the artist, a time when he or she had a breakthrough. Every artist has different moments. You need information. Nobody should just run out and start buying. You don't make good buys that way.

I usually make good buys when I start to think about somebody who seems to me to be under-appreciated. You can have some room without all the scrutiny. If everybody wants the same thing, you're not going to get a good buy. But that may not be the one, in the end, that you really want.

Resale agreements

It depends on how they're constructed. Mine state that if someone decides to sell something in the future, he or she will give me the right of first

Richard Prince
Untitled (girlfriend), 1993, ektacolour photograph, 58⅛ x 40 in. (149.2 x 101.6 cm), edition of 2 x 1 AP

refusal. However, if the client bought something from me that appreciated a great deal, I may decide not to buy it. If I am unable to meet the price, then he or she can do something else with it, that's fair. I would just like the opportunity, because I gave the collector the opportunity.

Art fairs

They've changed the business greatly. So much of what happens now is very event-driven. The advantage is that you can see so much work at one time, and meet so many people at one time. It's a very good way to get to know the galleries because everybody is present and available. But there are parts of it I don't like. Art doesn't look its best at fairs. The situation is certainly less than ideal; the setting is very ordinary, the walls and lighting can be tacky. On the other hand, so many

"Every artist has different moments. You need information. Nobody should just run out and start buying. You don't make good buys that way."

people can meet at one point. It's a very good way for curators to see many things, because usually their travel budgets are low – they can take in a lot, speak with collectors. That's a good way for a young collector to get started, to go with a local museum to one of the art fairs, under the guidance of one of the curators. If the collector sees something and it can be reserved, he or she can go and get the curator to come back and look at the work. The curator may say, "Oh, that's a good choice," or explain why it is not something to go after. So, for a novice collector, they serve a very good purpose.

I think that there is competition among collectors, in that they probably buy works at the fairs that they might not buy if they had more time to think about it. Once you've gone to the fair, you want to buy something.

For the dealers and gallerists, going to Basel, for example, provides the opportunity to talk with many, many collectors who would never show up at the gallery because they're either Belgian, or French, or Swiss, or German. When you meet people at the fair, it's more friendly because many of them, especially those who are new to collecting, find the gallery situation intimidating.

On visiting galleries

I think you can learn a great deal visiting galleries. It encourages the viewer to look and appreciate an entire exhibition. But it can be an intimidating place – it's very silent, no one is around. The first time a client approaches the receptionist to ask if you can talk to someone about the work, there is a pressure to have something to say. Often people have come up to me and said, "Oh, I've been to your gallery so many times, but I wouldn't dare ask for you." Go ahead and ask – it's not a museum.

Sarah Lucas
Self Portrait With Fried Eggs, 1996, C-Print, edition of 3 + AP, 60 x 48 in. (152.4 x 121.9 cm)

Marc Glimcher

Art Dealer, New York

Marc Glimcher is the president of PaceWildenstein Gallery, which was founded in 1960 by his father Arne Glimcher. The gallery is recognized as one of the oldest and most established in the city because of its longevity, and its representation of several major estates like those of Donald Judd, Jean Dubuffet, and Louise Nevelson, as well as Alexander Calder and Agnes Martin. The gallery is also associated with several artists of monumental stature including Robert Rauschenberg, Chuck Close, Robert Ryman, Claes Oldenburg, John Chamberlain and Lucas Samaras. Marc had studied bio-chemistry before dedicating the past twenty years to being an art dealer. His responsibilities include managing three gallery spaces in Manhattan as well as creating a programme of younger artists like Tara Donovan, Tim Eitel and James Siena who will help keep the Pace programme relevant and dynamic.

How to deal with the challenge of bringing younger artists into a programme of established stars

The problem comes when a gallery stops bringing on artists from the current generation. No matter how important your artists are, you, as a gallery, start to become a little ossified and in danger of being irrelevant, both to the artists you want and the artists you already represent. As Chuck Close once said to me, "This doesn't mean I'm getting old, it means you're getting old."

Over the last few years, we've seen a lot of young prominent artists coming on the scene who are extremely passionate about our programme, from Mark Rothko to Alexander Calder, to Agnes Martin and Bridget Riley, to Chuck Close and Alex Katz. Artists like James Siena, Keith Tyson, Tara Donovan, Corban Walker, Michal Rovner, Tim Hawkinson and Fred Wilson have joined the gallery in the last two or three years and they all seem like they've always been part of the family. Alex Katz was excited to hear that we had just taken on Tim Eitel.

The answer is, if you keep it going and *you* stay engaged, then the separation between the older artists and the younger artists becomes irrelevant, just like the phony distinctions between Modern, Contemporary, or Post-War – that's all nonsense.

Tara Donovan
Untitled (Toothpicks), 2004, wooden toothpicks,
48 x 48 x 48 in. (121.9 x 121.9 x 121.9 cm)

James Siena
Acidic Non-Slice, 2005, gouache on paper, 11 x 8 ½ in.
(27.9 x 21.6 cm)

How many of his artists will be around in ten years

I can answer that question very simply. If we do our job correctly, all of them will be around in ten years. Will the artist be around in the art world? Our answer would be unequivocally "Yes." These artists have all achieved to a point that we know they're sticking around. Will they stay with us? Our commitment to the artists is permanent. We have very few contracts – we have one only when the artist wants it, and that contract is completely one-sided in that it sets out the protections for the artist. We require no protection in the relationship because our philosophy is that we have to earn the artists' willingness to remain with us every day, and it's permanent. If they go through five years of making no art, or whatever the circumstances – it's been beaten into me with a stick – whatever the artists need, you must do.

Recent changes in the art market

Nothing has changed, and nothing changes. That is not to say that things do not increase; they certainly do. What most people identify as change in the art market – different kinds of collectors, people paying all kinds of money in different ways, speculators – is in no way fundamentally different from any other past peak in the art market. The reality is that if you take all the artists and all the galleries at any given moment, a vast majority of them are going to disappear anyway. At some rate of disappearance, the market hits a certain level and the effects become tangible to people who are not falling out. Then, the established collectors and established artists start to feel the pinch. But that is a completely natural process that has recurred through the history of the art market, which is an outstandingly long history.

Market characteristics

Actually, the art market is not really a market; it's too small to qualify as one. Furthermore, if it is a market, it's a market of uniques. Therefore, there is no true comparability between prices. Finally, it's a market of Geffen goods which is what gives it such strange characteristics. Geffen was a 19th-century economist who said that there are certain goods that will disobey the basic laws of supply and demand, that when the price drops to a certain level, instead of demand rising, demand will suddenly begin to drop. As the price drops, demand will drop further, so there is a cliff in the supply and demand curve at some critical price level.

Interestingly, if you have a very small market of unique objects that have this characteristic, you would expect that market to be incredibly erratic and volatile, and yet it isn't, it's very predictable. The art market does very well and then it levels off, goes a little down and continues to go up with some small dips or plateaus. Many economists try to get into the nitty-gritty of pricing and auctions when, in reality, any good economist will tell you that this little market is driven by basic economic prosperity. It can only be significantly influenced by extrinsic factors ... Don't tell anyone this, it's a big secret – when is the art market going to crash? When the stock market crashes, when the real estate market crashes, whatever market is out there that crashes, that's when the art market is going to crash.

Art is less a market than it is a basic by-product of human consciousness; it's linked to the general prosperity of the community or society or civilization as a whole.

Value of art

Art is an object with no utility, as the economists would say. The utility of a painting is zero. It has spiritual value, but no utility, like an orange, for instance, which gives you calories. So when you buy a painting, you are saying: "I am going to trade my hard work and the sweat of my brow for something that is completely ephemeral and has no physical utility at all." Now when we trade with each other, we're assuming that we, as a group, can determine the value of something that has no value – it is purely an agreement between conscious entities. That has to be the highest expression of human economics, in a sense, and therefore it makes sense that art is the most expensive thing in the world. If we can come to some agreement that these things have a certain value, then that object deserves to be of higher value than anything because it has escaped the bonds of the physical world. It's a way to touch something beyond us.

Art as an investment

It is best not to think of it that way, lest you make a bad investment. Art is an investment as part of its nature. But if you isolate the investment aspect, it will make you a very easy target for the vultures to come and get you. It cannot be invested in the way other things are invested. You cannot "due diligence" your way to having just the right portfolio of art. All you have to do is look at the collections that have appreciated in value; none of them were built like an investment portfolio.

A great collection of art and a great collector

They are one and the same thing, for sure. A great collector is invariably somebody who has this disease, and it is a disease. It might start with baseball cards – you know, the kid who just needs another Tom Seaver: "You already have a Tom Seaver, signed 1969 card, Jimmy! Why do you need another?" says Mom. "I just *need* another one," he says, "I'm going to trade this, then I'm going to get that ..." You know it when someone has the need to collect, the need to put together a group of something. There's a mental structure behind it.

The art collector is the ultimate example of that mental structure. If he is passionate about this or that, then he needs to have another one; mind you this is not about just getting more, this is about building something. It is also about much more than getting "the best". Don Fischer is a perfect example – did he buy his fifty Calders because each one is "the best"? No, that is much too simplistic for the true collector. Of course, his generally are the best of their area, but the completeness and his wonder of uncovering another miraculous find far exceeds some sort of boiled-down analysis of "this is better than that".

It is a certain sense of abandon rather than this prudish attitude of "Let's check it out, let's get all the metrics figured out for this painting ..." that drives a real collector. People have great collections of artists whose work they're never going to be able to sell. I know some people who have sixty-five Alfred Jensens, and they have continued buying Alfred Jensen regardless of the current state of the market. We still believe in Alfred Jensen, of course, we represent the estate, we have great shows coming up. But these people keep at it too, and when you go into their house, you will believe as well. That's a real collector.

How to make a good buy

Don't bother, that's my advice. Don't try to get a good deal, it's just a waste of time. If you're getting a good deal, it's a fluke, which is great, it does happen. You might get a good deal if your friend is an art dealer and you have compromising pictures of her from the Miami Art Fair or something like that. Barring that, my advice is to buy everything, not literally, but go out there and buy. The Meyerhoffs bought Johns, Rauschenberg, they bought Youngerman and D'Arcangelo, and twenty others on both sides. They made a good buy because they paid $500 for the Johns and $500 for the Youngerman.

"I like to say that art collecting is not a hobby for the rich, because they can't afford it."

Today the Johns is worth 15 million. Youngerman is worth $50000, although I think he's coming back. But the point is, that is the reliable way to make a good buy, and the way it's been done. You follow your passions, hold on to your collection and everything eventually works out.

How do you feel about clients buying work from you and selling them at auction?

I feel sorry for them if they ever plan on buying anything else from me … but seriously, when they buy a work from me they're buying it from the artist. And if they then take that piece of art from the artist and stick it in the auction house, that is an abuse of the relationship which is created through the purchase … the artist-collector relationship, which, by the way, is the central relationship in the history of art.

Someone bought a painting from Tim Eitel two years ago for $2000, it's nine inches square. They sold it at auction – those paintings are not $2000 any more, now they're $9000 – they sold it for $120000. That's vile. That's not art collecting. If you bought it two years ago, what happened? Are you broke now? No, that person is not starving. Did they turn to the artist's gallery and say: "Would you like a chance to place this in the right collection (because mine is obviously not)" or whatever? What happens is you breed a class of people like Charles Saatchi whose only interest, in my estimation, is to raise himself above the artists and take pleasure from destroying their lives. They attempt to corner the market by buying dozens or hundreds of works and then, when the moment is right, dump them in auction; they capture the upside and then the market falls away. The first artist Saatchi famously did this to was Sandro Chia, whose market never recovered. For what pleasure did he do this? To destroy Sandro Chia's life? What happened to his insistence that his devotion to the artists was the reason the dealer should sell him work after work? What about his friend Damien Hirst whom he extorted millions out of by threatening to dump a dozen major works at auction? The booming market and the auction system breeds this parasitic behaviour which to me is a little reminiscent of the Romans entertaining themselves by throwing the Christians to the lions. So I guess you might say, I'm not a big fan.

Advice for the new collector

It's really simple. The first thing you do, don't go to an art gallery or an art fair, or an

auction house. Find somebody who knows something about art and art history and go to the Museum of Modern Art. Start with Picasso and finish with Jeff Koons. Take your time, and try and assemble in your head some understanding of the architecture of what happened from the Impressionists until now. It is an oversimplification which you'll assemble in your head but that's fine, because you've got to understand why Braque goes here and Ryman is here, Warhol is there and where Twombly and Miró belong. It's not that hard and there is actually not that much but, until you assemble it in your head, you cannot start buying art. You need the framework.

Once you have that framework, find a thread that you want to follow, you need to find the galleries that are passionately involved in those threads. If you discover a feeling for minimalism and poetic abstraction in yourself, you make your way over to Matthew Marks and see the Brice Marden show, and there will be someone at Matthew Marks whom you can get to know and you will be on the right track. You are going to be exposed to the areas of interest that you've already exposed to yourself, and now you've got to find people with similar interests.

Is money a prerequisite to owning art?

One needs a lot of money. This is a very expensive hobby. I like to say that art collecting is not a hobby for the rich, because they can't afford it. That's why I have a print collection ... just kidding. It's simple math; only a tiny segment of our population is capable of making art and so only a tiny segment is going to be able to afford it – that's just how it is. There's no way that great art can be made democratically. There are many other forms of art for that. Agnes Martin used to say, "Painting is at the top and music is at the bottom, but music is truly the top and painting is really the bottom." By that she meant that music was, in her mind, the ultim-

> "The reality is that if you take all the artists and all the galleries at any given moment, a vast majority of them are going to disappear anyway."

ate form of art, without question the most primal and powerful form of art, and that painting was an extension of that idea to its absolute, almost until it was completely gone, but distilled into its material form. And so it was incredibly rare, and incredibly rarified, and it didn't have the breadth of music. Painting is like that. Anyway, this is how it is in collecting, and if it all sounds unfair, remember that what we all call museums are really just personal collections that have grown so big that the patron gives them to the public. That is how the circle closes.

Chuck Close
Agnes, 1998, oil on canvas, 102 x 84 in.
(259.1 x 213.4 cm)

Max Hetzler

Art Dealer, Berlin

Working from Berlin, Max Hetzler has been presenting a consistently high-level programme for over thirty years. Several of the German artists he represented in the 1980s became luminaries over a decade later. He has shown the great Martin Kippenberger, Thomas Struth, Albert Oehlen, and Günther Förg for decades, as well as bringing American stars like Christopher Wool and Jeff Koons to European audiences.

Why Berlin?

The political structure in Germany is very different from France or England. After the reunification and after the crash in the art market in the early Nineties, I knew this was an opportunity for me to move ahead again and participate in a new situation, because the desire for an intellectual, cultural and political centre was obvious. It could only happen in Berlin – and after a couple of difficult years, the city improved a lot, and it replaced Cologne as the centre of the German art world. Thanks to all the artists who settled in Berlin and worked with galleries that opened here, it became one of the European centres for art. So I am very happy to be here. For artists, it *only* makes sense to show in a capital of discourse, a capital with an intellectual climate and a centre for the arts.

The difference between a German art dealer and one who is American, French or Japanese

In Europe the market certainly is dominated by London with its auction houses, international galleries, and a strong relationship to American collectors. Germany is different; here you find local art communities, and not just one concentration, like Paris or London. This helps to create collectors and exhibitions in different cities, and it also generates internationally connected museums. It's a rich market in the sense that there are many collectors in different areas who like art and support the artists. For us, this means more travelling and work to get the art to the clients and to the museums. But it's a country with a tradition of collecting and even a longer tradition of museums. Being in Berlin, you profit from these resources all over the country. It's a good place to be.

Are your collectors truly Europeans or are they Americans?

Both. If an artist like Christopher Wool shows in a European gallery, he expects the

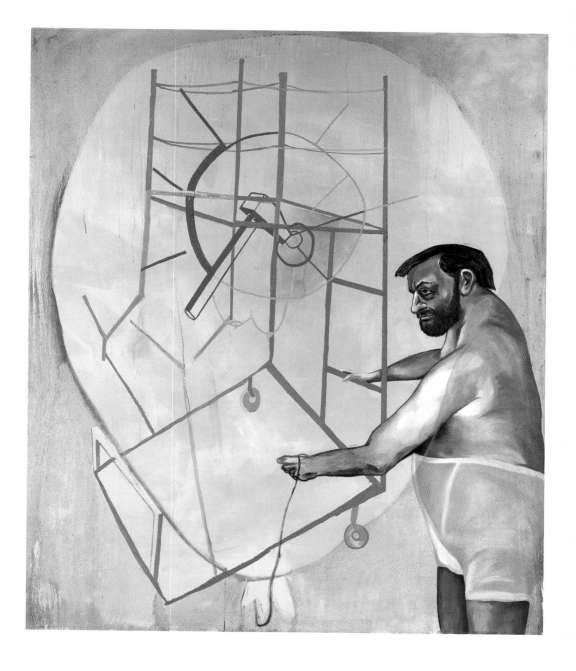

Martin Kippenberger
Ohne Titel, 1988, oil on canvas, 94 ½ x 79 in.
(240 x 200 cm)

Albert Oehlen
3 Uhr morgens, 2005, oil, acrylic on canvas,
110¼ x 133⅞ in.(280 x 340 cm)

dealer to place the work in European collections. It wouldn't make sense for the artist or for the gallery to sell back to the United States, or to just take the work to art fairs so everyone can come and buy and appreciate. If we show an American artist, of course, we try to place the work in Europe, and we try to place it with collections that we have a close relationship to. In that respect, my main concern is to work with European collectors.

The difference between European collectors and American collectors

I don't see such a big difference. I mean, it's a cliché to say that European collectors are not selling or are more committed, or even to say they are more educated. I know great collectors in the United States and I always admire how educated they are, how knowledgeable. I am always fascinated with collectors in America, how curious they are about art, how they want to learn about new artists and how dedicated they are. There is no big difference at all. It's an international world, with all the information you need to follow up.

Who is Martin Kippenberger?

One of the most inspiring persons I have met in my life. The first time I ran into Martin was in 1979 in Berlin. I was putting a show together, *Europe 79 – art of the 80s*, at that

time in Stuttgart and I wanted to invite him. He didn't have any work available, but he promised to come back with a group of works and asked me to do a gallery show. This happened two years later in 1981. It was the first show we did together, and from then on until I moved to Berlin in 1993, we did a show almost every second year. He was always special and different from the artists I knew at that time. He was not only interested in the art world, he was interested in life, and he combined his art with a personal view of how you can live as a creative person. Martin was a *Gesamtkunstwerk*, all he did was related and inspired by art. He wouldn't separate the work and the studio from how he performed in public – it was a unity. He was a very honest person, always looking for a laugh, and a man who gave a lot of inspiration to everybody around him. It's hard to talk about someone you admire as much and spent a lot of time with.

The year he died, his age, and the number of paintings he left

He died in 1997, 44 years of age, of cirrhosis of the liver. As far as the number of works is concerned … I don't know. He was constantly working, he was publishing a lot, he was printing, at one point he had his own magazine, his own record company – everything he did was aimed at creating beautiful stuff in every respect. There are a lot of works of Kippenberger around. Whatever he touched, he changed into something unusual. He designed books, posters, he did wonderful drawings, paintings, sculptures, whatever – Kippenberger is a phenomenon, because he didn't go to the studio every day like Gerhard Richter does, for example, to only create paintings. He was always thinking about what he could do next, and he absorbed the world around him; he was inspired by

"A collector should buy and should not hesitate to buy – and learn through buying."

people, but he gave it back, a generous man. I think the great thing about him is that he could absorb everything, but he could *give* as well. He was not this intellectual, creative person focusing just on one thing, going to the studio, doing paintings or sculpture or photography. He represented a different type of artist. I mean, Gerhard Richter is a painter, period; he changed painting, he let us see painting in a different way, he changed art and our understanding of art and the history of painting. Whereas Kippenberger is a new type of artist – he changed our lives, in a way, his approach was *completely* different, and that's what makes him special.

Who can be compared to Kippenberger?

Maybe Joseph Beuys, because Beuys also had this vision of the human being, how to influence and change it through art. Kippenberger was a missionary. He wanted to change *you* and not just your view of art, somewhat like Beuys.

Prices have gone from $50 000 to $1 000 000 in five years, a multiple of 20. What happened?

In the second part of the Nineties, painting became internationally important again through a new generation of painters. People realized that it didn't just come out of the

blue, that there was a father generation, with Kippenberger and Albert Oehlen. In another field, we now have the same experience with Richard Prince: people go back in history and ask, "Where does it come from? Who influenced this new generation?" Today's artists are important for creating this new market. Then one looks back and wants to know where the art came from and who were the important figures behind it. This is what happened to the Kippenberger market in an extraordinary way. Of course, his work is limited because, unfortunately, he died so young. He can't produce, he can't continue to create work and supply the market, and when there is a limited amount of work, it's normal that the market reacts and prices go up. I think there's no end to it.

A one-million-dollar Kippenberger

I see him in the same league as Jeff Koons. Kippenberger is one of the *major* figures of the Eighties and Nineties; he influenced a whole generation of new artists, and the art world recognizes him just as it recognizes Koons or Prince or Robert Gober or Jean-Michel Basquiat. His career, market-wise, is maybe comparable to Basquiat.

Regarding Albert Oehlen

They are the same generation, they started around the same time in the late Seventies in Berlin. Kippenberger was also a kind of impresario, who curated shows and invited Oehlen, among others, to participate in a show that he organized in his loft in Berlin. From the very beginning there was a relationship with Oehlen. I started to show both artists, first in group shows, and then gave them solo shows from 1981 on, and after that, both were represented by the gallery. At some point, they shared a studio in Spain, they travelled and spent time together in Los Angeles and in Rio de Janeiro, and they collaborated on works. So at certain times in their careers, they were very connected and inspired each other, but at other times, they couldn't be far enough apart. Both were very demanding artists and needed room to work for themselves.

What is Albert Oehlen's artistic statement?

He is a painter. Painting is what he is interested in: how far you can go as a painter, what can you add to painting, what does it mean to be a painter within the tradition of painting? For an artist today, I think the most challenging thing is to *be* a painter and to develop a new language of painting. After all, look at the great painters of the Fifties and Sixties, like de Kooning. What can you do today, if you don't want to be just a figurative, boring painter, if you don't want to just fulfil what people expect you to do? I think Oehlen is a researcher, he tells us what painting means today, that you can go a step further, that you can add something to the history of painting. So, for me, he is the most exciting and challenging German painter of our time.

Advice for a new collector

A collector should buy, and should not hesitate to buy. What I think is most important is to build up a relationship with a dealer whom you trust, and to learn through buying.

Christopher Wool
Untitled, 1990, alkyd and acrylic on aluminium,
108 ¼ x 72 in. (275 x 183 cm)

RUND
OGRU
NDOG
RUN

Albert Oehlen
Krisiun, 2002, inkjet plot on canvas, ten parts,
157 x 329¾ in. (399 x 837.5 cm)

Gerd Harry Lybke

Art Dealer, Leipzig – Berlin

"Our gallery works for the artists, and not the artists for the gallery," says Gerd Harry Lybke. He established his first gallery for Contemporary Art (Galerie EIGEN + ART) in Leipzig in 1983 and, a few years later, opened a second one in Berlin. Hailing from East Germany and a student of Karl Marx, he prides himself on guiding his artists for long-term growth and development as opposed to pushing them toward short-term marketing goals. He also takes special pride in being a global player because the "information and the market" are global. His formula works well: he has helped to arouse interest in painters like Tim Eitel, Jörg Herold and Neo Rauch, the "godfather" of the Leipzig painters, and was an early supporter of Olaf and Carsten Nicolai's work. At this writing, Lybke is planning two more galleries in Berlin, one for photography and another for sculpture.

How he became a dealer

I became a gallery owner because of my artists. I have been in the business since 1983 – Carsten Nicolai, Olaf Nicolai and Jörg Herold have been with me since then, and Neo Rauch and I have been friends since 1981. In 1992 we opened up a second branch in Berlin, which is nowadays the main office of the gallery.
The EIGEN + ART artists are Akos Birkas, Birgit Brenner, Martin Eder, Tim Eitel, Nina Fischer/Maroan el Sani, Jörg Herold, Christine Hill, Uwe Kowski, Remy Markowitsch, Maix Mayer, Carsten Nicolai, Olaf Nicolai, Neo Rauch, Ricarda Roggan, Yehudit Sasportas, David Schnell, Annelies Strba, Matthias Weischer.

What makes his gallery successful

These artists have made the gallery what it is today, and we work with them for the long term, watching their growth and progress. From the moment I start working with an artist, it's really forever. I have known each one long enough to know his character and know that he is a good artist – which means he doesn't follow the popular tastes. He is always questioning, and when he says, "I have finished a good piece – can I show it?" then I take the time

Martin Eder
Die Braut des Pierrot, 2004, oil on canvas,
98 ⅜ x 78 ¾ in. (250 x 200 cm)

to develop his career slowly, step by step. Sometimes, an artist is under pressure from collectors or from the market, but we stay with our own long-term strategy.

His artist roster compared to the market today

The best of all. I think art history is being made in my gallery. It's also important to think about history in relation to the artist. I hope that every artist and gallery owner thinks the same way about what he does. When you don't consider the past, then you have nothing.

How EIGEN+ART builds its artist roster

I watch the artists that I like for years, going to their studios, following their exhibitions and studying their work. It is only then, after five or seven years, that I ask: "How about working with me? You know what I do, and I know what you do, so let's merge." And from these years of looking and working, we come to a collaboration and work together. Whenever we are the primary gallery for the artist, we work only with one, single other gallery in the world. We have this connection with a great gallery like David Zwirner for Neo Rauch, Marianne Boesky for Martin Eder, and we have Uwe Kowski, one of the Leipzig painters, with Mary Boone where he'll have an exhibition in 2007. For Tim Eitel, we are working with PaceWildenstein, with Marc Glimcher. That exhibition opens in November 2006. That's it. Only one gallery for one artist – or call it two if you wish – the primary gallery and another one.

Why not keep them for yourself?

Keeping them for myself is also nice. I do keep them for a long time, for me alone. The first time

Carsten Nicolai
syn chron, 2005, 177 ⅛ x 472 ½ x 338 ⅝ in.
(4.50 x 12 x 8.60 m)
Installation view, Neue Nationalgalerie, Berlin

that I was connected to another gallery was with David Zwirner and it was a good experience. So I thought, why not try it with others?

His Leipzig painters

They are Tim Eitel, Matthias Weischer, David Schnell, Uwe Kowski and Neo Rauch. Neo Rauch is the godfather. I have known these boys now for ten years.

On why the Leipzig painters are so popular in the marketplace

First, there is the artist and the quality of the art. You can say what you want and you can wonder about what you want, but in the end, it's what you see in the piece. Art is a transparent thing, meaning that you can see whether it is good or not. Those who see this Leipzig art and talk about it and are really excited about the art do so because of the quality. In the end, there must be real quality. It is also so popular because we have lost so much of the feeling of how good it is to see a painting.

Many people forget that ten years ago, painting was dead. Back then, every professor said: "Take a camera in hand and forget the painting." Not so in Leipzig, though – there, professors like Arno Rink and Neo Rauch, his assistant at the time, said: "Painting is great." Another reason it is popular is that the girls in Leipzig like the painters. You go to a party where you see one fellow who is a painter, and another who makes films and videos. Where are the most beautiful girls? With the painters! Even ten years ago, when people elsewhere were surrounding the guy with the camera, the girls in Leipzig stuck with the painters.

Looking back ten years, the art public, basically, was looking only at photographs and video. The art community is making the same mistake now by focusing only on painting. That's okay, it's easier to eat one cake after the other. But photographs, video, installation art, conceptual art and painting do always exist at the same time. What counts in the end is the high quality of them all: great photos, great videos, great painting.

Is there really a Leipzig school?

It doesn't exist. It is only a name for export purposes. What these Leipzig artists learn is to work in the studio from Monday to Friday; art is hard work. In other schools, what you learn is what you feel. Your professor comes in every three months and he's a genius and he speaks of genius things. In Leipzig, the professor comes every week, every day. He not only has ingenious ideas, he has questions, like: "Why is this blue, why do you place the figure there, or why is the composition like this?" And then you realize that you don't want to make a piece of art that's horrible; you must think, you must know why you are doing this or that. To be a student and to be a professor in this way and to have that kind of involvement, is to be a Master. Master is a German thing.

On the excitement about the Leipzig school of artists

All these artists like Weischer, Schnell and Eitel came from West Germany, after the wall came down. When they were 25, they were able to move to Leipzig to study there. And these guys, having grown up in the West, came to study in the East, each one becoming his own person, creating his own personality, combining West and East. Now, five years after, they have their own alphabet and use it with this mix of East and West. Maybe

that's also the future of Germany – its people go not only from East to West, they also go from West to East.

The painters from the Leipzig school of art in our gallery form only one aspect of our programme. We do show a wide range of artists, coming from all over the world and everybody working with his very own methods, be it film, photography, sculpture or installation. I love the idea of seeing how an artist develops throughout his artistic career.

On why this generation of German artists has had so much of an international impact

With Neo Rauch, you find the first person who, after the Second World War, can say "I am a German artist." For the French artist, it's easy to say "I am a French artist." To say that "I am a German artist" was hard at that time or at any time because it meant "Uh huh, Germans ... No." You know what I mean? Now the time has passed since the end of the Second World War, so that this generation, with Neo Rauch, who is now 45, is the first one who can say "I am a German." And this is good because the world likes to hear a person saying: "I am from ..."

"Buy with the eyes. Buy with the eyes, first."

Changes in the art market

The Contemporary Art market has changed 200 percent or more, it is not the same as it was ten years ago or five years ago. And it will never come back to its former place. What I mean is that we are more recognized by the general public. Years before, it was a closed club of collectors, curators, and museum professionals. Now, art has become so much more popular, like music, theatre and opera. You can go to a party and talk about the last opera, and at the same party you will hear conversations about paintings and Contemporary Art. Everybody is informed and interested. Most people know what's going on in the art business, they go to the art fairs and the galleries – they no longer hesitate to enter a gallery. Art is no longer a big deal, and that's a big change. Before, every artist, every gallery was for fifteen collectors. Now, there's a big pool of interest, and for me and also for my generation, it's better now, it's great. You have more reaction coming back to you. It's not just about selling or the money or the business. It's also the people talking about it – you see articles on art in the daily press and in television programmes. So the artist is no longer in this tower of nowhere, contemplating his genius ideas. Now the artist is back on the stage, back on earth, and I like it. I like the idea that art is for the public.

Advice for the new collector

Buy with the eyes. Buy with the eyes, first. Then check it out, what was the right choice, what was not. To start, it's better to collect in your own generation – that's more easily understood. Then afterwards, you are able to take the next steps, to start looking around and see what came before, what came later, how to make the connection with the work of the older generation. But to start, I think your own generation is better because you'll better understand it. That's clear. And it's better to spend your money on art than on other things. That's also clear.

His perspective on the art world as someone living and dealing in Berlin and Leipzig

In New York and London, every day is an art fair, and I am happy that it is not the same in Berlin. What I like is to be in the studio and talk with the artists and work with them; this time is quality time for me. When there is a fair every day, I have a problem – to choose between the business and professional work, or the love of art and working for the long-term with the artist in the gallery.

On the level of speculation in the art market today

Speculators exist, don't they? It's not my problem. The problem begins when there are too many things on the market, when the artist in the gallery also has works on the secondary market. For example, I have twenty pieces a year from Neo Rauch, and to place these with the right people is not so hard. But if you have an artist who produces 400 pieces a year, then it's hard to do the right thing, to give every piece to the right person. To do it with twenty is easier – you might make a mistake, but you don't make a big mistake.

I mean, to speculate on a piece of art, you need to have that piece of art. And when it doesn't exist on the free market, it doesn't get speculated on.

For example, say an artist has five galleries and one of his works ends up at auction and goes for an extremely high price; the dealer has a client who is willing to pay the same, so he gives it to him for that amount. Then he calls the artist, saying: "Oh I'm so happy, I sold it for the same high price as the auction – here's the money." Two stupid people. One is the gallery owner for doing it, the second is the artist who does not punch him in the face and say, "What are you doing? We have a low price and a high price. I don't need the money." The money is not the important thing. What's important is to be in the studio, to make art, to develop your career, isn't it?

So if a high price occurs at auction, you think if someone tries to sell their piece at that high price and the dealer accepts, that the dealer is being stupid

We (the dealers) have the low price, which is the normal gallery price, and then the collectors come and the only consideration I have is: Is this collector a serious person, or should we give it to a museum, then it's safe and it's perfect. And when the artist doesn't understand this, forget him. When the gallery owner goes for the same high level as the auction price, it is not a long-term involvement with the artist. We work for the long-term with the artist. That is our position. And mostly we provide the artist with what he would like to have – time, without the worries of market issues.

On being an art dealer

I really come from another planet. First, from East Germany; second, I studied Karl Marx, everybody in East Germany had to do it. And third, most important for me is that I LIKE ART. Business is okay, it's like a car, it provides transportation so you can transport yourself, or your friends or whatever. That's business.

Following spread
Neo Rauch
Neue Rollen, 2005, oil on canvas, 106 ¼ x 165 ⅜ in.;
2 parts, each 106 ¼ x 82 ⅝ in. (270 x 420 cm; 270 x 210 cm)

Emmanuel Perrotin

Art Dealer, Paris – Miami

Emmanuel Perrotin started his art-world training at the ripe old age of 16 and opened his own gallery in his early twenties. Artist Maurizio Cattelan memorialized him early on in a well-published photograph, "Errotin le vrai lapin", and Emmanuel certainly can boast both tenure and pedigree in the Contemporary Art world of the last decade. Although he used to wryly admit that he was the "son of a butcher", now while commanding thousands of feet of gallery space in Paris and Miami, the charismatic and picaresque French dealer speaks more of the crossover potential into design, fashion and film. Creative genius loves Paris, and as the only gallerist showing today's international art stars in the world capital of nine-teenth- and early twentieth-century art and culture, many hot artists have sought out Emmanuel's Paris galleries. Some of their prized pieces were sold in Paris and subsequently bounced back to the New York auction houses where they made record prices for several artists (Cattelan, Takashi Murakami and Piotr Uklanski in particular), thereby underscoring how truly international the Contemporary Art market has become, regardless of where one's gallery is situated.

How he became an art dealer

Having worked since the age of 16, I discovered Contemporary Art by chance at Gilbert Brownstone's gallery, thanks to his daughter. I had no diploma and I wasn't quite certain of the artistic domain in which I was later to focus, so I took a job as a gallery assistant at Galerie Charles Cartwright and it's there that I progressively developed my passion for Contemporary Art from the age of 17 to 21 years old. After this gallery refused to allow me to organize shows within the heart of their existing structure, I decided to create my own. With hindsight, I realize now that this was a veritable folly, an irresponsible deci-sion, but my activities continued to develop into a business and ultimately a permanent career.

What stimulates him

I am a very bad collector. I don't need to possess works of art in order to feel that I am in contact with them. Very early on, my gallery gave several artists the opportunity to pro-duce their works, and this type of thing was not available in France in the beginning.

Supporting the artists who would not have found financing or contacts with which to create their work gave me a distinct advantage over the other Paris galleries. This part of my work is by far my greatest passion, but unfortunately, I have less and less time to focus on my passion, and more and more efforts are required to produce the artist's work which I represent. These moral and financial arrangements in which I am invested have often disrupted my personal life. For example, thanks to, or because of Maurizio Cattelan, I will eternally be known as "Errotin le vrai lapin" ["Errotin, the true rabbit", a reference to a photograph which Maurizio Cattelan took of his dealer, Emmanuel Perrotin, dressed as a pink bunny rabbit, hopping up and down in a lascivious manner].

Changes in the art market over the past five years

For a long time, New Yorkers from high society have enjoyed frequenting the art world. It is indeed a passion for some of them, but it's also a social life for many, with a busy calendar of international festivities, such as art fairs, biennales, other openings of non-profits and foundations. This is more than a mere rendezvous, this crowd loves to congregate in places where exposition catalogues are carried around as fashion objects. Certain art purists are confused by this, but they forget that these very same artists whom they have adored in the past become the social fixtures of the present. We may regret that Paul McCarthy has become a "must", producing his art on demand, but we should be rejoicing that it has shed light on the ensemble of his work and his contribution as an artist. If most galleries did not succumb to the

Paola Pivi
Untitled (Zebras), 2003, colour print on forex, 133 ⅞ x 168 ½ in. (340 x 428 cm)

weakness of adapting their artistic choices to this marketing phenomenon, it would be terrible. But galleries that choose the artists because they sell easily are often and quickly forgotten in the context of history.

Advice for new collectors

For me, a person who is immersed for the first year in the world of art should buy nothing. One should, first of all, visit the maximum number of museums and galleries with different horizons and perspectives, and read regularly all the spe-

Piotr Uklanski
Untitled (The Bomb), 2005, lanaquarelle paper
and gouache on plywood, 126 x 114 ⅛ x 2 in.
(320 x 290 x 5 cm)

cialized magazines to force one to think about more complex universes. One should also surround oneself with disinterested Pygmalions and be aware of art consultant charlatans, most of whom pretend to know the art world because they may know a few people, or they may have heard a few things, or have a big mouth in order to repeat what they have heard others say. After having developed a taste for one specific branch of the art world, one should dig in depth into the subject and begin to buy the major works of young artists. If you buy them without the desire to speculate, but only for the love of what they may represent for you, you will never regret it. Many people will push you to buy the sure thing and many are self-interested because they're also pushing the market of an artist in which they probably own several works themselves. Once you have developed your own sense of confidence, you'll have to be instinctive and quick in your choices.

Art as an investment

Art is an investment in terms of its economic value, but it is regrettable that so many people buy something hoping to see its value go up. When we are asked as dealers to buy back a work of art by an artist whose public recognition is not yet what we would hope for, it is always difficult to buy back that work. One must accept the fact that statistically, a work of art is more likely to not find a buyer in the secondary market than to have its secondary market value increase.

Difference between dealing in New York or Paris

Every passionate person in the entire art world must come to New York two or three times per year. Even if what is available in New York is a bit extreme, one can easily visit fifty galleries in two days. You go in, you leave, on to the next. If the word of mouth around your exhibition works well, you're guaranteed to have a very large public and to sell everything immediately. In Paris, we have only a very small audience compared to New York, which is the Mecca of the art world. People often laugh about our French market, yet nonetheless, we do have many good collectors in Paris whose reputations are greater than those in many other cities. The French love to complain. The competition between galleries is much less severe than it is in New York, but the copying of the New York scene still affects us. Certainly, New York has made a lot of art dealers very unhappy, but that's because it is always trying to outdo itself. If you don't succeed in New York, you can't feel good about yourself, and you can't blame anyone else in the way that the French can by claiming that their own failure is due to an unfavourable art-world context. When the art magazines dedicate only two articles to an entire country like France, then, despite the fact that we have a greater number of public institutions and museums, one has to accept the fact that there is little chance of having your exhibits reviewed.

The international collectors come to Paris only every two or three years, or sometimes never, so we need to find other ways to make ourselves known. The principle is simple: if you produce fantastic works of art which cannot be found anywhere else, people will come and find you wherever you are. Thanks to Colin de Land, the famous and now-deceased New York dealer, I was invited to participate in the Armory Show in New York when I was only 25. When I was 26, I was invited to participate in the Art Basel and in

the Tokyo Art Fair. Had I never had the chance to produce wonderful artists, maybe I never would have been admitted to these art fairs. The advice of collectors is also very important. The internet has allowed us to offer works on preview, without any type of geographic barriers, to collectors all over the world, and luckily, people have enough confidence in our programme that they will buy a work of art from us without ever having physically seen it. In conclusion, Paris is definitely not New York, but it is not all that bad.

How a new collector can gain access to good work

A gallery is always dependent on the evolution of an artist's career. We hope that artists will get the best museums, biennials, the best art reviews, and the other steps that are required for them to achieve renown. In order to help this process, we must of course try to place their works in the collections of great museums, but also with certain private clients whose personal collections are well known and respected. Artists always create about the same number of works, perhaps even less than they did in the 19th century. New clients always want to obtain the same status as great collectors, but they will have to be patient. In order to buy major works of art in the very beginning

> "For me, a person who is immersed for the first year in the world of art should buy nothing."

of an artist's career, you're going to have to take a big chance, or accept the fact that one will have to pay a lot more money on the secondary market.

How can the art dealer feel confidence and trust in a new client's motivations when all clients promise that they're economically disinterested, passionate for the art? When people buy a work of art from us, it always seems like we're charging too much and the work is too expensive. But those same clients forget that when they want to resell, they always ask us to sell it for more than they paid for it. This arbitrage is in fact a very complex one. We are not proud of this ability, this power, and I am somewhat embarrassed by it. When clients choose to sell a work of art that they bought from my gallery, the gallery is often criticized, the gallerist often experiences the artist's derision, and with good reason. Sometimes when I have to excuse myself that I cannot sell such-and-such a work of art by explaining what my situation is, few clients want to accept this reality. At the end of the day, you are left with only one solution: that is, pre-selling works of art before they have even been seen by the public. This eliminates all lies and all frustration. The reality is that if the clients got their choice of what works they were offered, based on how quickly they could run and make it to our stand in an art fair, or how long they were willing to wait in line in front of the opening of our gallery show, then certainly this would be a lot sportier, and our choice would be a lot easier, perhaps somewhat less responsible.

Would one find it honest if we pushed our artists to respond to the marketplace and just satisfy

Paul McCarthy
Blockhead, 2003, steel, vinyl-coated nylon fabric, fans, wood, vending machines, hard candy bars, paint, glass, rope, 85 x 37 x 56 feet (25.90 x 11.30 x 17 m) Installation at Tate Modern, London

demand by creating more and more works of art? We try to manage our artist's careers as well as possible, and often the choices that we are forced to make are above and beyond our abilities, but we try to do the best we can.

Andrea Rosen

Art Dealer, New York

Canadian-born gallerist Andrea Rosen is among the many charismatic figures in the New York art world. She opened her gallery in 1990 with a prescient Felix Gonzalez-Torres exhibit. Although this brilliant artist died from AIDS in 1996, she continues to represent the estate, as well as that of the late John Coplans. She has nurtured the successful careers of several compelling artists, including her former beau John Currin. Recently, as Currin's most beautiful paintings soared above the million-dollar price threshold, he defected to Gagosian Gallery in a much publicized art-world brouhaha. Her programme includes respected artists like Matthew Ritchie and Sean Landers, and she continues to seek out promising newcomers like David Altmejd, a hit at the 2004 Whitney Biennial.

On establishing a strong gallery programme

I think collecting and having a gallery are incredibly parallel, because, for me, the reason to have a gallery is that it's fascinating that people can walk in the door, and the structure of the gallery affords them the right, the opportunity, to have their own point of view. No one has to like what I do; no one has to like what's up on the walls. You go to a museum and somehow you're sort of tied into it, assuming that what's there is historically relevant, that it's important in some way, that if you don't like it or don't understand it, you're wrong. You retreat to the wall text as if it were the ultimate authority in terms of what that work is about.

The gallery is sort of void of that. If you want to seek out information about the work, it's there for you, but you don't have to take it. You can walk into the gallery and you can walk out again. What's great about the gallery is that ninety-five percent of those who come in are not art-world people. They're a more general public, and they have a right to a point of view. It's really powerful.

In my opinion, each artist in your programme has to be particularly strong in his or her own right. So I am always interested in artists who are the strongest. There are programmes in art galleries that show a school of work or a particular philosophical point of view or an agenda. I think that those galleries suffer, because ultimately one of those artists becomes the best of whatever that school or group is.

Selecting the artist

Picking artists is subjective. When you're young and you're first starting, you put a corps of people around you that you think are the people you want to be inspired by, the people you want to be identified with. As time goes on, you diversify.

I can say that the basis of how I take on artists is that their medium has to be integral to the content of the work, it has to be imperative. With John Currin, it was obviously really unfashionable to be a painter in the early Nineties. Painting and John's content are completely and utterly intertwined. If you're looking at clues as to how to look at a specific work, I think it's really important to ask certain questions: is the medium that's being used imperative to the nature of the work, to the content of the work, and to the intent of the work?

The significance of Felix Gonzalez-Torres

He was one of the reasons I opened the gallery. For me, Felix absolutely epitomized an artist who is really interested in formal issues. I mean obviously, all of Felix's work is sort of breathtaking in a certain way, it's physical, it's visceral, it's emotional and, although it embodies some very complex content, it's also universal. He was an incredible person. He was generous and active and responsible, and he articulated in his work this idea that you could actually have a voice in the public world.

David Altmejd
Untitled (Blue Jay), 2004, styrofoam, resin, paint, fake hair, jewellery, glitter, 35 x 32 ⅞ x 15 ¾ in. (88.9 x 83.36 x 40 cm)

On sculpture

I'm particularly interested in sculpture. There has to be some transcendent process in the mak-

ing of the work. I think that that's why sculpture is difficult, because sculpture *is* phys-ical, but it's not interesting if it is just about the making. There has to be something *in* the physical making of sculpture. That's why I love David Altmejd's work. It's all about that physical hand, there's an open-endedness about it. He allowed me to see work in a truly three-dimensional way again. We are so influenced by the flat screen and the narrative of television and film that we have forgotten how to look at something in the round. I personally don't like work that's just sort of a manifestation of an idea.

About Maurizio Cattelan

I think that Maurizio is mostly trying to find ways to visually shock you. I do find that some of his work is amazing, sometimes beautiful, but in general he's just trying to find another idea to have a reason to make a spectacular piece of art. That probably is a really good example of what I consider to be something that doesn't work in my programme. However, there are pieces of Maurizio's that I do love. I love that "Pope" piece [*La nona ora (The Ninth Hour)*, 1999], I thought that was just incredible, the meteorite that fell through the ceiling.

The number of artists who will survive the decade

That's not how and why I pick artists. If you can show an artist who is going to influence the moment, who alters the way that someone perceives things now ... there is no way that all of my artists are going to sustain themselves.

My personal interest is to affect the socio-political realm – if I can make people more aware, more self-responsible, all of those things. There are some things that can do that in the short term, and some that can do it over the long term. Obviously, the goal for an artist is to sustain himself or herself. I don't know of a single artist who doesn't want to be historicized.

I have to say that, in the past, I would only take on artists I felt had a long-term possibil-ity of being significant; one has to assume that you're going to be inspired by that rela-tionship. In the case of David Altmejd, I think he really stands out, but I didn't take him on because I thought, "Oh this is going to be a good market choice." I took him on because I really think he stands out in terms of his intelligence, his physical agility with material, the singular vision of his work – there's nothing else that looks like it – which is very difficult these days, to make something that no one has ever seen.

I've also taken on artists I like and who are deserving of attention, although I don't have such profound relationships with them. That might be slightly more speculative – although "speculative" is the wrong word, because I'm not interested in speculating on the market – but it's worth it because I think they add something to the dialogue right now. Hopefully, they will develop to be significant in the dialogue later, but if they don't, there's room for that as well, because you can't have the same kind of profound relation-ship with twenty artists.

The secondary market and resale

I think there's an appropriate time for artists' work to appear at auction, and I've been outspoken about thinking when that is. One thing that's really important about being a good gallerist is recognizing that not every situation is the same. Not every artist wants

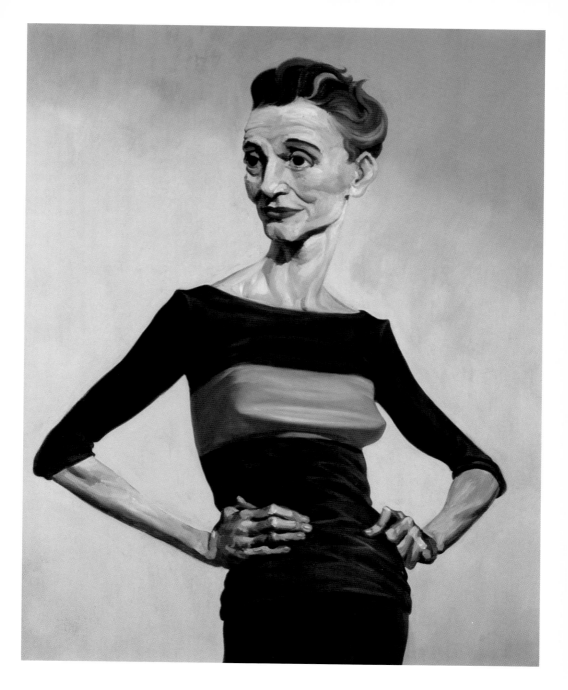

John Currin
Ms. Omni, 1993, oil on canvas, 48 x 38 in.
(121.9 x 96.5 cm)

the same kind of career, or has the same goals, or can move at the same pace. I do think that there's some authenticity at auctions, and then there are some parts of auction that make it completely inauthentic.

There are a lot of people who are involved with auctions for another reason. To say that it's some sort of pure market is really naïve. There are a lot of people who have vested interests in something doing well and some other things not doing well. A lot of collectors think, "Oh, well, if they say it's good and it has this price and this value, it has a certain sense of authority." It's not true.

On resale agreements
I wouldn't say I've had to enforce them. My opinion about the resale agreement is that there was a big part about collecting that was unspoken. Collectors didn't know the rules, collectors were being – for lack of a better word – fucked over in terms of their reputation because they didn't know the rules.

People didn't know that if they sold their work at auction, that galleries were going to call other galleries and say, "Never sell to this collector again." That's what happened in the Eighties, people were blacklisted because they sold works at auction. But it's changed. I think because of resale agreements, people have a lot more flexibility. I believe that if you write things down and people are really clear about your expectations, you're a lot less likely to be disappointed. Collectors, in my opinion, have been more than happy to fulfil their resale agreements, whether or not they thought they were binding, or that I would enforce them. Personally, I think the resale agreements have changed collecting

significantly in the area where people can actually feel safe and comfortable to sell works.

I actually think the resale agreements have created a much healthier market around reselling work. Most collectors, if not all, that I've dealt with – if they can actually get the same price that they would at auction – would be delighted to see the work go on to another collector and not sell it at auction. I feel like it's a much more open dialogue. If someone wants to go to an auction house and see what they can get and then come to me – either I can match it or I can't.

> **"Collectors didn't know the rules, collectors were being ... fucked over in terms of their reputation because they didn't know the rules."**

I also think that when you show young artists, there are different kinds of collectors. There are collectors who are willing to take risks on very young artists and others who are not. It's an opportunity, when you get works back, to say, "I feel more comfortable that I can sell this work." You actually end up being less controlling in a certain way, and you get to engage in this kind of more pure act of just selling work to whoever wants it.

Advice to new collectors

They should look a lot, and they shouldn't assume that anyone else's opinion is any more valid than their own. They should really spend a lot of time just going to galleries, reading art magazines, and getting a sense of how it feels. The best collectors are subjective collectors, because they're not listening to what everyone else is saying.

Also, there are a lot of very good art advisers now, some who want to educate you and some who want to hold on to you. I would tend to say an adviser who doesn't charge you a fee is probably not a good adviser to have, because it means they're only able to sell you works that they can get discounts on. As a collector, you know that you can't always get discounts on the best work. Often, you can't get discounts on the things that are most in demand, so if you're working through an adviser who takes a percentage, don't always expect a discount.

I also think that new collectors should be less afraid of galleries. Most galleries would be more than happy to sit down with a new collector, someone who's genuinely interested and inspired. Most galleries would be happy to give you a sense not only of what they do in their own gallery, but what's going on in the art world in general.

I feel it's really important to respond to what you like. As a collector, I think you also have to say, "I may not like this artist's whole body of work but I may be really moved by this one piece." Maybe that's enough. You know, a lot of the time collectors want to make sure that someone is sure of an artist's entire career. I would say it's okay to have pieces in your collection that are not so certain, but that really move you.

Felix Gonzalez-Torres
Untitled (Portrait of Ross in L.A.), 1991, candies individually wrapped in multicoloured cellophane, endless supply, ideal weight 175 lbs. (80 kg), dimensions vary with installation

Stuart Shave

Art Dealer, London

Stuart Shave opened Modern Art in 1998 and he consistently maintains one of London's younger and edgier galleries. He is best known for launching the careers of British post-YBA art-market stars Tim Noble and Sue Webster, and following up with hot newcomers like apocalyptic painter Nigel Cooke. He originally started out as a studio assistant to YBAs Jake and Dinos Chapman. After working briefly for art dealer Lance Entwistle, he struck out on his own, selling work out of his flat. Today, Stuart is one of the leading young gallerists of London's fashionable art scene.

Getting started in the art business with Noble and Webster

The gallery opened in November 1998, but I've actually been in business longer than that because two years before opening the gallery, I was working with Tim Noble and Sue Webster independently. I organized an exhibition in their home.

I met Tim and Sue at a party in New York and just got talking to them, and we decided really there and then that we should do something together. We spent six months trying to find a warehouse to do this overly ambitious show, and we couldn't find one. So in the end we just did it in their house, we turned it into a gallery and built walls and it was great. The whole show sold, and that's how it started out. I didn't even know how to type an invoice.

Initially they attracted me because there was this sense that here were some people in my age group who really wanted to make something happen. Then, I went around to the studio and saw *Toxic Schizophrenia* (1997), and I couldn't help but be hypnotized by it. I'd seen nothing like it at all. I opened the gallery for them. I didn't know who else I was going to show. At that time, I just knew that I wanted to show them.

On prices soaring in the secondary market

I think it's good and bad. The one thing that's really distressing to me at the moment is that the young Contemporary Art world is experiencing an acceleration that is beyond control, because pieces are being auctioned after a year from purchase. One begins to think about whether to enforce some kind of contractual agreement. It's great that the

work does well in auction and that there is this strong secondary market. At the same time, I think things happen a little too fast. I'd like it to slow down a bit.

It only takes two people to create that price, it's not really an accurate market value. It's this kind of hyper-competitive bidding that is indicative of auctions and of collectors. I seem to spend a lot of time trying to explain to people that their pieces aren't worth that kind of money, they're probably worth half that.

Does a high price at auction prove a work is important?

It shows the massive difference between a critical understanding of the work and the auction or market perception of the work. In the case of the *Dollar Sign* (2001), I've been working with Tim and Sue for eight years and I love the piece, but it's not a particularly seminal work. It has definitely gained this iconic status because of the public nature of auctions, and in any case the work sort of engages within that framework. They made that piece for an art fair; it was particularly apt. I don't want my artists to be known for merely having great auction success. To have a healthy market is great, but for the artist, on a day-to-day level, it's just not something we talk about. What happens at auction is completely irrelevant in many ways.

I don't know what the longevity of these auction results are for *any* artist, not just *my* artists, but any of them. It seems that as soon as someone's market slows down in auction, there's always a new artist that's coming up. Then any good result at auction provokes a new interest in the work. Artists

Nigel Cooke
Gifts of the Garden, 2005, oil on canvas,
72 x 107 ⅞ in. (183 x 274 cm)

continue to make work regardless of auctions; often it has taken years of dedication and commitment to even be able to sell one piece.

Keeping prices reasonable in order to sustain demand

I think that it's really important. When you're building an artist's career, you need to consider the collectors who have much less in their budgets to spend on art. These are the people who essentially help you build the artist's career, and if you put up the prices too quickly, you're bypassing this whole segment. I'm interested in building something with sustenance, so I don't really need to have some sensationalist price over night. However, the auction

Tim Noble and Sue Webster
Forever, 1996–2000, 196 XLamps, holders,
ice-white UFO reflector caps, foamex,
electronic sequencer (3 channel dimmer effect),
33 x 89 x 3 in. (83.8 x 226 x 7.6 cm)

houses do have a useful role to play because they have become a kind of barometer of public interest.

On building a successful gallery

One thing that I think is always really enjoyable about looking at art is to actually see that this is someone's personality transformed into form – like a sculpture or a painting or what have you, to see character and personality and individuality.

"I don't want my artists to be known for merely having great auction success. To have a healthy market is great, but for the artist ... it's just not something we talk about."

There's a difference between being a gallerist and being a dealer. The term "dealer" seems somewhat cold to me, and purely concerned with sales. I think my gallery – and for my contemporaries as well – is really about building a career from the beginning, but also about engaging all the different aspects of that career. Of course sales are part of that. But there's so much more in terms of museums, writing, and the framework of interesting exhibitions. The dialogue with the artist is not simply about buying and selling; it's a much bigger picture.

Trends over the past three to five years in the art market

Definitely, there is a return to painting, and what's interesting is that there always seem to be new geographical locations. When I first opened the gallery, everyone wanted a young German artist. Just before I opened the gallery, it was Los Angeles. Now people are talking about Poland and even getting fixated on a particular town, like Leipzig.

The consensus seems to be that more and more money is being spent on art every five months. At every auction, there's this discussion about record prices being made. At every art fair, the responses from dealers are always the same: It's always that it's going unbelievably well.

On obtaining access to works

The demand for the work has completely superceded, beyond all proportion, what these artists and the galleries can in any way meet. At one point we counted a ridiculous number of people on Nigel Cooke's waiting list, so the answer is "no" to the new young collector, if we are talking about important, seminal paintings.

You want to disperse the work as much as possible, but at the same time some collections make great contexts for a body of work by an artist. You can limit the amount of work that any one person can buy; most people would only be offered one painting in this instance.

How a new collector can gain access

They have to look at buying quality works on paper, and they have to build a relation-ship with the gallery – like building up a dialogue. There's no way that I'm going to choose to sell a painting to a new young collector if I could be placing it in a museum or a foundation. There just isn't that kind of availability in some of these cases.

On great collectors

I think a great collector is someone who has a sense of responsibility towards the work that he or she buys. A great collector is essentially a facilitator, someone who can ensure that artwork actually has a life after it has been sold, and that it will be loaned and that it will be respected.

A good buy

A good buy? In investment terms? Well, that's interesting because people are always asking, you know, if so-and-so is the next thing. I suppose it is my job, in some ways, to advise people on who I think is interesting, and I endeavour to reflect that in my programme. But in terms of mak-ing a good buy, I think you just keep your ear to the ground. A good buy seems to me to be a little less about looking than it is about listening.

"There's no way that I'm going to choose to sell a painting to a new young collector if I could be placing it in a museum or a foundation."

I don't think this is a good thing at all, by the way, but there's this sense that information is shared between collectors and dealers. It's about consensus, and if you can find a young artist and if there's a consensus between the artist, the dealer, the collector and whoever else, then you know that there are some really powerful structures at play. I suppose, it's getting the work before a market accelerates out of control.

Tim Noble and Sue Webster
Toxic Schizophrenia, 1997, 516 XLamps, holders, coloured
UFO reflector caps, foamex, aerosol paint, vinyl,
51 channel multi-functional sequencer,
102⅜ x 78¾ x 2¾ in. (260 x 200 x 7 cm)

Iwan Wirth

Art Dealer, Zurich – London – New York

Already listed as No. 8 in *Art Review* magazine's recent Power 100 List, and still in his thirties, this Zurich- and London-based dealer even has a New York partnership with esteemed gallerist David Zwirner called Zwirner & Wirth. With three major galleries and a roster of superstar artists like Paul McCarthy, Louise Bourgeois, Raymond Pettibon and Pipilotti Rist, it is no wonder that Iwan Wirth is known to be the dealer/adviser of super-power collectors like Mick Flick. With his youthful charm and unassuming manner, Iwan knows how to charm collectors as well as bring top artists to his growing programme.

Early days as an art dealer

I opened my first art gallery in the Swiss countryside in 1986 when I was 16 years old. Our school was closed on Wednesday afternoons. Seeing as I could only run the gallery in my spare time, the gallery opening hours were Wednesday afternoon, Saturday and Sunday. There I sat, waiting for collectors. I whiled away the hours doing my homework or enjoying visits from my girlfriends. It dawned on me that good collectors and good artists are a rare species. Later I moved to Zurich and started up a gallery there, by which time running a gallery had become my profession.

Collaborating with artists

Even in the early years, the art world held some indefinable attraction that stimulated me. My main interest back then, as it is now, is to be able to collaborate with artists while enjoying their trust, even friendship. Moreover, the extraordinary combination of money and spirit also fascinates me. The art market also offers a certain amount of freedom. It's a great feeling to be able to work closely with an artist and enable them to produce an artwork that will outlast time.

Recent changes in the art market

I often refer to the art market as a truly global business. All participants – artists, curators, collectors and gallerists – think and act globally. People are more informed than ever. The impact

John McCracken (left)
Hum, 2004, violet-black column, polyester resin, fibreglass, plywood, 96 x 23 x 17 ⅛ in. (243.8 x 58.4 x 43.2 cm)

Paul McCarthy (right)
Santa Candy Cane, 2004, bronze (painted),
49 ¼ x 24 ¾ x 28 in. (125 x 63 x 71 cm)

Dealing from New York versus Zurich

I work in three cities: New York, London and Zurich and they are all unique. New York is the ultimate trading floor, London is getting there, and Zurich is where, thank God, we have a bonded warehouse.

Key to attracting great artists

We accompany them in every aspect and are critical. Ultimately, we will do anything that is good for the artist!

How the new collector gains access to good work

These days there are more collectors than great works. It is a sellers' market. In order to try and obtain great works, you really need to establish a close relationship with a small number of galleries and be disciplined.

To buy in a gallery or at auction

It really depends where you position yourself as a collector. If you are collecting young emerging artists, then you have to get to know the younger galleries. If you are a more conservative collector, then the more established galleries and auctions will be delighted to offer their services.

Raymond Pettibon
Untitled (Alabama ...), 2004, ink on paper,
13 x 16 ⅞ in. (33 x 43 cm)

A great collection is ...

It can be anything, but it must be passionate and bursting with character.

THE AR
CONSU

Who are these people? And why would you want to pay their fees? The truth is that some of them are very good and you may benefit from them more than you realize. There are a zillion galleries all over the place and if you have a day job, you will want to be in touch with someone who is shopping full-time for good work. Another reason is access: They've been doing business with these galleries for years and they can help you get the work you want, or advise you to wait until something better comes along. Last but not least, remember, artworks are also being traded privately; they can be sold by one collector to another without passing though a dealer or auction house, and you want access to this

T

ЛTANT

"grey market". Some of the best secondary buys that I have made have come through an art consult-ant, so don't make the mistake of thinking that you know better: Nobody definitively knows anything in the Contemporary world, as far as I can tell; that's the mysterious and exciting part of it.

Generally, the consultant will work as a personal curator or adviser for an annual retainer or a commission of ten percent on everything you buy. The dealer's customary ten-percent discount has already accounted for the fact that a consultant may be collecting that percentage.

Diego Cortez
Art Consultant, New York

Diego Cortez, born James Curtis in 1946, changed his identity and moved to New York City in 1973. A classic art-world personality, he was Jean-Michel Basquiat's first agent/dealer and an original founder of the legendary Mudd Club back in the Eighties. A survivor of several art world booms and busts, he works today as an art adviser for a select group of collectors.

On getting started in the art world

I was an artist first. I moved to New York and I made experimental films and did performances, then after some gallery shows, installations in New York, in Düsseldorf with Konrad Fischer, and in Italy, I got tired of being an artist.

I began about five years of various kinds of projects, from working with *Semiotext(e)*, a semiotics journal at Columbia University, edited by Sylvère Lotringer, to doing a book on Elvis Presley in Stuttgart, then getting involved with the punk rock scene, managing groups, and finally I started a rock club called the Mudd Club with a couple of friends.

In 1980 to 1981, I returned to the art scene by curating shows, including *New York/New Wave*, at P. S. 1. In 1982, I met my first collector, Peter Brams, a New York jeweller, through my friend, Massimo Audiello. Peter is the brother of Sandra Fineberg, wife of Gerald Fineberg of Boston, the second collectors with whom I subsequently worked as a private curator or adviser.

When I met Peter, he was interested in buying works by Keith Haring and Jean-Michel Basquiat, as I was also their first agent. I represented them, finding them their dealers and selling a few things to collectors. Brams was mainly collecting young artists of that moment. He had fifty or sixty works by Basquiat. He got them for very little. He only collected, maybe, six or seven artists, like Gilbert & George, Rosemarie Trockel etc. – just a handful of artists, but in depth. I worked with Peter for about five or six years, then met the Finebergs when they attended exhibitions of Peter Brams' collection at Hamilton College and Phillips Exeter Academy.

All the other collectors that I've subsequently met, I've met through the Finebergs or through Michael and Joan Salke, my second main clients, who were introduced to me by the Finebergs. It's sort of like friends, and friends of friends. I've never really gone out after

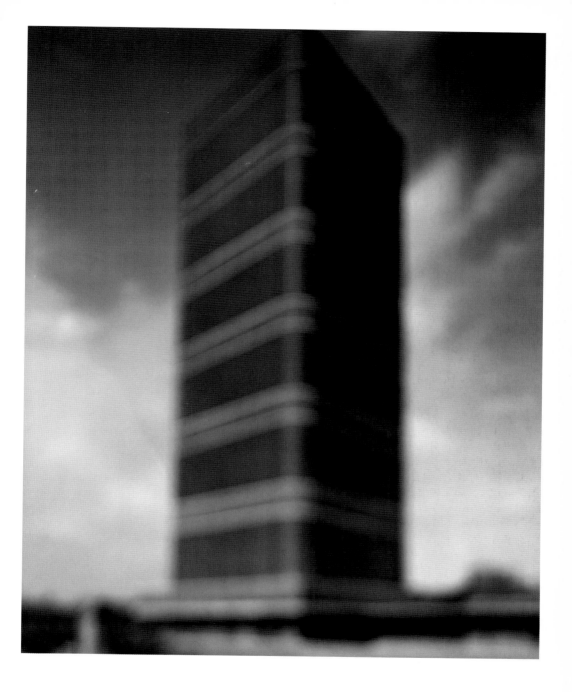

Hiroshi Sugimoto
S. C. Johnson Building – Frank Lloyd Wright, 2001,
black-and-white photograph, 71 ¾ x 60 in. (182.3 x 152.4 cm)

Gilbert & George
Sting-land, 1988, mixed media,
94 ½ x 157 ½ in. (240 x 400 cm)

collectors. I evolved, from curating shows to advisory work. For some time now, I've only worked with two clients with very large collections.

On building a collection

I don't really look for areas of collecting, as much as looking for A-plus works by A-plus artists. The collections I've done are more anthological and broad, rather than collecting deeply in a specific area, except, perhaps, for photography. When I say "anthological", I mean having fewer examples by many different artists as opposed to collecting select artists in depth, maybe, ten pieces by that artist or something. There are great collections of this sort – I'm not putting it down. That's just not the interest of the people I work with.

A great collector

Great collectors have to have a good eye, a good idea on how to limit their collection, good pieces, and singular memorable works, not only predictable, "typical" works. The "typical" work by an artist is a syndrome I hate. Many collectors collect in different areas, and you understand the idea of what and why they're doing that, when they pull it off. Two years ago, while visiting an art fair, I went to a known private collection, specializing in photography, and I was shocked at how bad it was, how big it was, how much money was wasted. I'd never witnessed such an embarrassing situation, where only about five percent of an enormous, grandiose collection was great, and ninety-five percent of the works were bad or mediocre. Without knowing exactly the background of this dreadful collection, I concluded that it was built by either a stubborn "eye", an ignorant curator, or the corruption of several important dealers pushing bad work onto a helpless wealthy individual.

Trends are necessary to launch movements in art, but the thing I like best about living in New York, compared to other world art capitals, is that we are more trend-less and neutral. Trends are dangerous for any creative work.

To see with your eyes, with your heart, or to follow your nose

What we call "taste", or having an "eye" for something is, actually, a much more cerebral activity. I think you have to buy with your brain. You draw on all the information you have gathered, being in the art world for many, many years, which tells you what's good and what's bad.

A lot of new artists don't even know some of the recent marginal artists, actually not marginal to me, who are forgotten, from perhaps only twenty years ago. Very few young artists know who Gino de Dominicis is, or Pier Paolo Calzolari, or Pino Pascali, or Carlo Alfano – people like that. I always call them the cement that holds the bricks together, the bricks being the more famous artists like Mario Merz, Alighiero Boetti, or Jannis Kounellis. These other artists hold them together, and while not as important, they've made incredible works, and have influenced the more dominant artists.

Some new artists also seem to have sprung out of these forgotten artists like Gino de Dominicis. For example, Maurizio Cattelan is completely relevant to de Dominicis' work. When you look seriously at Cattelan's work, then de Dominicis', you're going to be shocked, and pleased.

De Dominicis died a few years ago, but his early works are collected in European museums. He didn't make that much work; he was a kind of Roman eccentric. His late work was not very good, the paintings and stuff like that. I don't know where to even look to buy the early major works, if any are available. One of my favourite pieces seems as if it were made by Maurizio. It's a human skeleton lying on the ground, and in its hand is a dog leash, leading to a dog skeleton also lying on the ground (*Il tempo, lo sbaglio, lo spazio*, 1969). You look at this vignette of a human walking a dog, flat out on the ground, just two skeletons with a dog leash in between. It's a scary, hilarious one-liner joke, and great. Maurizio takes this idea to the next "terror alert" level.

> "I think you have to buy with your brain. One draws on all the information that one has gathered, being in the art world for many, many years, which tells you what's good and what's bad."

Favourite artists

Cattelan is definitely one of my favourite artists, another one on the level of Takashi Murakami, whom I also admire. I've bought several of Cattelan's major works now. Collectors I respect love his work – Peter Brant, François Pinault, Don and Mera Rubell, Dakis

Joannou, very serious collectors. The work is very popular on one level and very intellectual on another. It really covers both bases, I think, like Warhol. Warhol is both erudite, intellectual art, and at the same time, broadly popular. That doesn't happen so often.

I like the Japanese art scene: Takashi Murakami, Yoshitomo Nara, Hiroshi Sugimoto, Daido Moriyama, Makoto Aida, Genpei Akasegawa, Yurie Nagashima, Takashi Homma, Chiho Aoshima, Mr. and many more.

I might have some track record of predicting future art things, and I guess that is my main work – futures, or predictions. Even if there is some financial gain on paper for my collectors, they usually don't sell. Still, I know they like the fact that a work is worth more as time passes. For me, it's more important that it becomes more and more relevant with time. Future relevance is the key principle or game.

On changes in the Contemporary Art market over the last five years

It's grown enormously. I think you could really see what's happened by comparing it to the general international economic downturn in the last five years. The art market, however, continued to be perhaps the strongest market of any market we saw. It continued to grow, and there are a number of reasons for that.

First, it's tangible and it's something you can live with. Second, more and more people became educated about art, through magazines, etc. Third, there was an emotional solidarity with Contemporary Art and culture during the difficult period following 9/11, and the subsequent exploitation of that by the right wing in this country and in Europe.

Finally, and perhaps most important, the period of collecting all kinds of historical things is over. Everything has been bought up, or is in museums, or not for sale. Everything is too expensive unless it's very new – Contemporary. So in a way, I think the future of collecting art, in general,

> "I might have some track record of predicting future art things, and I guess that is my main work – futures, or predictions."

will basically be *only* Contemporary – because everything else is gone. Even the Contemporary market is seemingly overvalued. I don't like paying the kinds of prices that a lot of new artists are getting; it seems ridiculous, but one has no choice sometimes.

More people have flooded into the art market. It's a much broader market now than it used to be, more people there to sustain it. In a way, that's good that there are more people playing the game. It might make it a little harder for people like me to do business, but overall it's a healthier market. Twenty years ago, it was much easier doing advisory work and I probably had a lot more income in the Eighties than I do now.

How to buy

Ninety-five percent of the things I've bought for my clients in the last twenty years are from primary dealers, and done in a slow way. I don't like buying quickly. Mistakes are made. Now even the auctions are showing "hot" new artists at almost the same level of

Jean-Michel Basquiat
Untitled, 1982, Devil, acrylic, tempera, enamel on
canvas, 94⅛ x 196⅞ x 1½ in. (239 x 500 x 3.8 cm)

speed as the primary dealers. Brand-new artists are on the cover of auction catalogues and *Artforum*. It's a new game, but I prefer the old game. I say to my collectors, who are always pressuring me, "Go to the art fairs, go to the auctions." I say, "Listen, you're the ones who like to drag your feet when you buy a work of art. You want me to go there and present to you something that you have to decide on in five minutes? Is that what you want?" It makes it impossible for everybody.

Paul Virilio, the French philosopher, says that we've already colonized space, and now we're colonizing time. Speed is of the essence. Speed, speed, speed, faster, faster, faster, now, now, now. Digital communication. The "conveniences" of modern life. But art is about going slow. I think the art objects themselves are about making still objects – inert objects – for contemplation. They are meditation points. The whole hoopla of going fast is almost the opposite intention of art.

Likewise, the museums and private collections have got to be horizontal, not vertical methods of analyzing the contemporary phenomena of art and culture. New tourist museums have emerged: the Tate Modern, the Mori Art Museum, and now the new Museum of Modern Art. There is nothing casual about the way one is forced to look at art inside these new types of museums. In terms of collecting and the speed with which one must make purchasing decisions, I do appreciate Larry Gagosian's line "You snooze, you lose," with regard to overly-deliberative collectors. One does have to be a bit on the ball, eyes wide open, looking carefully for things. Sometimes you *do* have to be fast to get a really important piece. But in general, as art is a luxury, it's also a luxury to do things slowly. I think that you should enjoy the practice of acquiring things in a way that's a little more casual than instantly. It's nicer. You think about it over the week, and talk about it with your wife – where is it going to go, and will it look good with this stuff – it's the old-fashioned way of doing it.

Mark Fletcher

Art Consultant, New York

Oklahoma-born and bred, this astute art-world veteran gave up a career in business, and another working in interior design, to dedicate himself to the world of Contemporary Art. Mark Fletcher worked several years for Barbara Gladstone (for her interview, see page 70) and subsequently for erstwhile London mega-dealer Anthony d'Offay. Fletcher started his own art consultancy in 1998. He emphasizes a traditional approach to art buying, encouraging his clients to become true collectors, and eschewing market-driven speculation.

What is an art consultant

To me, an art consultant does not hold inventory to sell, and he is on hand to help buyers navigate the purchases and sales of their art collection, ideally, as far removed from transaction-based financial gain as possible. He or she is someone who can navigate the primary market as well as the secondary market, who understands the underworld – which I liken to the artist's world – and can translate that to the upper world, which is the buying community.

Function of the art consultant

It's about presenting choices to people. It's about allowing access to people. It has become more and more difficult to buy art these days, especially in the primary market, which is a highly imperfect market. Unlike auction buying, the primary market is based on relationships of trust that have *nothing* to do with the size of someone's chequebook, but have everything to do with how trusted the purchaser is to honour the art object and to be respectful to that. If these art objects have any validity, they'll outlive us all.

On clients expecting to make money

Fortunately, the clients I'm working with now absolutely do not expect this. At one point, someone asked me if we could put together an art collection that would be considered an asset base. I said that's something that could be done, but it is impossible for me to do. In my role – securing works of art for people – if the dealer community feels that my intention or the intention of my client is toward financial gain, if there's whiff of financial speculation, my resources would dry up. It's just not worth it for me.

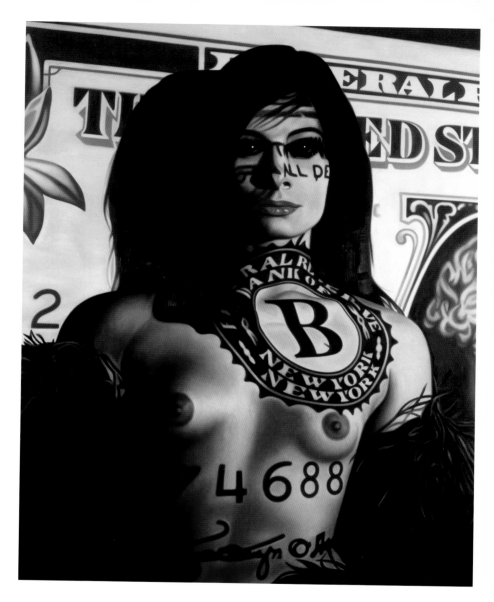

That is not to say that everyone is not aware that these objects are tradeable in the future, but I think one has to be responsible about how that's handled. One of the ways to handle it is to take responsibility and go back to the person or gallery that sold you the work and give them the first opportunity to resell. It's important to have an open dialogue with those people. To date, nothing that I have placed in seven years has ever become available on the resale market … so far.

Richard Phillips
8, 2004, oil on linen, 108 x 85 in.
(274.3 x 215.9 cm)

Piotr Uklanski
Untitled (The Nazis) (detail), 1998, 164 chromogenic, black-and-white and colour photographs laminated and mounted on board, 14 x 10 in. each (35.5 x 25.5 cm)

Why hire an art adviser

Someone who prefers to buy at auction probably doesn't need an art adviser at all. The auction houses do a fantastic job of cataloging and researching works of art for sale. However, if someone wants to put together an art collection that's indicative of our time and place, he or she is not going to gain immediate access. The beginning collector can't walk into the galleries of eminent dealers like David Zwirner or Barbara Gladstone, or Larry Gagosian or Marian Goodman, and be offered works. It's a relatively closed system, and what a good art adviser can do is to allow access. For example, one can get to view works before an exhibition opens, or privately. As you know, the majority of exhibitions of internationally recognized art are generally pre-sold before the show opens.

The international scene

The production of art has become wholly decentralized. There is no single centre of cultural production any longer, like Paris was in the nineteenth century or New York was in the second half of the twentieth century. Secondly, there is an interest in art buying all over the world. The gallerists can no longer cover it all. Typically, they're looking after sixteen artists and can mount maybe eight exhibitions a year. The gallerists can travel widely, but they don't have the mobility. You still have to open up your shop every day. So there is an increasing role for someone who is mobile enough to be in London or Los Angeles four or five times a year in my case, a few times in Berlin, get to the international exhibitions in Zurich, Basel, Venice, and have relationships with the dealer communities in those places. Today, one finds oftentimes that the artists are also showing internationally; they have gallerists in the various European cities and in Japan. The market has become a matrix, and people who are serious collectors may need a little help to navigate that matrix.

On changes in the Contemporary market over the past five years

Last five years? Increase in demand, unparalleled. I remember that when I started working in Contemporary Art in the early Nineties, you literally had to put a bow around a painting and send around a bottle of wine to thank people for buying the art. It was very

definitely a buyer's market, not a seller's market as we see today. Interest in Contemporary Art has increased beyond anything I would have ever, ever have dreamt ... the increase in demand for art making. You see it in the auction houses, in the number of lots that they're selling semi-annually in New York and also in London, you see it in the value increase, you see it in the number of art fairs that are able to be sustained. I would never, ever have guessed that people would have wanted art as much as they do today.

Is this bubble going to burst?

My belief? Unless there's some cataclysmic event, I don't think it will. Because of the increased access to information and wealth creation, the global wealth creation.

On what has changed

Clearly, we're in a different world now, relative to the distinction between male and female artist. This is my belief, whether I'm right or not ... I didn't live through the time when Lee Krasner and Pollock were working simultaneously, or Eva Hesse was working at the same time as Richard Serra, or Joan Mitchell was working alongside de Kooning. I would think that those women were probably also considered secondary artists merely because they were women, and the secondary market has only exacerbated that belief, going through time. What I see now is that there's no difference in demand between work by a female artist like Lisa Yuskavage and a male artist like John Currin. Works by both of them are *equally* sought after. It doesn't make any difference. There is equal demand in a primary market for a work by Rachel Whiteread or Damien Hirst; for a painting by Cecily Brown or Richard Phillips. My sense is that as we proceed through the art history bit and the relevance part, there will be no difference between gender gap and market value.

> "... the primary market is based on relationships of trust that have nothing to do with the size of someone's cheque-book ..."

The number of artists who will survive this decade

It's anyone's guess, but if I had to guess, I'd say ten. Who are they? I won't say as a matter of principle; it's not important publicly and it's not important to my clients, either. It's a personal decision. I think that the moment that someone thinks that they can pick the "right ten" is the time to get out of the business, because it means that you're fixed in your perception. The only thing that I can offer my clients, besides being trustworthy and correct, is the doubt – what art is, and who these artists are ... the moment I think I know, I should change careers.

Sanford Heller

Art Consultant, New York

Relative newcomer Sanford (Sandy) Heller has enjoyed an almost meteoric rise and success-fully represents an all-new type of art consultancy. This approach is one based on market savvy, and he reliably follows every transaction in the top artists' trends and trades. Appropriately, he is known to represent several major hedge-fund tycoons who are usually seeking blue-chip Contemporary icons, or stocking up on tomorrow's stars.

The Contemporary market today

I've been buying art for approximately ten years. I was amongst the crew of younger col-lectors going to SoHo and the beginning of Chelsea in 1995. We were being welcomed with open arms as Wall Street really started to pick up and New York again became a des-tination. New York in the Eighties represented a huge part of the art world. It's not that way any more. The art world is global: It's Portugal, it's Belgium, it's all of Europe, it's Korea, it's China, Japan is active again, and yet everyone still comes here. If you take New York out of the art market, you still have a good part of the world supporting Con-temporary Art.

It's very important to address the issue of the market crash in the early Nineties, because artists were working in media that were very low-budget. High production costs were not yet a part of the equation. I think that artists such as Jeff Koons – who maintained his integrity – and Matthew Barney and Damien Hirst were creative and clever and seduc-tive enough to convince the galleries supporting them that they were worth the risk. If Jeffrey Deitch couldn't take the risk, Ileana Sonnabend or Larry Gagosian would. Every-one has a high cost of production right now. This is one reason for the very expensive state that Contemporary Art is in. It's not just painting on a canvas, where your over-head is the cost of paint, fabric, wood, nails and staples. Artists are really dreaming and they're going off in very interesting directions.

I think the sweet spot in the market today is mid-career artists who have never quite made it in a broad market sense, like Paul McCarthy and Richard Prince. With guys like Hirst and Barney, you can't go wrong. They were the real trail-blazers in innovation, cre-ating language, designing an ideal plan for expression and art forms for the next gener-ation. These are two artists who are so important that their markets are relatively safe.

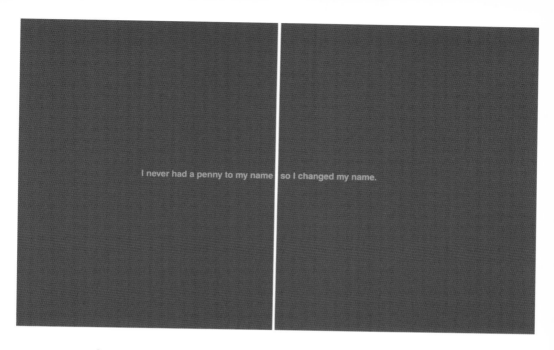

On advising: what to ask a prospective client

What is it you wish to achieve by starting a collection? Is this for your family? Is this for you? Do you intend to give this away at one point or do you wish your heirs to sell it off at auction? What art do you feel comfortable with? What art don't you understand? What don't you like? I find *that* a more interesting topic – what don't you like – because that's the challenge. Let's get them to like this stuff; even if they don't understand it, they should still be challenged, because it's always a personal journey. I mean, the art moves so much quicker than we do, that we need to understand what we're judging before we judge it, and why. It's also about ourselves. Art is a mirror in a lot of ways.

The people I work with are ambitious on their own; they've reached a level of success in their professional lives. They know what it is to take a risk, and they realize the risk inherent in buying art and building collections. To view it as a market is certainly a healthy way to kind of gauge the ups and downs. But to view it as a long-term lifestyle passion, and as a privilege, to be involved with innovation and creativity and the wonder of it all, is something that has to get plugged in equally, to the degree that you understand or work the market. You can't just be involved in art for the market's sake. You have to be involved with the art for the love of art, the love of wonder, curiosity and appreciation.

I haven't experienced too many times when I needed to twist an arm because the collector didn't get it. My job as an adviser is to give them as much information – on the artist, on the artwork, on the market, on other collectors, museums, etc. – as possible to help the collectors make the decision, because they're the ones who will live with it, or give it to an institu-

Richard Prince
My Name, 1991, acrylic and silkscreen on canvas, 52 x 42 in. (132.1 x 106.7 cm)

tion or sell it at some point. But there is always a leap of faith and a blind judgment that an art collector must make in pulling the trigger and buying a work that seems either ambitious or problematic or a conservation nightmare.

On finding good value

It is very important to keep an eye on what's young and emerging, because you have a greater potential for growth and appreciation with early-stage artists making work that could be groundbreaking. It's risky, but I don't advise buying young with one hundred percent of your budget. I advise it with, say, twenty percent of your budget.

The greatest collections are built on boldness, risks, integrity and conviction. There's got to be an attitude of "what the fuck" in the collection: I like it; I don't care what anyone else thinks. I like to see the identity of the collector, the sense of humour, the wit, the characteristics – that's what separates the good from the great.

There are a number of things that go into that bold decision on what to buy. Number one is you love it and you have to have it and you've always wanted it, so the financial risk is worth the intrinsic dividend that it will pay, having owned it. That's something that each collector must measure out carefully when considering budget and overall risk-taking. Great opportunities exist if

> "Do you intend to give this away at one point or do you wish your heirs to sell it off at auction? What art do you feel comfortable with? What art don't you understand?"

you are patient. You can come in with all the money, and there's someone right next to you doing the same thing. If you're friendly and the gallerists like you, they're going to want to do something nice for you. I think that galleries are really in the position to *give* you things – even though you're spending $ 100 000, it's still a gift, because as soon as you buy it, it's worth $ 200 000. I think primary opportunities are still the best opportunities in the art world, so if there is a sweet spot, it's remaining close to the galleries that represent the artists you're interested in.

Being as informed as you can helps the decision-making process. Gifting to museums is a critical part of the environment that we're in right now. The galleries' way of enticing younger collectors to gift is via strings-attached sales, where you can purchase a piece only if it's going right to the museum. That's a tremendous burden to put on a young collector. So I like the idea, rather than selling off work because of fear that the market is going to turn, that you gift – fractionally, of course – to institutions that you feel comfortable with. It's problematic if you become known as a seller or a speculator.

I also think conservation is a very serious issue. What happens when the tape loses its adhesiveness and everything starts coming apart? I appreciate material integrity. I try and buy conservation-minded. I think these things need to stand up as long as they can.

Favourite young artists

John Bock is one of the better young artists making work today. He challenges me, constantly. And Carsten Höller is probably one of the most challenging artists I've ever come to terms with, his understanding of architecture, art history, psychedelia, fantasy – I think he has great potential to be super-important.

The level of competition for "younger" art today

What's driving this market? It's the collectors. The collectors are getting in the way of how it used to be, where you could walk in and take your pick. Now you have to get in before the show even opens, or buy from a jpeg on a screen. The digital age has really revolutionized Contemporary art buying. There is a level of competition that I don't think existed ten years ago. There's an A.D.D. (Attention Deficit Disorder) generation that's going to lose patience very quickly if the art isn't fresh, exciting. I mean, the art world used to take a break in August, not a peep. Now it's just as busy as any month. There's such a big infrastructure needing support that it's non-stop. It's self-fulfilling. The whole prophecy is a cycle, and spinning around in that cycle are the collectors who fuelled it originally, but now you have the artists who need to make work for the galleries that need to show it and sell it, and for the fairs. It's fast, it's hectic, it's amazing, it's awesome.

Philippe Segalot

Art consultant, New York

Philippe Segalot left Paris to run Christie's Contemporary Art Department for five years before starting his own art-consultancy business with his partners Frank Giraud and Lionel Pissarro. While at Christie's, his passion for Contemporary Art prompted him to include younger and younger work in his auction catalogues. This shift permanently changed the contemporary auction market, much to the chagrin of the many dealers, who valiantly labour to "defend" their artists from the vagaries of the auction marketplace. He is known to represent super-collectors like Christie's majority shareholder François Pinault (for his interview, see page 198) and handle only top-dollar works by skyrocketing artists.

Art consulting

We work closely with a limited number of clients, and we don't have any inventory. We never buy and sell for ourselves, we act only on behalf of our clients. Not buying and selling for ourselves gives us independence as advisers, a freedom to say what we think about such and such an artist or such and such a work. We are three partners dealing in different, complementary periods, we cover a very wide range of artists, starting in mid-nineteenth century and finishing today, and we cover a large territory with access to European and American collections.

We collect commissions from our clients, who are the buyers. We represent the buyers in the negotiation, and get the best price possible for them, and then we charge them a commission in a very transparent transaction. Our commissions never exceed ten percent, they vary between two and ten percent, depending on whether we buy at auction, or from the trade, or from private collectors, and, obviously, depending on the value of the work.

Because we have a strong relationship with our clients, they will often come to us for advice, whether they want to buy or sell something. When they want to sell a work of high quality by an artist we are interested in and the price they expect is fair, and obviously if we believe we have a buyer for the work, then we take it on consignment. We try to deal with the upper end of the market. It has to be the kind of work about which you can call a client and tell him, "Listen, we got this piece, and you have to see it because it's really special and it will fit your collection in the best manner." In some cases we

don't have a client in mind for the work, or the artist is not an artist that we are active with, or we feel that the work will sell better at auction. Then we would not sell the work ourselves, but would represent the owner and sell the work on his behalf at auction.

If we consign a piece at auction on behalf of a client, we first speak with the different auction houses, but because we know the game so well, we know who to speak to, we know what to ask, we know what we can get. We know the best way to market the piece. Because I've been there myself, I've done it, and I trust myself more than the others. So we tell them exactly what we want, where we would like it to be in the catalogue, where we believe it should be in the exhibition room, etc.

At the end of the day, every collector is different. How do you decide if you are going to signal a work to Mr. X or to Mr. Y? How do you make these choices? I honestly can tell you, there are not that many choices to make, because the beauty of our job is to offer the right work to the right person. In *most* cases, when we see something, whether it's at auction or in the international trade or in a private collection, we naturally, in fact *immediately,* associate this work with one person. There is a natural link between one work and one collector, so this is not an issue.

I am not saying we succeed one hundred percent of the time, but mostly when we offer a work to someone, we know that person well, we know the collection and the direction the collection is going in – and we are surprised when it doesn't happen, and of course disappointed. The beauty of the job is to marry a work and a collector, and in most cases, it happens when you offer the right work to the right person.

Mike Kelley
Arena #10 (Dogs), 1990, stuffed animals on afghan,
11 ½ x 123 x 32 in. (29.21 x 312.42 x 81.28 cm)

Recent changes in the Contemporary market

I would say since the early Nineties, we have seen a number of new actors in the Contemporary market. This started probably with the

emergence of photography as a "noble" medium, because before it was considered a second-rate medium. With the technological revolution in the early Nineties, for the first time artists were able to print huge photographs with an extraordinary quality of precision and sharpness. New media came out at the same time with video, etc., and enabled some younger collectors to identify themselves with these new forms. For them it made much more sense to collect contemporary photography on a large scale than classical paintings. You saw a number of new actors coming into the market, and even the old-time collectors were shifting into photography or looking at photography in a different way. At the same time, the Nineties represented a very strong economy worldwide. There were a number of people making a lot of money and spending their money on art. Something even more interesting is happening right now, which is the development of art events all over the world – from the Venice Biennale to the Basel Art Fair, and the list is long. When you collect Contemporary Art, you don't only *buy* works, you buy a way of life, you buy your way into all of these events. When you buy a Contemporary artwork, you *belong*; you become part of a club. It's a lifestyle. You start travelling around the world and meeting people, meeting artists, and you organize your year, your life around your art-collecting. It's a lot of fun. You have great art on the wall, but it also improves your lifestyle, and I think today it's a very important part of art-collecting – enjoying the art, and also enjoying the life around it.

If you were to speak with the auction houses today, they would tell you that a number of buyers and bidders in the Contemporary sales are people they have never heard about before. The market is very strong, and I can understand why some people would take advantage of the strong market to sell. But I don't see anything in the market right now that would indicate a drastic change. The people who spend money are spending their own money. I don't see any reason why they would stop, except if there were a major event outside of the art market. It's certainly a good market to sell things because there are so many buyers and the demand is so strong. At the same time, I expect it to continue like that. Of course, a number of artists are very trendy now, very expensive, and some of them will disappear, but these are the ways of the market.

"When you buy a Contemporary artwork, you belong; you become part of a club. It's a lifestyle."

Great Contemporary artists

In a generation, there are not more than ten great artists, say between five and ten. You go back to Impressionist paintings and you can name five guys, you go to the Cubists, to the Surrealists and Pop, the same thing, and it's exactly the same today. We could name the ten great artists of the last twenty years. They are going to remain in art history and are going to see their prices grow and grow, with fluctuations, obviously, over a long period of time. But many others will disappear, or will see their prices going down. That's the way the art market is, because at the end of the day, and everybody should be aware of it, there are not so many geniuses around and not so many great artists around. Again, if there are ten per generation, it's already a lot.

If I had to name the top artists of the Eighties and Nineties, because it's really one generation, they would be Jeff Koons, Jean-Michel Basquiat, Cindy Sherman, Richard Prince, Felix Gonzalez-Torres, Charles Ray, Mike Kelley, Martin Kippenberger, David Hammons; I cannot *not* name a German photographer, so I would say Andreas Gursky.

I forgot Damien Hirst, who should definitely be in this list, as well as Maurizio Cattelan. Takashi Murakami and Luc Tuymans could start the twenty-first-century list. So now we have twelve names in the list. Matthew Barney would be in the top 15. He's a very good artist, but for me he still has something to prove. Like Robert Gober: He is a great artist, he produces very strong and recognizable work and he will remain for sure, but I'm curious to see what he's going to do next.

A long time ago it was very different, it took many years, and sometimes decades, and sometimes lives, to determine who were the great artists of their generation. Today, the Van Gogh syndrome is over and cannot happen again. Today, with the variety of actors in the market, the number of dealers, curators, advisers, collectors, critics, art historians, it takes much less time to determine which artists are really marking their generation. That's why, if you go back twenty years to the early Eighties, and take some distance to look at the

Charles Ray
Family Romance, 1993, mixed media, edition of 3, 53 x 85 x 11 in. (134.6 x 215.9 x 27.9 cm)

work of an artist like Jeff Koons – if Jeff, you know, would stop working today – you see that his work has marked his time *so much* that there is no doubt that he will remain in the history books for what he has done.

But again, these guys like Damien Hirst and Jeff Koons, they're so strong that when you look at the Damien Hirst book, you realize how creative he was, how far he went, how *extreme* he was, and so early in his career. When you think about the Nineties and you try to identify three works in those years that you will remember ... you would pick Maurizio's "Pope" [*La nona ora (The Ninth Hour)*, 1999], Damien's "Shark" [*The Physical Impossibility of Death in the Mind of Someone Living* (1991)], and Jeff's *Balloon Dog* (1994–1999). I would also add Felix Gonzalez-Torres' string of light bulbs [*Untitled (America)*, 1995] as one of the works that have made a real mark on time, in a totally different sensibility.

I think Mike Kelley is a major artist. He's sometimes difficult to understand, sometimes ahead of his time, but he is such a complete artist, and he has produced such a varied body of work. Mike is the kind of artist, when you see a show of his, you don't get it at first, you get it only two or three or five years afterwards. Then you realize how great a show you've seen and you say, "Oh this was really great, but I didn't get it at that time." I think there are plenty of good Mike Kelley pieces, but the ones that come to mind in the most obvious way would be the "Arenas", the pieces with the stuffed animals. Today, a great "Arena" piece is certainly worth around $600000 to $800000. There are very few of them. Altogether, there must be around twelve "Arenas". They were shown in 1990 at Metro Pictures in New York. It's this kind of show I was telling you about. It was my beginning in the art world. I didn't get the show. Obviously, the works were very cheap at that time, probably around $20000 or less, and I didn't think of buying one. But the show stayed in my mind as really weird, interesting. A few years after, I realized how great that show was.

Collecting Contemporary

There are two different ways to collect. There is one way where you buy a very wide range of works, at low prices, because you don't want to miss anything. You don't have the distance, but you are interested in things and you see things and you react quickly, etc. Then you end up with tons of works, and usually with an unfocused collection.

There is another way of collecting and this does not depend on how much money you have: It is to do your homework and get to know what you really want. I advise people who want to start collecting not to rush, and not necessarily to buy very low-priced works, because it's easy to buy; it's much more difficult to resist buying. I would rather encourage a new collector to spend one time $50000, instead of $5000 ten times, buying a work by an artist who already has years of experience, has been shown in some recognized galleries and whose work you can judge with the necessary distance.

You can buy works by a recognized artist on the primary market, like when you go to Metro Pictures and buy a work by Cindy Sherman, who has been a major artist for the last thirty years. I believe that the really great collectors are the ones who suffer when they buy a work – I mean buying a work which is expensive for them – and it strikes any level, whether you are Mr. Pinault or whether you are a young guy who has just finished

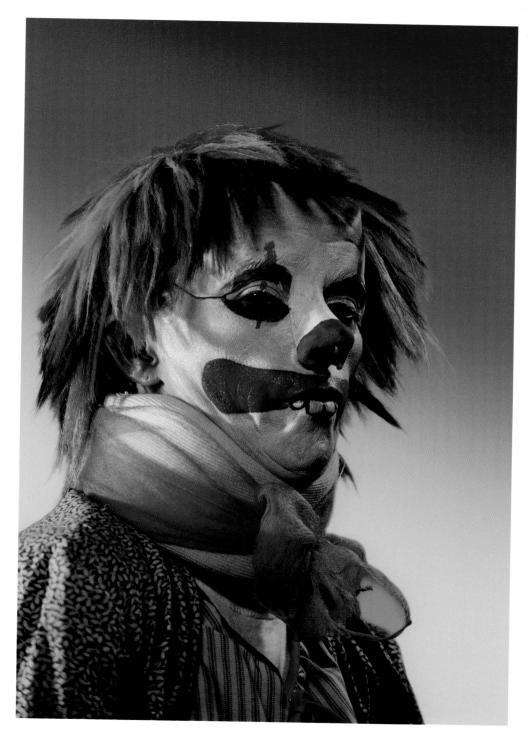

school and started collecting. I think that the most challenging, demanding purchases turn out very often to be the best ones.

Also, you should ignore the question of space – where you are going to hang something is totally beside the point. You should just go for the best, for the works that move you the most, that challenge you the most, and not set any limits upon yourself.

You do have a chance, because when you are a serious collector and you do your home-work and you don't buy things and resell them immediately, the galleries know it. It is important to develop a strong relationship with a few galleries. When you develop a strong relationship with a dealer, when you visit the gallery regularly, when you buy not necessarily from every show, but on a regular basis from him, then he will *tell* you when he gets something great, whether you are the richest guy in the world or not.

We are in a strong market now, with prices growing fast. I guess there will always be speculation, you know, some people putting together funds, some people buying to resell, etc. We just happen not to work with these buyers. Again, when you work for an auction house, you work with every-body. When you work as an independent dealer, one of your luxuries is to choose the people you are working

> "... at the end of the day, and everybody should be aware of it, there are not so many geniuses around and not so many great artists around."

with. We like the dialogue with the collector, we like the idea of really contributing to building collections over a long period of time. That doesn't exclude *selling* some works when you want to upgrade the collection, or just to fine-tune it.

I am against speculation, because art was not made to be a subject of speculation. It turns out that the people who collect for the right reasons are also the ones who are making the most money with it, because when you collect as a true collector – again with this eye, with this selectivity, with this toughness, with this determination – you happen to make the best purchases.

Mike Kelley
Pagan Altar, 1989, synthetic polymer on 3 panels and dried corn, 98 x 100 x 8 in. (249 x 254 x 20.5 cm)

Thea Westreich

Art Consultant, New York

Thea Westreich has been advising major private art collectors for almost twenty-five years. Her staff of research assistants provides sophisticated coverage of the international art market. She has survived the vagaries of the Contemporary market, and her animated and opinionated approach has served her and her clients well for many years.

The Contemporary market today

First and most important, the Contemporary Art market is more internationally driven. Secondly, there are certain art fairs that are in ascendancy in importance, and that too changes the market. There are more artists being exhibited worldwide, many of them very young, and there is a demand of an increasingly large collector base with ample means to drive the market.

Also, there is change in the way the auctions play out in the marketplace; they are auctioning the work of younger and younger artists and establishing higher and higher values on the secondary market for artists very early in their careers. They're also marginalizing, to some extent, the educational role the galleries have in representing artists, so that the collector sees a work at auction and buys it, instead of really developing relationships with gallerists and with artists. It truncates the learning curve, often to the disadvantage of the collector's acquisition decisions.

There are more artists working and the culture is more complex. That will mean that there will be many more voices heard around the globe, and they'll be more interesting voices that we'll want to listen to and investigate. But there still will be a hierarchy over time, and only some of the many will remain in the canon, and they'll be there because they change the way we see in provoking and sustaining ways. They will, in the end, transcend their own time.

On Jeff Koons

Jeff is a very singular figure in the history of twentieth-century art. I think he is the one artist who most interestingly extends the art-historical impact of Warhol in a unique, clear and individual way. Remember, you're asking a person who was in Jeff Koons' studio on Maiden Lane and started buying the work for clients back then. I bought a work of art

out of that studio that wasn't delivered to me until many years later, and I couldn't have cared less. I knew it would come, and that when it came it would be a great work of art, and indeed it was.

The *Jim Beam — JB Turner Train* (1986)

Our client bought it for $ 5.5 million. Koons has suddenly become very appreciated by a certain segment in the market. The value of the *Train* is about the market. Clearly Jeff Koons' market is in ascendancy, and people who are far wealthier than Jeff's original collectors – Eli Broad notwithstanding – and people who believe in his career in the same way that some of us, early on, believed in his career, like Jeffrey Deitch, are supporting it. It's clearly in the ascendancy and justifiably so.

The *Train* was a major piece in the "Luxury and Degradation" series. It operates at all levels of Jeff's work; it basically congeals the very intentions of Jeff's work and expresses much of what makes Jeff Koons really great. It was available at the auction, it was a piece that, if you wanted to buy, you were going to have to ante up for it. We were able to show the client that this wasn't an unreasonable price to pay for that *quality* of Jeff's work.

The value of the *Train* is also supported by the quality of the artist and how it fits into the overall intention of that artist. If you accept the fact that Jeff is an important artist who has continued over two decades to make interesting, provocative, intelligent work, and you take that career and you drop it into the overall history of twentieth-century art, you come out with: He is a very strong voice, he's imperative. We need to know him to understand where we are in the history of art and in relationship to our culture. So we establish the fact that Jeff is an artist of extraordinary importance. Then you say, "What is the centrepiece of Jeff's intentionality?" and you find language to describe that. Then you look at the *Train* in the context of Jeff the artist in the twentieth century, and you say, "This *does* it."

"An artist like Jeff Koons can go on making great work decade after decade, and an artist like Frank Stella may not."

An artist like Jeff can go on making great work decade after decade, and an artist like Frank Stella may not. The hardest thing for an artist to do is to sustain a vibrant and radical career over time. It's really difficult to do. Some artists do it, others don't. Jeff may be one of the ones who does. I believe in him, I believe in what he does, I think he's likely to go on making good work, work that continues to evolve in important and compelling ways.

Advising for a great collection

Our clients are very discerning and tend to be driven by their own aesthetic sensibilities. Part of the service we provide is information to guide their decision-making activities. Those decisions have very little to do with anything other than quality and value, which always manifest themselves in long-term financial worth.

We offer our clients information and critical analysis garnered over twenty-five years as

professionals in the art market. So when somebody says to me, "Prove to me that I should pay $20 million for this piece of sculpture," I'm looking at not only the performance of *that* sculptor over the last twenty years, and where that sculptor fits in the overall canon, but also, how iconic works of art, sculptural works of art in the twentieth century, have escalated in value and why. What makes that happen?

I think the marketplace right now is accustomed to looking in time bites and that is a mistake. Whoever collects that way is going to get burned. You can't look at the marketplace in ten minutes' time, and you can't come in and think you will get to know enough to make judgments that are going to be accurate and long-term.

"You can't look at the marketplace in ten minutes' time ..."

How to collect

The right way to collect is ultimately driven by the informed collector. There are many young buyers who want to acquire the art of their time, and that's a perfectly legitimate approach, and perfectly appropriate to this generation. I applaud it and I approach the

art world in that way, as do many of our collectors. Still, the process is benefited by a lens that goes back over the history of art and says: "This object has some merit. Why does it have merit, what makes it interesting?" It's not just that everyone says, "You've got to buy this thing." You have to see what the art is saying. A photograph can't be just what the photograph is of; the subject of the photograph does not mean it's interesting as a work of art. If it conveys something *beyond* the subject matter – transcends what is depicted – then it's compelling and important. To know what that is, is to know what art is about.

Jeff Koons
Jim Beam – JB Turner Train, 1986,
stainless steel and Bourbon, 11 x 114 x 6 ½ in.
(27.94 x 289.56 x 16.51 cm)

THE COLLE

Here they come, the good, the bad, and the ugly: Which one will you be? It depends on who you are looking at, and who is looking at you. Let's never forget that when dealers or art advisers are talking to you, you can practically see those dollar signs reflected in their pupils. Don't be surprised, this is, after all, the "art biz", and your cash is going to fund the next show, pay the rent on the gallery and the mortgage on the summer home, or help them get that big studio space they've been waiting for. Fear not, historically the good collectors have benefited most from the art market; they have the ability to buy and hold. Think about Ronald Lauder or Peter Brant; they may have made more money with their collecting than in their businesses. Then there are those like the Nahmads and the Mugrabis, whose collections are their businesses, not to mention billionaire dealers like the Wildensteins and William Acquavella.

CTOR

If you have some money, discipline, and plenty of patience, the art market is tilted in your favour. You will still need to collect seriously and in depth, and that means using every possible resource available to you, but if you have a decent eye or know someone who does, this hobby will pay for itself, and may even turn a healthy profit. I don't believe the truly great collectors make it their goal to just make money; they want to live with major masterpieces. The beauty is that you can do both. The collectors in this chapter have taken serious risks that paid off in a big way; their comments should be both encouraging and useful for you too.

Peter M. Brant

Collector, Greenwich, Connecticut

The dynamic newsprint and publishing entrepreneur Peter Brant has been collecting art since the age of eighteen. He has exhibited an excellent "eye" on the polo fields and racing world, winning the 1984 Kentucky Derby, and his involvement with the art world goes back even further. He was an early patron of Andy Warhol's work and films, and later funded Julian Schnabel's film *Basquiat* as well as Ed Harris' *Pollock.* He has accumulated an astounding collection of works by Warhol, Lichtenstein, Basquiat, Koons, Prince and Wool. He also collects furniture and magazines (*Art in America, Interview* etc.). Reportedly, he has commissioned several top Contemporary artists to make portraits of his second wife, Stephanie Seymour, as an art project on portraiture.

Building a Contemporary collection

My interest began with classic Renaissance through Impressionist pictures but I collect Contemporary work because, like the great art dealer Bruno Bischofberger said to me when I was sixteen years old, "You can never have a great collection of Impressionist pictures – they're too costly, they're all in museums or in great large collections. You have some of the greatest artists in the world in New York, that's what you should be interested in." Then I went to Leo Castelli and started collecting. I bought Jasper Johns, Robert Rauschenberg, Andy Warhol, Roy Lichtenstein, and then Sandy Brant and I started to become friendly with many of these artists. Late in the 1960s, Sandy and I became very friendly with Andy and published the magazine, *Interview*, with him and later produced two movies with him. However, I had collected his paintings for a year and a half, prior to meeting him.

I bought my first work when I was eighteen years old from Virginia Dwan Gallery – it was a major Franz Kline painting, the first picture I bought. Then there was a David Smith sculpture that I bought from Marlborough and some of Andy's work at the same time.

I guess one of our favourite works for both Stephanie and me is Andy Warhol's *Thirty Are Better Than One* (1963) – it's thirty Mona Lisas. This was *Andy's* favourite work. I was on my

Andy Warhol
Thirty Are Better Than One, 1963, synthetic polymer paint and silkscreen ink on canvas, 110 x 94 ½ in. (279.4 x 240 cm)

honeymoon in Kenya in 1969, and I knew that a woman in South Africa had this picture. When I got to Kenya I called her and said, "Look, I love this picture, if you ever would think of selling it …" She said, "No, no, no, I'm not." Six months later, she called me and she said, "I'm getting a divorce, I'd like to sell this picture. I want $20 000 for it. Send me the money and I'll send it to you." So I did that in 1970. I was always really proud that I had the desire to pursue this painting while I was in Africa, contacting the owner from the bush. It's one of the greatest pictures we have, or ever will have in our collection.

Collecting in depth

I started buying Jeff Koons around 1986. I originally saw the vacuum-cleaner pieces and liked them very much. I subsequently bought a basketball piece from Charles Saatchi, a single basketball in a tank [*Spalding Dr. J. Silver Series* (1985)]. Ever since then, Stephanie and I have been avidly collecting his work. We bought the nude painting in the spring of 2004 auction (*Ponies*, 1991). We bought the *Pink Panther* (1988) and the *Woman in Tub* (1988), also at auction.

On art reviews and the art media

I pay attention: If people are critically against somebody, that's a sign to me that there's some interest there, that there's an interesting statement there. If I hear that somebody's getting

Maurizio Cattelan
The Ballad of Trotsky, 1996, taxidermized horse,
leather saddlery, rope, pulley, life-size

really bad reviews, that sometimes attracts me because historically, many great artists have gotten very *bad* reviews. I talk to a lot of artists and I pay a lot of attention to them, I always have. I find that many art critics as well as movie critics try to cover too much of the waterfront and therefore lose their focus.

On buying primary versus at auction

I just look for the work. I don't look for standing in line to beg people to sell me stuff. I figure if I can't get it there, I'll get it somewhere else. I have the advantage because I can *look* at a work for a while and see if it holds up. I mean, you wind up buying everything in primary, and you get in line, it's great in an up market, it's bad in a down market. You cannot judge work by what art dealers like, they like what they sell and show.

About maintaining conviction in a soft market

My conviction is not shaken at all. For example, Julian Schnabel is a great artist. I think he's one of the greater artists of our time and one of the most talented people of our time. I have great belief in his ability and in his work, and it's the same for a lot of artists that I really admire. I've been recently buying some works of his as I have for many years.

On size

I don't think about where I'm going to put artworks when I buy. It's very abstract, where it's put. I would say of the all the things in the collection, probably about half is ware-housed. I bought Maurizio Cattelan's horse (*The Ballad of Trotsky*, 1996) for $800 000 (in 2002). I couldn't hang it anywhere. I thought it was one of his most important works. I like him as an artist. I have many other things of his. The very fact that it was taxi-dermied was a problem, in terms of humidity; I really didn't see a place for it, where it would weather well in our spaces.

The horse was sold at Sotheby's for $1.8 million two years later – had he tired of it?

No, I love his work, I think he's one of the best young artists. I'm also very interested in Richard Prince's work. I like Thomas Ruff's work. I like Mike Kelley. They're not young, they're in their fifties. I think that there are a lot of talented people around today. Younger artists I look at who are really young, in their twenties, that I collect here and there – there are some young German painters who are good, and I like a Polish artist, Piotr Uklanski.

Changes in the Contemporary market in the past ten years

There is much more appreciation for art now than there was ten or twelve years ago, and there are more people interested in the Contemporary young artists all around the world. But I think there's this tremendous desire to hunt out the new, good, young artists, maybe at the expense of some of the older artists who are probably more accom-plished and have done more and have achieved more, and who are at a much lower end than some of these newer artists who maybe can't play with the guys who are fifteen or twenty years in the game. Today, you might have a young artist who's been around for a few years, selling for double or triple what some of the guys like David Salle or Julian

Schnabel or Eric Fischl are – these artists were considered the measurement standard of an accomplished artist in the Eighties.

Some of the German painters and photographers – the Andreas Gurskys, the Thomas Ruffs, all of which I collect – are good artists, but should they be selling for three times what the Eighties artists are selling for? Ten years is really a bad comparison because things don't move in the art world in a period of ten years, they really move in periods of twenty-five to thirty-five years. As a collector, you really have to be thinking about what people's tastes are going to be like ten or fifteen years from now, and not what art lovers like to look at now, because taste, beauty, aesthetics, are things that become socialized. It's a *social* phenomenon. What becomes beauty is what people have been spoon-fed over a longer period of time, and therefore socialized to *mean* beauty.

I can only go back to when I started collecting. The most popular artist of that time certainly was not Andy Warhol. The most popular artists, the only ones that stayed, really, were Johns and Rauschenberg. At that time, if you look at what the Museum of Modern Art was doing, you would see that they didn't really have Warhols, Lichtensteins, Twomblys. In 1978, I offered them a 15-foot *Mao* painting, which was painted in 1972, as a gift. They said they had two pictures of Andy Warhol and that was enough in their collection. I knew Henry Geldzahler over at

> "I don't look for standing in line to beg people to sell me stuff. I figure if I can't get it there, I'll get it somewhere else."

the Metropolitan Museum of Art. He persuaded them to accept this gift from us along with a great collection of Art Deco furniture and glass. The Met has not shown this in their galleries in the past twelve years, even though it's one of the greatest Contemporary pictures they have.

Advice to the new collector

Visit a lot of museums and see a lot of shows. I think it's important to talk to a lot of people, but only filter what they have to say. Then form your own judgment, react to your own gut instinct, but that gut instinct must come from having connoisseurship, really studying what you're doing, reading, opening your eyes and going to see a lot. I think that's extremely important, more important than what an art dealer tells you or an auction house tells you. For vendors, that's their livelihood, they're not reading, they're selling. They love what they're doing, but what they're selling today might not be so hot tomorrow. Is Jeff Koons going to be hot tomorrow? He is already, you can't get much higher than he is, there's no question about it. It's like IBM stock at 400; if it's 250 it's still a great company. I buy his art because I think he's a great artist and I love his work. Personally, I think his work is very, very high in price. It keeps on going higher, I don't know why. For Stephanie and me, the higher prices make us more interested in the people whose works now are not that hot, but are still great artists.

Jeff Koons
Pink Panther, 1988, porcelain,
41 x 20 ½ x 19 in. (104 x 52 x 48.5 cm)

Eli Broad

Collector, Los Angeles

Eli Broad has built both Sun-America (insurance) and KB Home (real estate) into Fortune 500 companies. Since 1984, the Broad Art Foundation has operated an active "lending library" to over 400 museums and galleries worldwide. He serves on the boards of the Museum of Contemporary Art, Los Angeles, the Museum of Modern Art, New York, and the Los Angeles County Museum of Art, where he announced a major $60 million gift to build the Broad Contemporary Art Museum. He is known to accumulate trophy pieces for significant sums and his holdings include some of the best works of the past twenty years.

Art collecting and building a foundation

My wife Edye and I have been collecting art for some thirty-two years. We collect because it's intellectually stimulating. We've been Contemporary collectors for about twenty years. We like Contemporary Art because it's the art of our times. We enjoy meeting with artists, we enjoy going to studios, and we enjoy spending time with them because they have a different view of our society and our times than we business people have. It's truly a broadening experience and very educational.

In addition, it has its social aspects. It allows us to meet people throughout the world, and over the years I've gotten more and more involved. I kid around and say that twenty-five years ago when I was a founding chairman of the Museum of Contemporary Art (MOCA) in Los Angeles, my innocence as a collector ended. I serve on a number of museum boards, including the Museum of Modern Art and the Los Angeles County Museum of Art (LACMA), which we're redoing. Then I'm a regent of the Smithsonian Institution, which is responsible for seventeen museums. So I've become hooked.

About twenty years ago, after building up a personal collection of Contemporary Art and seeing that museums did not have the resources to buy Contemporary Art, we said, "How do we continue collecting?" So we created The Broad Art Foundation, which became a lending library to museums throughout the world. Between our private collection and our collection at the Broad Art Foundation, and not counting the corporate collections, there are about 1100 works now, and we are proud that we lend to about four hundred museums worldwide, both from the foundation and our personal collection.

Jean-Michel Basquiat
Untitled, 1981, acrylic and mixed media on canvas,
81 x 69 ¼ in. (205.7 x 175.9 cm)

On art and money

We do not see art as an investment. It's an investment in time. My advice to collectors, young people who want to get involved, is, if you just think it's a financial investment, then don't do it. You're probably better off with real estate, stocks or other investments, because if you're a true collector, you fall in love with your art and it's like your children, or your home, you can't sell it. So if it goes up in value, all you get are bigger insurance bills.

Maintaining and building the collection

We've only sold three or four things and we've exchanged probably eight or ten pictures in all those years for works of greater import to our collection. We try to upgrade things when we can, but we're not sellers. I'm in a position where our estate plan is such that our children are taken care of, so we are not going to have to sell. We see ourselves as guardians of this work over our lifetime, and it's going to end up in one or several public institutions when we're no longer here.

On changing tastes

For example, in the East Village years, we were sort of more in the discovery business, so to speak. In those years, we bought a lot of Jean-Michel Basquiat early on, actually from the basement

Jeff Koons
Balloon Dog, 1994–1999, high chromium stainless steel with transparent colour coating, 121 x 143 x 45 in. (307 x 363 x 14 cm)
Moon, 1994–2000, high chromium stainless steel with transparent colour coating, 130 x 130 x 40 in. (330 x 330 x 101 cm)
Installation view, *Apocalypse*, Royal Academy of Art, London, 2000

where he was living and painting. From Metro Pictures we bought the first Cindy Sherman works, the "Untitled Film Stills". We became the largest collector, with 114 of her works in our collection. Some others have, frankly, fallen by the wayside and have not passed what I call the test of time. We've kept those works; we don't think it's fair to sell works by young, living artists. What we may do is donate some of the works to museums and to college or university galleries.

On Jeff Koons

I think we've got the largest collection of Jeff Koons' work. Early on, when Jeff Koons initially had great popularity, we didn't really collect the work. The first thing we bought was *Three Ball 50/50 Tank* (1985). We followed the work and I became more and more interested. Then Jeff needed to raise funds for his ambitious Nineties works, so we bought the *Rabbit* (1986), *Michael Jackson and Bubbles* (1988) and *New Hoover Deluxe Shampoo Polishers, New Shelton Wet/Dry 5-Gallon Displaced Quadradecker* (1981–1987), all at once. Then we bought a number of other works, all the way from *St. John the Baptist* (1988) to the *Italian Woman* (1986), *Lifeboat* (1985), and a few others. Of course, we bought *Balloon Dog* (1994–1999), and *Tulips*, which is in fabrication, from the "Celebration" series. Recently we bought two works from the studio that are being completed as we speak. One was a turtle on a chain-link fence, *Chainlink* (2002), and the other was the *Caterpillar Ladder* (2003). Once we get interested in an artist, either personally or for the Foundation, we want to collect that artist in depth, not have one or two or three things. We feel very good about Jeff. We are friends and we see him often. I think he is a great artist.

The collection's growth

We're not in what I call the discovery business; however, we do buy young artists. Who will be added to the collection? I'm not sure I can give you any names. We own several pictures of Ellen Gallagher's, and we'd like to buy more. I keep saying to the director of our art foundation that we ought to find the time to do several things: one, to refine the collection and even de-accession work by giving it to a museum or selling the work that we're not serious about because we've got too many artists in the collection; and two, we ought to start thinking about artists of the twenty-first century. We really haven't done much with that, we haven't found the time to do it.

We're not as venturesome as we once were. With Damien Hirst, we weren't there early, perhaps we

> "We do not see art as an investment. It's an investment in time."

should have been. But we decided he's an important artist. We acquired *Away from the Flock* (1994). We want to buy more things. We have a big "Spin" painting, and we've got a large "Butterfly" painting.

On access to great works

People know that we're serious collectors. We do not sell, we will lend, and the works are

Damien Hirst
Away from the Flock (II), 1994, steel, glass, formaldehyde solution, lamb, 37 ¾ x 58 ⅝ x 20 in. (96 x 149 x 51 cm)

going to end up in public institutions. Frankly, artists and their dealers will often favour us over people who don't have those same attributes. Also, they know I'm on the boards of several museums.

I think a dealer has a responsibility to place the artist's work, and if he can get a major museum to buy it, I think that's very appropriate. Now having said that, I will tell you that oftentimes, artists would prefer that they sell the work to us rather than to a museum. The reason is very simple. They know that we'll lend it anywhere they want. But if they sell it to one museum, it will be in storage ninety-five percent of the time, because most museums, as you know, can display maybe five percent of their collections. So there's an advantage in having our foundation own the work, because we will lend it for shows within reason, or when the artist wants it placed. In effect, the artist still has the right to place it, but gets the money paid for it.

With regard to buying primary or secondary, we do both. For example, we were not big collectors of Andy Warhol until almost a decade ago, so we bought a lot of Warhol in the secondary market.

Why Warhol?

We weren't there at the beginning, but after I saw the show at the Museum of Modern Art about twenty years ago, and saw all the work together, with all the comments people

Jeff Koons
Rabbit, 1986, stainless steel,
41 x 19 x 12 in. (104 x 48 x 30 cm)

were making – we try to buy with our eyes, not with our ears – it became very clear that this was the most important artist of the second half of the century. Now I say that, although we have a large collection of Jasper Johns and others, but it took time to appreciate how important Warhol was.

Staying informed

We don't use art advisers. I do have a curatorial staff. I have a director and chief curator, a curatorial assistant and a registrar of our Art Foundation. But I spend many hours in whatever city I'm in, going to artists' studios or museums or shows. You've got to do that. I read all the art magazines and so on. I don't think you can be a collector and just be passive and say, "Oh, I like that, I'm going to buy that, it'll look good over the fireplace."

Importance of meeting the artist

It is and it isn't. In the end, it's the quality of the work that counts, but also knowing the artist, conversing with the artist – every artist is different. You've got Jeff Koons, who is one personality; you've got Mark Tansey, who is a very different personality. It's good to hear them talk about what they had in mind and how they see the world and so on. But in the end, it's the quality of the work that wins out.

You know, there are some tough artists out there that we collect. Richard Serra happens to be one – we're friends, but he's not exactly a glad-hander. We like Richard. He's doing some great work. I think he's the most important living sculptor in the world today, without any question

Cindy Sherman
Untitled #112, 1982, colour photograph,
45 x 30 ½ in. (114.3 x 77.5 cm)

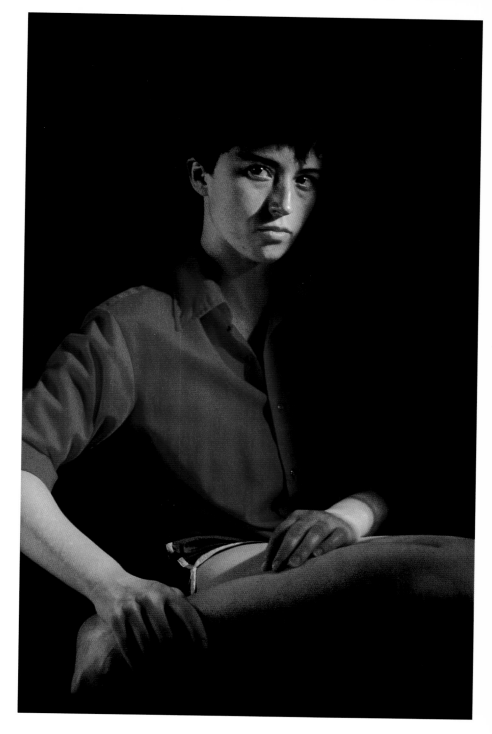

Francesca von Habsburg

Collector, Vienna

The daughter of Baron Hans Heinrich Thyssen-Bornemisza – Europe's fabled art collector whose extraordinary collection is housed in its own museum in Madrid – has created a new foundation whose commitment to funding Contemporary artists' ambitious projects puts her into her own category of art patronage. Francesca von Habsburg is married to Karl von Habsburg, the eldest son and heir of the historic Imperial family of Austria, but her commitment to art goes well beyond her historic geneology. She is chairman of Thyssen-Bornemisza Art Contemporary (T-B A21), her foundation, which collects works by important and challenging artists, offers artist-in-residence support, and produces unique artist-designed projects throughout the world, most recently the Eliasson/Adjaye Pavilion at the 2005 Venice Biennale, and Kutlug Ataman's Küba which travelled "Against the current" up the Danube river from the Black Sea to Vienna on a converted industrial barge. This new foundation seeks to continue and redefine the family's history of art patronage: "I would like to overcome the permanence of museum structures."

The impulse to collect

For years, I tried very hard to resist becoming an art collector, but it's an inherited gene.

What do you enjoy about your collection?

Working directly with artists on the commissions that we make. Being able to take risks together with them and feel their creative juices flow! It's so exciting!

On buying versus commissioning

I don't buy any more, I commission unique, large-scale projects from Olafur Eliasson, Doug Aitken, Matthew Ritchie, Janet Cardiff, Ernesto Neto, Kutlug Ataman, Diana Thater, Cerith Wyn Evans, Jim Lambie, Jun Nguyen-Hatsushiba, and recently a selection of young emerging East European artists. What attracts me to their work? It varies enormously. Sometimes it is their social and political conscience, sometimes it is the imagery or pure beauty. Also I like working with artists when I can ask – regardless of the medium they prefer and the discipline they are in – if they are ready and willing to explore other avenues.

Changes in the art world in recent years

Museums have had to reduce their acquisitions and commissioning budgets. It is all the more relevant that collectors become more committed to supporting special commissions. It creates a healthy balance between the frenzied market and the furthering of the artistic process, without which the whole art world could implode into commercial mediocrity! I do not invest in art as a financial tool. Art is an investment in the quality of life.

Have the art fairs changed the market?

No, the market has changed the fairs.

Do auction prices affect her collecting?

Not at all! I feel that I am in the pre-primary, not the secondary market! Sounds like school doesn't it? It's such a learning experience, so it is fitting. My feeling is if you missed it the first time round you missed it, end of story! There can be exceptions to the rule of course! However the auction prices do have an underestimated influence on artists' primary market, and this can be very unsettling for them. A sudden rise in prices in the value of their work of over 300 percent can be very destructive, as seductive it may seem in the first instance. Exaggerated estimates and collectors eager to prove they are good investors are hell for them.

A sense of duty

I think that owning art is a huge responsibility towards the artists and the art works themselves, well into the future. I think that many "collectors" could discover that they would have as much of an interesting and inspiring time supporting NGOs like Artangel in London and the Public Art Fund in New York, or even some of T-B A21's co-productions and performance art pieces – because they would feel as much ownership towards a work that resulted from their participation; they would share that experience with other

> "I don't buy any more, I commission unique, large-scale projects ..."

like-minded people and, at the same time, they would not be burdened with the exorbitant storage costs and responsibility that go with actual physical ownership. Art is there to stimulate our spirits and challenge the way we think, not to become another investment fund!

Concept of art patronage: the Eliasson/Adjaye Pavilion at the Venice Biennial

The *Black Horizon* pavilion, which everyone admired so much, was a pilot project for the new Limited Edition Art Pavilion concept that I dreamed up last year. I had been brainstorming about it for some time with Olafur Eliasson and David Adjaye particularly, but also with Elmgreen & Dragset, Olaf Nicolai, Carsten Höller and Matthew Ritchie. This was the result of a lot of shared creative thinking. The plan is to share the unique T-B A21 commissions with a global audience in specially designed pavilions that are

about 500 square metres, cost between one and two million Euros to build, and lie in extraordinary landscapes within reach of some of the world's most exciting cities, as opposed to being in their urban environment. The experience will be worth the effort and attract a dedicated audience, as Marfa (Texas), Roden Crater (Arizona) and Angkor Vat (Cambodia) have done in the past.

The artists love the idea, since we will be celebrating a unique vision of theirs, leaving the show up for six months, allowing it to be experienced through different seasons, and be revisited, if requested, by the artists. The pavilions will have the most extraordinary views, inviting the outside in through the brilliant architecture of David Adjaye. They will sometimes include their own modest and very private living environment, and be scattered around the most extraordinary places, such as Iceland, Lebanon, Argentina, South Africa, Korea, Japan, India, Switzerland, etc.

Advice for newcomers

The new collector should think about what he can do for the artist's dreams. Be generous, and be prepared to spend money not only on acquisitions but also on projects, publications, co-productions, etc. I learned more about art in this way than listening to all the self-appointed advisers and gallerists, who are more than happy to try to influence one.

How the new collector gains access to good work

He or she must genuinely care about the artist and his work, and understand what would honour the piece and render it to the public in a generous way. Putting good work in storage for extensive periods is a sin.

To buy in a gallery or at auction

It depends on how shy you are! Developing a good relationship with a few key gallerists is a great way to learn. Their job is to be people-friendly, which most of them are, and explain artists' work in a coherent way, even to people not so familiar with the artist. I used to be shy to enter the really cool galleries in Berlin – believe it or not! Now they can't keep me out of their storerooms. Just don't be shy!

What makes a great collection?

Being passionate, bold and having a courageous heart! What also makes a great art collector is continuity. Being able to keep one's passion and interest sharp whilst collecting within one's means, on whatever level, is very important. Taking risks is crucial but not a license to be foolish! Remaining partly, at least, philanthropic is also primary.

No one can really teach you how to become a great collector. I remember everyone asking my father what his secret was. I never really heard him answer them, other than to make a humorous quip that it was the same as collecting beautiful women, except that the latter you could not hang on the wall, which had its downside too.

To acquire a feel for art, one needs to learn about it not only through intellectualization, but through perception of its essence. This only comes through personal exposure to the process of creativity. My father, who collected mostly old masters and classic modern works, was very engaged in their conservation, practically hands on. This process

brought him extremely close to each work as the layers of the paintings were discussed in detail with Marco Grassi, his close adviser and conservation expert. I run a close parallel to that by commissioning new works from Contemporary artists, who allow me to participate in the many layers of the creative process of these works. I do so in an extremely supportive way, and feel very privileged to be able to do so. This is why I encourage others to support NGOs which commission new works; it allows them an otherwise extremely restricted access to that process. That's where the real learning takes place. In my experience, as long as you know that you still have something to learn, you will never get bored with collecting, nor will you ever stop being a philanthropist. That's what is important. There is nothing more boring than a blaze collector, or one who boasts about how much money he is investing/making in the art market. I run a mile when I meet them!

A great collector defined

Someone who comes up with a new and innovative strategy to share his collection, and who is trusted by artists. Collecting is all about trust.

Olafur Eliasson
Your Black Horizon, 2005 (previous spread),
installation in the Thyssen-Bornemisza Limited Edition
Art Pavilion (below). Design: **Adjaye Associates**, Temporary
Pavilion, 51st Biennale di Venezia, Isola di San Lazzaro

Dakis Joannou

Collector, Athens

Born in Cyprus, Dakis Joannou is a civil engineer and architect by training. He is the chairman of a group of privately held building and civil engineering companies. Joannou is renowned as a voracious yet discerning collector of Contemporary Art. He sits on the boards of the Guggenheim Museum and the New Museum of Contemporary Art, and is also an international council member of the Museum of Modern Art and the Tate. He is often closely associated with Jeff Koons, whose work he has been diligently collecting and supporting since the famous "Equilibrium" series (1985), and more recently with the British artist duo, Tim Noble and Sue Webster. The Deste Foundation in Athens, which Joannou founded and privately funds, acquires the work of several promising young artists on a continual basis, and has, since the late Eighties, mounted large Contemporary shows with impressive catalogues, most recently the *Monument to Now*, which was staged to coincide with the 2004 Summer Olympics.

Building and maintaining a collection

I started collecting about twenty years ago, when I saw Jeff Koons' *One Ball Total Equilibrium Tank* (1985) at his first show at International with Monument. I have always loved Jeff's work; he's always coming up with stronger ideas and pieces.

I started the Deste Foundation in 1983 to organize exhibitions, events and publications which engage in a dialogue with Contemporary Art and the cultural community in Athens and abroad. The foundation offers me a special opportunity to share my collection with the public and to open up a dialogue that might not be possible with a private collection in one's home. It is important for me to maintain that openness and communication rather than keeping the works in my home only for myself, my family and friends to see.

I often concentrate on an artist's work over a long period of time, building on my relationship with the artist and developing an in-depth engagement with his or her body of work, which also connects to my collection as a whole. I'm very engaged personally with the works in my collection and I know immediately, when

Maurizio Cattelan
Untitled, 2001, wax and fabric, figure: height 59 in. (150 cm), manhole: 23 ⅝ x 15 ¾ in. (60 x 40 cm) Installation view, Museum Boijmans Van Beuningen, Rotterdam

I see a piece, if it's something I want to live with and bring into my home. The important thing is to have respect for the art and for the artist, that's paramount. Once that is there, whatever you do depends on your priorities, your interests, your personality.

On art advisers

I think a collector has to have his own opinions, his own strategy, his own personality, his own character and his own vision. It's important to get opinions from art advisers, from galleries, from other artists, from curators; information never hurt anybody. But the bottom line is: you have to make your own decisions. I would not advise any collector to buy whatever one adviser tells him. Then he won't have his own collection; it will be something else.

I have known and worked with Jeffrey Deitch for the past 23 years. I have a special relationship with Jeffrey that goes beyond the formal art adviser/collector relationship. We have organized several exhibitions together and he is one of the curators of the 2004 exhibition of works from my collection, "Monument to Now".

On large-scale or difficult-to-house works

I'm in a special situation, having the collection and the Foundation, so the scale of works isn't something I consider so much. I give a lot of importance to living with the art, but at the same time, I don't exclude a piece that doesn't fit into the house. I always have the opportunity to enjoy the work in a museum, in a group show somewhere or in an exhibition at the Deste Foundation.

Buying and selling

As you grow, so does your collection, and occasionally you re-assess and edit the collection to become more focused.

I mostly buy works on the primary market, it's the nature of my collection.

I am always interested in a great Koons, a great Maurizio Cattelan, a great Noble and Webster, and a great Chris Ofili, and if the opportunity appears, I will buy on the secondary market or at auction.

"I think a collector has to have his own opinions, his own strategy, his own personality, his own character and his own vision."

Recent developments in the Contemporary Art market

I think what has happened in the past few years in the Contemporary Art world is fantastic. More and more people are getting involved. There is a better understanding and a better acceptance of Contemporary Art. People are not cracking jokes any more. The works are taken seriously. There is more engagement with culture and with art. This engagement enriches one's life, it enriches one's psyche. There are now a great number of collectors, and the general public is more interested in art. Mainstream magazines are covering Contemporary Art in a serious way, and there is a broader awareness. It's important that the art world escapes from the insular bubble and relates to a larger public.

The opinions that matter most in the art world

The artist's, the artist's opinion foremost.

When Jeff Koons created the "Statuary" series with Louis XIV (1986), the Italian Woman (1985) and the Rabbit (1986), Louis XIV was the highest priced piece. Today, history views the Rabbit as Koons' most valuable and iconic work. Can the artist be wrong?

Really, I didn't know that! I am glad to hear it. I felt the same way. I have Louis but not the Rabbit. So was it a mistake? Maybe it was. Maybe it was not. We don't know. In the end, I think history will go on the side of the artist. Time, history, that's much more important than the media. I really think that what remains is what the artist has put into the work.

For me, it's important to meet the artists, especially if you consider acquiring a work from one of their first shows. It's essential to talk to them to understand what they're doing, to know them, to understand how they think, understand their vision and feel the energy. That helps me to relate and engage with the work on a more personal level.

Previous spread
Jeff Koons
Michael Jackson and Bubbles, 1988, porcelain,
42 x 70 ½ x 32 ½ in. (106.7 x 179 x 82.6 cm)

Chris Ofili
The Adoration of Captain Shit and the Legend of the Black Stars, 1998, acrylic, oil, resin, paper collage, glitter, map pins and elephant dung on canvas with two elephant dig supports,
96 ⅛ x 72 x 5 ⅛ in. (244 x 183 x 13 cm)

Baroness Marion Lambert

Collector, Geneva

Born in Amsterdam, Marion Lambert has been collecting for over twenty years. She married a prominent collector and was one of the early collectors and patrons of contemporary photography. Her close relationships with artists, combined with a well-honed "collector's" eye", enabled her to assemble the photography collection she entitled *Veronica's Revenge* after St. Veronica, whose veil miraculously retained the image of the suffering Christ, thus producing the first "photographic" image. The collection was exhibited in the family-founded Bank Brussels Lambert in Geneva in 1996. Protests from a bank director led to its removal and subsequent sale at auction in 2005. A book on the collection, *Veronica's Revenge – essays on contemporary photography*, was published by Scalo in 1998.

What she collects

Collectors are hoarders, and probably fodder for shrinks. I am no exception, although with the years I have learned to control myself while weeding out the mediocre and superfluous from the essential and best. I have collected ancient Greek embroidered material, Swiss Folk Art, Greek Folk Art, 1950s design, houses, dogs and friends, to mention but a few. Never husbands – I stopped at the first one, who comes from a prominent art-collecting family in Belgium, and that is how I got involved in art.

On collecting

From the day I was born, I have amassed all sorts of objects. Later in life, and financial means permitting, my focus was and still is on art. Somehow, the idea of a painted wooden Swiss box becomes more interesting if one possesses more than one, because the comparison between the different ways of expressing the same idea conveys a message and gives a perspective. It is like following Ariadne's thread, one work leads to the other, and one's understanding benefits from the continuous search.

Why collect photography?

When I started to buy Contemporary photography, very few were interested in this particular field. We are talking about the Eighties, and people were lining up in the front of galleries to buy Salle, Bleckner, Clemente, and other artists, who all sold out before the

show opened, at tremendous prices. So, out of frustration, I started to look elsewhere and discovered that young artists were doing interesting work with photography, using the medium in a way close to painting, by removing this "tool" from its documentary past.

A collection should reflect the subject matter – I have always disliked people who buy to decorate their houses, or buy what they call in French *des coups de cœurs* (it is so beautiful, let's buy it). Collectors often do not make an attempt to establish a discourse between the works, and do not build something coherent. They buy names, fashions, trends, and what their neighbour has.

On how much she invested

I have no idea how much we invested, and, as far as I am concerned, money is the opposite of art. People who only buy art to invest, sooner or later will fall flat on their faces. Art is the expression of ideas – some of them very foresighted – of lofty ideals, of political insights, and of deep-felt emotions. As such, it should not be price-tagged.

I sometimes wonder how many of today's collectors buy a Richard Prince "Cowboy" while understanding the underlying message. If they did, they might not so grossly overpay for some works!

"Collecting is like following Ariadne's thread, one work leads to the other, and one's understanding benefits from the continuous search."

Profits in art trading

We bought in dollars, and we live in Switzerland, so anybody smart can figure out that we certainly did not make money on the sale of the collection, as the dollar has lost half of its value over the years. I did not buy or sell to make money, I bought out of passion and I sold for personal reasons.

Why the collection was sold

The collection of Contemporary photography, from the very onset, belonged to my two children. It was my gift to them.

My daughter's untimely death, as a result of the devious and criminal acts of a perverse individual (who remained unpunished because of the statute of limitations, but was never acquitted), left the collection without a future. She was deeply interested in art and would have continued the collection. My son's interests lie elsewhere.

On dealers getting angry

Some were angry, others understood. I have a very low tolerance for some of the dealers' "holier than thou" attitude. After all, they are merchants, making money by selling art, and from the moment the transaction is accomplished, they forego, by my standards, further claims regarding the work they agreed to sell.

A lot of their sour attitude comes out of spite. I paid $750 for my first work by Matthew Barney, for example. But their anger is unjustified – I feel that I did more for the field of Contemporary photography than some other collectors and proved my real and sincere interest in art in more than one way.

We published a book that became a reference text for art schools and universities; we organized and paid for 13 museum shows all over Europe, even in Australia, at a time when most of the artists working with photography had little exposure here, and I feel I proved my loyalty to the artists.

> ## "People who only buy art to invest, sooner or later will fall flat on their faces."

Is she still offered good work?

Of course I am offered work, all the time. There are a few exceptions I will not name, one well-known gallery in New York, whose owner said to me that she will never sell me anything again (after making good money over the years on my many purchases from her), and one equally prominent gallery-owner in Zurich, who behind my back told his staff that I only buy to sell – which is totally untrue – but I could not care less, there are ways to circumvent their abuse of power.

On the difference between European and American collectors

Money and history. Americans are infatuated with the present, they are not stuck in their past, as we Europeans are. And, they have greater financial means.

Aside from Mr. Pinault, whom I greatly admire, there is no one in France with a vision. There are some individuals in Germany, a few English collectors, some of whom are really dealers, an Italian here and there. On the whole, the picture on our side is bleak in comparison with the United States. The American system, which includes such benefits as tax deductions for donations, museum committees etc., greatly encourages the range of collecting.

Works she is buying today

Works of which I am certain, in the sense that in today's crazy art market, and crazy world, one has to ask oneself the question: "Is this really relevant and will it still be, many, many years from now?" Much has already been said and done in Contemporary Art – only what is profound and wise will last.

Advice for a new collector

Never buy to invest. Buy only when you understand the work, and when its meaning and message enhance your vision of the world and enrich your life.

"Buy only when you understand the work, and when its meaning and message enhance your vision of the world and enrich your life."

Mike Kelley
Ahh … Youth, 1991, 8 cibachrome prints, edition of 10,
24 ⅜ x 16 ⅞ in. each (61.9 x 43 cm)

Jean-Pierre Lehmann

Collector, New York

Jean-Pierre Lehmann moved to New York from Geneva in 1992, and he and his wife (success-ful Chelsea-based art dealer Rachel Lehmann) have been dedicated collectors for over twenty years, showing consistent support for artists who inspire their commitment. They have been early collectors of Jeff Koons, Matthew Barney, Kara Walker, Jeff Wall and Gabriel Orozco among many others.

Why collect Contemporary?

The first object I bought was a woodcut by a Finnish designer, Tapio Wirkkala, I was 19 then! I was introduced at a good level – because you can also start at the wrong level and lose a lot of time finding your way to the quality galleries. Maybe the choice wasn't so much about Contemporary at the beginning, but early on, there were two or three good reasons why I took on Contemporary. There was no question of fakes, like in antiquities; there was no question about attribution – who did it, at what time, is it a copy, etc. To a certain degree, I rejected photography because, again, in the photography field, there was a question of who did the print, at what time, which paper is it, was it the artist who did the print – I'm talking about photographs between 1860 and 1950. What I find most interesting in Contemporary collecting is the adventure – nothing is definite, everything can be questioned and *will* be questioned, at some point. Why this artist versus another, why this painting versus another?

What is your purpose?

In life, making money in business is one dimension; having a family, emotions and friends is another dimension; and collecting is yet another dimension. It's a dimension which includes adventure, emotion, choices, investments – not only some of those, but all of them, so it's a life adventure. Some people create a large company, some people do good things in Africa, some people are great doctors, and some can also collect. Probably in my case, our two children will decide what they want to do with the collection, which will be a witness to a period of art with a lot of misses, with a lot of limitations – because there is never enough money to do everything you would like, because maybe some-times you don't have access to an artist or their gallery (you know how they play games),

or maybe you have missed a whole area of an artist's work, and so on. But at least it is building a body of work that bears witness to the time, to a life, or to the life of my wife Rachel and myself, and to our adventure together. I don't have any other ambition.

I am trying to see as much as I can because, in the end, art is about looking, and sometimes touching, but mostly looking. You have to get educated about looking, and think about it and read about it and hear about it ... Art – although it's sometimes conceptual – it's mostly *visual*.

Maintaining a collection

I don't think that you should limit yourself to the size of the walls, because there are already enough restrictions, so that restricting yourself to the size of the walls or the size of the spaces in the home is really a bad limitation, one that you shouldn't put on yourself. Now, whether you should put a thousand pieces in storage is another question. But I think you should have the liberty to have things that don't fit in your house, don't suit the style of your furniture, and so on, and the ability to change, because your taste will change in time, too. Maybe instead of putting some pieces in storage, it's the furniture that you will throw away, or the house that you will change. I would like to have the means to have the space and the personnel to see everything, at least some time, but I know it's not going to be possible, so I have to live with that.

One of the difficulties, when you continue collecting artists, especially those who

Gilbert & George
Hands up, 1984, mixed media, 95 x 158 in.
(241.3 x 401.3 cm)

become well-known and expensive artists, is that it becomes more and more difficult because the prices go up. If you can buy when they are young – ten artists at $2000 to $10000 – when their work is worth $100000, you have to reduce the number, if you have the same type of budget or even if your budget has increased. Then the question is: Do you keep buying artists who are renowned, expensive and well-known? What do you do with the younger artists? So we've tried to do a little bit of both, which is to continue following some of the artists we have liked for a long time and, at the same time, discovering new artists – because the adventure is about discovering new artists. But it's also interesting to see how more mature artists develop, how they avoid repeating themselves, or how they do.

On changes in the Contemporary market over the past ten years

It is a much broader market than it used to be, whether it is collectors, gallerists or artists. I think the quality is high, but the variety is so enormous that people have problems defining what is good or what is not so good, because at the beginning, it's very difficult to assess the quality of certain things. That's why, when you've seen a lot before, you can at least eliminate some of the repetition. So the change is evident in the broadening of the market, the variety of the types of art, the inflation of prices, and the multiplication of galleries, artists and everything they produce.

There hasn't really been a financial crisis in the art market since the early Nineties, so there has not been a cleaning up of that scene. When there is a financial crisis, some galleries disappear, a lot of artists disappear, for good or bad reasons, but that's what I call the "cleaning". Basically, there have been two very low times in my experience, between 1974 and 1975 and then between 1981 and 1982. There was a fairly low time in the late Eighties and early Nineties, and there have been some lulls and some highs, but no real large lull in the last twelve years. On the contrary, Contemporary Art has become fashionable.

There is an implicit inflation in all asset values in the U.S. at this moment, and I think that these values will change. Either there will be a big general inflation that will reduce the real value of those inflated values for art, or the prices will go down. You still have to remember that a Jasper Johns sold for $17 million in the Eighties [*False Start*, 1959]. So why not? If you lower the interest rates to near zero and therefore print too much money, then you get those prices. I think it's a world of fools, and you know it when everything goes up at the same time – the good, the bad and everything in between!

One of the problems artists today are going to face is that life, in general, is much longer than it used to be. You don't have artists dying of tuberculosis or alcoholism when they are thirty-five or forty and leaving very interesting works – but very limited quantities, because their lives were limited. Now, most artists will probably live like everybody else until eighty, ninety or one hundred, and if they want to produce until the end, they'll have problems, because their productive years will be much longer. Probably then you will see the difference between the good and the less good, because most of them will repeat themselves, and only some of them will still create late in their lives – like Matisse did at the end, by cutting papers.

Jeff Koons
Elephant, 1995–2004, high chromium stainless steel
with transparent colour coating,
150 x 120 x 7 ⅛ in. (381 x 304.8 x 18.1 cm)

Selling from your collection

First, I am not a dealer. Second, there are things that I might sell, but experience has shown me that some things out of fashion may come back. Whether we like it or not, there is always an element of fashion, of hype, an element of the "art of the time", although I could clean up some areas of the collection. The other thing that happens has to do with the really bad things that you bought to be nice to somebody, or that you did on the impulse of the moment, and so on. If they really are bad, they are not worth anything, so why sell them? Except for cleaning your warehouse, there is no reason to do it, because you cannot sell them. The good things that may not meet your taste of the day, may be the taste of the day in five, ten, or twenty years. I can open an *Artforum* of the Seventies for you, and you would recognize only a few names. It will be the same in twenty years for the last issue.

We've chosen never to sell a work, and this is also related to a basic mistake I made, probably about thirty years ago. I had bought small works – because I had little money – by very good artists. I had works by Yves Klein, Robert Ryman, Piero Manzoni and people like that, and I thought, after a while, that I should sell all these small pieces to "upgrade" by buying two large pieces. I bought a large Robert Rauschenberg and a Roy Lichtenstein. It's not the regret of my life, but it is a deep regret, because I thought that the Ryman, the Klein, the Manzoni were really representative of what my taste, my interests, my collecting were at the time. The others were bought for the wrong reasons at the wrong time. Rauschenberg was beyond his interesting time, it was still good, I still like the piece, but it's beyond his best period. The Lichtenstein is fair but not exceptional, and I think I would have been as well off keeping what I had rather than "upgrading". A lot of people make that mistake. It was a rational decision and it was missing the emotion of discovering, appreciating, hesitating, buying, etc. That's why I think it was an error.

> "I don't buy secondary because, basically, the adventure is about discovering new artists, discovering new exhibitions, a new vocabulary, a new image, a new impression, whatever you want."

One of the mistakes that too many people make, especially in this country, is to equate a piece of art with its total value and its price on the market: "It went down. Why should I keep something which went down?" I think you have to take a longer-term view and a more quiet view of the market. The market is one dimension, but some artists come back later. People like Ed Ruscha never had a market until two or five years ago. Some people come back and, as I said before, if a piece is not worth anything, why sell it? Or if a piece that you paid $100 000 for is worth $20 000, is it because the market collapsed, or because the artist was hyped and his market collapsed? Except for taxes, I don't see any reason to sell.

Buying primary versus secondary

I don't buy secondary because, basically, the adventure is about discovering new artists, discovering new exhibitions, a new vocabulary, a new image, a new impression, whatever you want. Once in a while, Rachel and I have bought in the secondary market, but then usually it was for artists we were collecting, where we had missed part of their work, so it was more to complete the collected work of that artist than to buy secondary. I think by nature you are always more attracted to certain dealers because of their choice of artists, which fit your taste better than some others, and also because of their personalities. That doesn't mean that you don't like some of the artists of the other dealers.

Secondly, buying and being the client of a dealer is also having a relationship with that person. If you have a bad relationship, you may want to buy once, maybe twice, but you cannot have a lasting relationship with that person. In the end, it's about relationships with the art, with the dealer, sometimes with the artist – otherwise you buy in auctions, I guess. If you don't want to have a relationship with anybody but the market, then you go to Sotheby's or Christie's. Otherwise you have relationships. Also there are some limitations, you know there is never enough of the good work. Like in the Eighties, the time of the waiting lists has now resurfaced. So having a good relationship with certain dealers, I think, is part of the game.

Lisa Yuskavage
XLP, 1999, oil on linen, 40 x 75 in. (101.6 x 190.5 cm)

Eugenio López

Collector, Mexico City

Since 2001, 36-year-old collector Eugenio López, sole heir to the Jumex fortune (fruit juices in Mexico), has been his country's largest Contemporary Art patron, opening an art warehouse space in Mexico City to exhibit his vast collection and even planning a new gallery. The collection currently includes more than 1200 works of art by artists from all over the world including Olafur Eliasson, Francis Alÿs, Doug Aitken and Maurizio Cattelan. Reportedly Jumex has spent around $80 billion over the past ten years.

Starting out as an art collector

I've lived with art practically all of my life, but at the beginning of the 1990s I began to acquire the works of some Mexican painters and sculptors. As I travelled abroad to more places and visited more museums, this began to change. I remember visiting the Whitney Museum of American Art in New York in 1994, where I became fascinated with the work of the Abstract Expressionists. It was at that point that I began to collect pieces done by great artists of the Sixties like Richard Serra, Jasper Johns, Donald Judd, as well as works by artists from other countries and from Mexico who belonged to my own generation and with whom I had many things in common. That's how I began my own research into Contemporary Art.

> "Art fairs have proven themselves to be very good ways of learning a lot, since galleries from practically all over the world come together."

In 1997 I bought Marjorie Jacobson's book, *Art and Business*, which I devoured. I couldn't believe the number of collections put together independently for corporations who then exhibited the work to the public within their own premises. At that moment I got the idea to create a foundation, and little by little it took shape. I needed the infrastructure and assistance of the Jumex Group, so I spoke to my father and the directors of the

company. I had to convince them one by one to help me establish the foundation, given that it was not a project that would contribute financially.

What stimulates him

Art is my day-to-day passion; it occupies an important part of my life. It's something I never stop thinking about, and I can't wait to begin several new projects. Right now, for example, I'm planning to inaugurate a new space in Mexico City where the library I've been assembling will be housed. To date, we've purchased more than six thousand titles, all dealing with modern and Contemporary Art.

Art-market changes over the past five years

One change is today's ever-increasing interest in Mexican and Latin American art. Although interest was always there, it was conditioned by criteria that were for the most part historical. Today, the work of young artists like Gabriel Orozco or Vik Muniz are shown and acquired internationally. You see evidence of this interest in the increasing number of Mexican or Latin American galleries that participate in international art fairs. Both private collections and museums are very actively acquiring the work of these artists.

How art fairs have changed the market

Fairs have proven themselves to be very good ways of learning a lot, since galleries from practically all over the world come together. Besides, there are experimental spaces as well as commercial ones. You get to know a lot of new

Vik Muniz
Mass, 1997, C-print, 2 parts, edition 1/3,
63 ⅞ x 52 ⅛ x 2 ⅛ in. (162.3 x 132.5 x 5.5 cm)

people at fairs and meet up again with others: artists, curators, gallery owners. Another advantage is that you can buy pieces that sometimes, for lack of time, you cannot buy in the place where the gallery is located. In this sense the fairs are an excellent option for buying and judging current trends and interests in the art market.

Art as an investment

Art can certainly be perceived as an economic investment, but also as a sound investment on a human level. For example, if you develop a collection and you then give people access to these works of art, whether by lending them to museums or showing them in your own exhibition space, this goes way beyond an investment of money. That's how I like to do things.

Art patronage and the Jumex Collection

I never understood why collectors bought only the work of local artists. Mexicans used to buy only Mexican art; they weren't interested in the work of artists from the United States or Europe. Many people in Latin America used to buy exclusively this way, that is, the work of artists from their own country. Here's where I saw an opportunity.

First, I had to form a collection that was international in scope. From the beginning I was very much aware that I didn't want to have a collection that would be just like the other collections in my country. Secondly, the idea took shape when I went to London and

I saw the Saatchi space. I said to myself, "My God, we have nothing like this kind of alternative space in Latin America."

Then people said to me, "Oh, but you have a museum in Mexico." True, the company had an exhibition space in Mexico, but it wasn't a museum as we know it, since the goal of a museum is to be big and important. When we started the Foundation five years ago, I met Patricia Martín, who was the first curator of the Collection, and together we planned a different kind of project, an adventure that grew from that point and continues to do so. Patricia helped me clarify the concept of the gallery, whose physical space was designed by Gerardo García, a very talented young Mexican architect. The building is really beautiful, in the minimalist style, and for it we developed exhibitions with works from the Collection, inviting international, Mexican, and Latin American curators, or sometimes inviting artists themselves to produce pieces. Patricia and I organized nine exhibitions in the gallery, some that she curated and others with other curators. We also had two that travelled outside of Mexico: *Edén*, in Bogotá and *Los usos de la imagen* in Buenos Aires. Abaseh Mirvali is the current director of the Foundation and we are working with her to solidify this great project in terms of its legal and financial status, partnering the efforts of Jumex with companies and cultural organizations from Mexico and other countries.

"I think it's not just about collecting art. I mean, in the end, how many pieces can one have?"

What makes a great collection

I think it's not just about collecting art. I mean, in the end, how many pieces can one have? Rather, what we've tried to do is create a network that allows us to bring curators to Mexico and send artists abroad, and to promote specialization for curators and critics. At times this means that if a young artist needs $4000 to create a project, we'll finance it. In Mexico, if you ask for money for an exhibition of 500-year old Pre-Hispanic art, it's very likely that 40 companies will sponsor it. But if you say that you're an artist who needs a trailer to leave on a busy street and document this act, only very few people or companies will support you. In this sense, the Foundation has taken these sorts of "risks", since it understands the driving force behind these kinds of ideas. Otherwise it would be difficult for the artists themselves to assume all of the expenses.

Santiago Sierra
8-Foot Line Tattooed on Six Remunerated People, 1999,
documentation, C-print, edition 1/5,
60¼ x 85⅝ x 2⅜ in. (153 x 217.5 x 6 cm)

Bernardo Paz

Collector, Minas Gerais

Entrepreneur Bernardo Paz is a leading Latin American collector and the creator of the Contemporary Art Center Inhotim (CACI), a continuously evolving garden/art space in his home state of Minas Gerais, Brazil, where Contemporary Art exists in an intimate relationship with nature. In 2004, members of the art world were invited to visit his "dream" where an enormous country house, gardens and seven galleries are spread over 300 000 square metres, and sculptures and outstanding international pieces are installed in an idyllic setting. The collection comprises more than 450 works of Brazilian artists as well as foreign artists. Paz bought his first piece of Contemporary Art, an installation from the Brazilian artist Tunga, in 1998. "I can't understand a world divided into foreign and Brazilian artists," he says. "Humanity prevails over cultural differences, especially today in our globalized world."

On becoming an art collector

My collection was developed alongside the spaces where it is shown. So I thought about ways of presenting it and about its context from the beginning. I started by collecting Brazilian modern art, but later realized that for me, the most important thing was not to think about nationality or history, but to relate to the current artistic thinking worldwide – to consider art as a universal and human value. Art and culture were always very present in my life and I think they are a strong way to construct a better future.

> "I think art is an investment in our future."

Why collect

What interests me the most about art is to capture the spirit of the artists' ideas and participate in the process of creation, offering them conditions to achieve ambitious new projects. It is precisely what is not known or not understood that interests me in Contemporary Art.

On recent changes in the art market

It has gotten much more expensive.

How to choose the artists to buy

I am interested in artists who have a fresh way of looking at the world. For my collection I am specifically interested in artists who have ideas that go beyond what a usual private or institutional collection can contain. I am interested in providing an environment where artists can dream their biggest dreams, and have the opportunity of juxtaposing their work within a natural environment – where they can experience art under a stimulus that is different from the context of a museum, or gallery, or home. What I am most interested in is to be able to interact with artists in a way that others cannot.

A new collector getting started

A new collector should spend a lot of time looking. They should not be in such a rush to buy, but they should really educate their eye. What you love at the beginning is not what you love six months or two years later. Educate your eye, seek the advice of people who really know what they are doing and then make up your own mind.

Cildo Meireles
Inmensa, 1982–2001, steel,
157 ½ x 69 ¼ x 318 ⅞ in. (400 x 176 x 810 cm)
Installation view, Centro de Arte
Contemporanea Inhotim, Minas Gerais

On art fairs

The art fairs play an important role in the exchange of ideas and information between the public and the market. However, I personally

avoid attending them. Even though there are good opportunities, there is too much of a climate of spending, and my decisions are best made when they are considered over a period of time.

Art as an investment
I think art is an investment in our future. Art reveals possibilities and explores the unknown, and that is the greatest investment you can make.

What artists in his collection have yet to achieve the recognition they deserve
Cildo Meireles. His totally unique way of combining social and political issues with extreme formal and conceptual intelligence has always touched me very much. I think his way of looking at the world is very special. It is the kind of art work which has the potential to transform one's life. Cildo's work deserves a lot of attention and this has actually been happening in recent years. I am very much honoured that the collection is part of this recognition.

Effect of auction prices on collecting
The hysteria with which people overspend at auction has created difficulty for all

collectors who want to spend time thinking about what to acquire. Art has gotten very expensive.

How his concept of art patronage differs from the typical collection

I try to create an environment that will ultimately take days for people to experience, and where art is meant to unfold through the experience of the landscape. Sometimes this is achieved in cultivated gardens that come out of Roberto Burle Marx and the expansion of the gardens. At other times it happens through the natural environment, which is what we are just starting to evolve for the collection itself. In the instance of Inhotim, there is no way to separate art collecting from art patronage, because the very idea is that we are trying to engage with artists to create the most ambitious works that would not ordinarily be possible to create in terms of scale or conceptual ambition.

"The best thing collectors can do is to spend time researching their potential choices."

How a new collector gains access to good work

Access is a very difficult and tricky matter in the art market. One must do a lot of research and be very selective in making choices. If you are not granted the opportunity to buy the best works that interest you, then respond to the best opportunities you have and begin to create some credibility that will ultimately give you greater access.

To buy at a gallery or at auction

Too many collectors rush to overspend for works at auction that could be purchased in galleries with not that much difficulty. The best thing collectors can do is to spend time researching their potential choices.

What makes a great collection?

Independence of mind.

Defining a great collector

Someone who exercises independence of mind wisely over a period of time.

Tunga
True Rouge, 1997, mixed media,
157 ½ x 472 ½ x 315 in. (400 x 1200 x 800 cm)
Installation view, Centro de Arte
Contemporanea Inhotim, Minas Gerais

François Pinault

Collector, Paris

Born in Brittany, France, François Pinault was originally in the lumber import/export business before entering the retail industry by buying the department-store chain Printemps and subsequently acquiring the Gucci Group. He is also the sole owner of the famous Château-Latour vineyard, as well as the art auction powerhouse Christie's. He has been the most aggressive European collector of Contemporary Art in the past several years, and was planning to build his own museum in Paris, designed by the renowned Japanese architect Tadao Ando. Soon after this interview, in May 2005, he scrapped his plans because of multiple delays prompted by the local municipality. He is now exhibiting in the refurbished Palazzo Grassi in Venice, Italy, with an off-site expansion by Tadao Ando on the drawing board.

Why collect art?

I am passionate about art of every shape and form. To collect is, above all, to understand how to observe. My first acquisition was over forty years ago when I bought a work by Paul Sérusier (from the school of Pont-Aven). Years later, when I found myself in a New York auction house shopping for a Henry Moore sculpture, I was stopped in my tracks by *Tableau Losangique II,* a 1925 Mondrian. I bought it, and that day I understood that I could gain access to the best art of my lifetime, and that I could dream of a collection of that quality. This would of course require plenty of focus and perseverance. Later, I familiarized myself with the American post-war artists, and with the universe of Contemporary artists. One must look for what is ahead of the curve, and explore the relationship of today's art to the world we live in.

I feel that I am in touch with the present. I am a man of today and I truly believe one has to live in the present. One cannot live by constantly looking in the rearview mirror, surrounded by nostalgia for the past, and by works of art which have already been sanctified. The world we know consists of the past as well as the present and also the future. The past we already possess, so it can never be risky. The present and the future require the act of creation, and therefore they allow for audacity and adventure. As a businessman, I am naturally drawn to what is being created now.

Jeff Koons
Elephant, 2003, high chromium stainless steel
with transparent colour coating,
38 x 30 x 20 in. (96.5 x 76.2 x 50.8 cm)

Whose opinions to consider before buying

First and foremost, I trust my own eye, my personal judgment and, ultimately, my emotions, the happiness that I feel when I discover a new work of art and the types of questions and issues it evolves. Several other factors play into the equation, for example, the anticipation and excitement that I feel at the prospect of adding a certain new piece to my personal collection. Of course, from time to time, I do consult with experts whose knowledge I respect, but the final decision I make on my own.

On recent changes in the Contemporary market

From a global perspective, one must recognize that this market is extremely dynamic. This is observed through the development of huge art fairs, the extraordinary strength of certain galleries, and especially by the variety and quantity of today's artistic creation. Unfortunately, this dynamism has not reached us in France as much as elsewhere. I believe this is because there are fewer major collectors in France compared to other countries. I hope that this market will continue to develop, especially with respect to the number of French art galleries. I am happy to see a new generation of French art dealers who are dynamic and risk-takers. From time to time I worry about art-market manipulation, and one must accept the fact that the market attracts its share of speculators. This is unfortunate. I believe in buying art out of conviction, passion and other strong emotions, and not in order to speculate.

> "One must look for what is ahead of the curve, and explore the relationship of today's art to the world we live in."

Building a museum of his own (since cancelled)

I wanted the collection I have been building to be housed in a meaningful space, and to allow it to be shared with as many people as possible. I feel the obligation to share my passion for art. There is still a lot to be done in order to introduce the general public to Contemporary Art. I want my museum to welcome all different types of art. This is why I chose a fantastic building site in Paris. After a design competition, which included six proposals, I chose Tadao Ando to build me an outstanding museum. This is a museum for the art, for the artists and for the public.

The museum is 100 000 square feet (32 700 metres), and half of it is dedicated to exhibition space. It will open with some great works from the Sixties and Seventies, and will run the gamut all the way up to today, with a deliberate emphasis on an international perspective.

What purpose a museum?

I want the artists to be recognized, the works of art to be appreciated, and for the public to further develop a passion for the art of today. This museum will focus on exhibiting my personal collection through different and constantly changing installations. I also see

the benefit of having other great private collections exhibited, and I am ready to accommodate them. A programme of thematic exhibitions as well as one-man shows will permit us to keep the public's interest in today's art and our living artists. The museum will be simple, dynamic and alive. The public will feel right at home, and so will the artists.

Previous spread
Damien Hirst
The Fragile Truth, 1997–1998, glass, stainless steel and drug packaging, 98 ⅜ x 144 ⅞ x 11 ¼ in. (250 x 368 x 28.5 cm)

Urs Fischer
What if the Phone Rings, 2003, pigment, wax, wick, edition of 3, 41 ¾ x 55 ⅞ x 17 ¾ in. (106 x 142 x 45 cm)

The Judith Rothschild Foundation

Harvey S. Shipley Miller, *Trustee*, New York

Harvey S. Shipley Miller is the sole trustee of The Judith Rothschild Foundation. The Foundation spent over $7 million in a year (2003–2004) to build a collection of Contemporary works on paper by over 400 artists, including classics like Jasper Johns, Cy Twombly and Gerhard Richter, while moving boldly into the present with promising newcomers like Christian Holstad and Hernan Bas. The Foundation promised to offer the collection as a gift to the Museum of Modern Art, and therefore received major discounts on valuable works from enthusiastic dealers and artists. MoMA subsequently accepted the collection.

What is The Judith Rothschild Foundation?

Judith Rothschild was a noted abstract painter who died in 1993, and in her will she set up the outlines of the charitable foundation, which had multiple purposes. It's an operating foundation. It's more like an institution, and *all* the resources and assets have to be devoted to the pursuit of its approved mission. It has a sunset provision: 25 years from date of death, everything must be used and distributed and all of its aims accomplished as best one can. One of the purposes is the stewardship of *her* work. She also left some things formulated generally, saying the trustee should do special projects generally in support of art institutions – "museums" was actually her term. So her executor and I interpreted that broadly.

Special projects – what I call trustee's discretionary projects – that I've undertaken *must* be in support of an art museum. *The Russian Avant-Garde Book 1910–1934* (at MoMA) was one collection I formed and offered to the Museum of Modern Art, and it turned out to be, unintentionally, the most definitive collection of the work in the world, including Russia. The Jacques Villon print collection that went to the Philadelphia Museum of Art was the second, and the works-on-paper collection that we are building now (The Judith Rothschild Foundation Contemporary Drawings Collection) for MoMA is the third.

Building a Contemporary drawings collection

It started really strongly about five-plus years ago, people turned their attention to drawings. There's a big renewal of interest by collectors,

Douglas Gordon
always and forever (detail), 2001,
chromogenic print, edition 1/13
24 x 20 in. (61 x 50.8 cm)

Peter Doig
Country Rock Version, 2000–2002, oil on canvas,
74 ¾ x 108 ¼ in. (190 x 275 cm)

museums and artists. Today, one *looks* at a drawing. In historical times, by and large, artists did drawings as a step toward a final work or a look back at a completed work.

The goal was to build a collection. I won't disclose what we've spent on it. But it's probably the last one we'll do. I serve on the drawings committee at the Museum of Modern Art and now I'm a trustee. I was looking at Contemporary drawings, another underappreciated area. I was at the Miami Art Fair and I stopped in front of Gasser & Grunert's booth and turned to the then-intern André Schlechtriem and said, "I don't get it any more, I'm out of touch," and he was so articulate about what's going on in the Contemporary Art world that I later came back to the gallery in New York and bought a drawing for myself. He explained some more, and I bought a second one. Now he works for me. He's a full-time curator for the duration of the project. The definition is: Every approach to mark-making on paper – performance, notational, abstract, conceptual, lyrical – you know, every minimalist approach, but not every artist. So everything has to be a drawing, you know, loosely speaking, collage would count, watercolour etc.

There are 2500 works in the collection by about 400 international artists – emerging, mid-career, modern masters, of the last twenty to twenty-five years, and a few historical, contextual ones. The working title is "Panorama", it's a one-year core sample, a survey with a few antecedent touchstones that were relevant to understanding the work today; it's not encyclopedic. For example, we have works by deceased artists such as Joseph Beuys, Philip Guston, Warhol, Öyvind Fahlström and Ray Johnson. If we went to an

older living artist such as Louise Bourgeois, we wanted her work from today, or the last twenty years, not from fifty years ago. But we had a beachhead and if there was opportunity, quality, and we could afford it, we might go back in time and create a grouping, so that where possible the artist isn't represented by just one work.

We combed, we worked it, I had André and I also had Gary Garrels (former Chief Curator of Drawings and Painting at MoMA) as a collaborator, part-time. In fact, we did a lot of it ourselves. But every now and then, Gary would say, "I put some things on hold that I can't buy, why don't you go see them?" More than ninety percent of the time, we felt they were wonderful, and we bought them only if we believed in them. André and I agreed about ninety-eight percent of the time, which was great.

We tried to take every approach that we could find, and again, there was no template. We didn't sit down and say, "Well, we have to have a modern Surrealist, or a modern abstract." It was collect, build, but in the course of that, we did hope to find every major approach to mark-making, to drawing. So there are works that relate to video, like Douglas Gordon; we have some sketches and his early notebooks that relate to and are the sources for his videos and films. We also have work that he's making today, where he appropriates black-and-white movie-star photos from the Fourties and takes out their eyes. We have Philippe Parreno using computer manipulation for his film. We have these two huge blackboard chalk drawings by Tacita Dean. Think of the collection as stratification or layering – young emerging, mid-career and modern masters.

We very rarely went to the artist directly, because it's awkward if you're in a studio and you're not responding. We went a few times, where we knew we loved the work, like Roni Horn or Sherrie Levine. Ellsworth Kelly is a friend of mine and invited me to come by. It was mainly primary market, but there was also secondary for the more classic figures.

What is it worth?

The collection is already worth more than we paid for it because of the generosity of people and the sharply rising current market for works on paper. The final, undiscounted value for insurance purposes would be somewhere between $50 and $70 million. Gary Garrels has said it's the greatest collection, public or private, of Contemporary drawings in the world, but it's miraculous because there are things that one couldn't get again.

> "We very rarely went to the artist directly, because it's awkward if you're in a studio and you're not responding."

People let go of such treasures, and there were gifts made – one of the most famous artists in the world today was so intrigued and loved the project, that for every one we were allowed to buy *at cost*, with the dealer absolutely willing, he *gave* us one, and this is someone who has never given anything, or never been known to. He just loved the project.

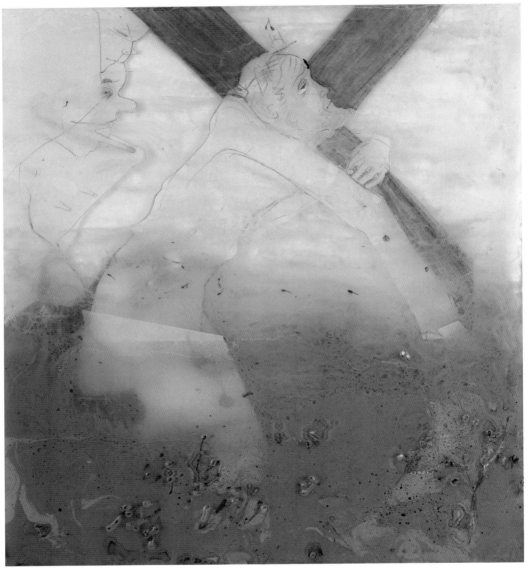

Kai Althoff
Untitled (Resin with Jesus Figure), 2001, epoxy, resin,
drawing, seeds, 27 ½ x 25 ¼ in. (70 x 64 cm)

Modern Masters in the collection

In no order: Sigmar Polke, Georg
Baselitz, Gerhard Richter, Jasper
Johns, Ellsworth Kelly, Cy Twombly, Roy Lichtenstein, Robert Motherwell, Lee Bontecou
etc. Jean-Michel Basquiat would fit in as somebody who's very much in the wind, very
much attended to by younger artists and collectors right now, who made a singular state-
ment and did works on paper that are signature. You know a Basquiat when you see one.
Whether he's a master, I leave to the ages. Right now, he's held very much in high

esteem, as you know. The drawings market is hot as hell, and the works are finite, there are only so many. He died young, and his genre of quasi-outsider, somewhat untutored, coming out of the street, but making art that played with the canons of high art – I mean, with the energy and ferocity of a fellow who looked as if he never went to art school – that kind of art is being mimicked by a lot of young people. There is this new interest in outsider art, where there's an untutored, raw quality to it, and which harkens back to Jean Dubuffet. It's not as if people haven't done that before.

Mid-career artists in the collection

For the mid-career, we have people who had some acclaim, like John Currin, Kai Althoff, Peter Doig, Rosemarie Trockel, Cosima von Bonin etc. I would say Damien Hirst is now recognized. He and Matthew Barney and Jeff Koons are mid-career in terms of their life cycle, but they're considered major artists. Their recognition is huge, their market is strong, they're in major museum collections; they're seen as younger masters.
I think Chris Ofili is a marvelous artist. We have two of the "Kissing" drawings in colour. They're sort of classic, signature pieces, but what we wanted was a tour de force showing his facility with graphite, so we got a black-and-white, large-format graphite piece. It's one of the strongest I've seen.

The most expensive works

I guess Barney is the most expensive of the mid-career artists. Robert Gober would have been, but he was so generous in pricing that we were able to acquire four major Gobers. It's hard to parse. Peter Doig was so generous with us, but the very big oil-on-paper was expensive. Kai Althoff is becoming increasingly more expensive, too.
The collection is not definitive, but it's very broad. We may have 25 works by Raymond Pettibon, and we watched him grow from the first group of drawings we bought to work done eight months later. The prices went up, but the scale, the ambition and the mastery of the line and colour changed, got bigger, more magisterial, more gestural. But then we had the opportunity to buy arguably his most important, seminal early series called the "VaVoom" series (1987).

Emerging artists

Martin Creed is one of the top names that come to mind. I like people who work with paper. Christian Holstad, Marc Brandenburg and Nick Mauss are others. It's hard for me to pick because there are so many people that I can't really make hierarchies like that. If you mention someone, I can tell you if we have him or her, and how I feel. It's easier because I don't have the inventory in front of me … I would say a quarter of the collection is emerging.

Gifting the collection

The collection *has* to go to a museum. It's a foundation project. The MoMA has full discretion to turn it down, even though Gary Garrels did collaborate, but if they turn it down, then it will be offered to another museum. I have no doubt that MoMA will take it, but if it were declined, I would feel responsible to go back to all the dealers and artists and say "May I offer this, with your permission, to Tate Modern," which would probably

be my second choice, or to the Pompidou. If people didn't agree, I might consider exchanging them back, because we did say we were offering it as a gift to MoMA.

The reason we got good prices was not just that it was created as a collection to be offered to MoMA; many of these artists are in there already. It was also that a single donor, The Judith Rothschild Foundation, was putting together an unprecedented project to document and collect the best of Contemporary drawing, what was out and about over the last twenty-five years, in this one-year period. There has never been a project like it. Fifty years from now, you can actually look at this as a time capsule of what was current in the art world, generally, the artists of interest in 2003 and 2004, by looking at this collection and at the archives and the reference library we're forming as well, to give to the Museum. So it has an integrity of its own and it records a moment in time in the art world, in a particular medium.

Are you exploiting an unfair advantage with the dealers and their artists?

We were doing this for one year, and everybody knew it. If it went on forever, I think that would be a problem for many people. Everyone knew it was a one-year, unprecedented, probably never-to-be-done-again project. In some cases, artists will tell their dealer, "This particular work from my show can only be sold to a museum or someone who promises it." And by promise, it's no longer your word – you sign an agreement with the museum. I think that's perfectly valid.

An artist can prescribe whatever he wants for his work. There may be certain works he feels are institutional. They may or may not be his best work, because the artist's judgment of what his best work is may not be what history says. Other collectors will walk away and say, "No." Some people are very happy just living with the work. Other people feel they have to own it, they look at it to some extent as one of their assets, and therefore they don't want to be bound by promissory agreements with institutions, so they'll pass on that.

If collectors come in and say, "Oh, I'm going to give it to a museum," that's looked at very sceptically today, unless there's a donor history. We did that with the Russian avant-garde books collection. That catalogue was a calling card. They saw that we had formed a collection and given it and funded the catalogue, and the show travelled, and it was a huge success.

What if the collection is not accepted by MoMA?

The Museum of Modern Art doesn't accept just anything that comes along. And it has a different mandate from a comprehensive or encyclopedic museum. Alfred Barr said the sin of omission is worse than the sin of commission. In other words, don't miss the boat. And the collection can be refined or upgraded in the future.

Raymond Pettibon
Untitled (Acid Got Me Fired …), 1986, ink on paper,
14 x 11 in. (35.6 x 27.9 cm)

Charles Saatchi

Collector, London

Charles Saatchi has been collecting art for the last thirty years and showing it, for the last twenty, in his own gallery in London. In its early days, the Saatchi Gallery mounted landmark exhibitions of American artists, including Donald Judd, Brice Marden, Sol LeWitt, Dan Flavin, Bruce Nauman, Richard Serra, Jeff Koons and Robert Gober, giving British audiences unprecedented exposure to this work. Following the stock-market crash of 1989, Saatchi sold most of his blue-chip works to become Contemporary British art's most enthusiastic champion, in the process launching the careers of some of today's best-known artists, collectively known as the YBAs (Young British Artists); they include Damien Hirst, Sarah Lucas, the Chapman brothers, Rachel Whiteread, Chris Ofili, Tracey Emin and Glenn Brown. He exhibited and promoted the YBAs in several shows, including the Royal Academy's historic *Sensation* blockbuster, which travelled to the Brooklyn Museum in 1999.

Always the subject of controversy, he is renowned for buying an artist's work in quantity and then selling the work years later at a large profit. He has been the largest and most successful art collector/speculator in the market for the past twenty years. In London, his reputation for not granting interviews and not attending his own openings, such as the blockbuster *The Triumph of Painting* (2005), has served to insure that the art world is constantly speculating on his next move.

On being a "super-collector"

Who cares what I'm described as? Art collectors are pretty insignificant in the scheme of things. What matters and survives is the art.

I buy art that I like. I buy it to show it off in exhibitions. Then, if I feel like it, I sell it and buy more art. As I have been doing this for thirty years, I think most people in the art world get the idea by now. It doesn't mean I've changed my mind about the art that I end up selling, it just means that I don't want to hoard everything forever.

Charles Saatchi as art patron

I don't buy art to ingratiate myself with artists, or as an entrée to a social circle. Of course, some artists get upset if you sell their work. But it doesn't help them whimpering

Ron Mueck
Mask II, 2001, mixed media,
30 ¾ x 46 ½ x 33 ½ in. (77 x 118 x 85 cm)

about it, and telling anyone who will listen. Sandro Chia, for example, is most famous for being dumped. At last count I read that I had flooded the market with 23 of his paintings. In fact, I only ever owned seven paintings by Chia. One morning I offered three of them back to Angela Westwater, his New York dealer where I had originally bought them, and four back to Bruno Bischofberger, his European dealer where, again, I had bought those. Chia's work was tremendously desirable at the time and all seven went to big-shot collectors or museums by close of day. If Sandro Chia hadn't had a psychological need to be rejected in public, this issue would never have been considered of much interest. If an artist is producing good work, someone selling a group of strong ones does an artist no harm at all, and in fact can stimulate their market.

The rules and advice to consider

There are no rules I know of. Nobody can give you advice after you've been collecting for a while. If you don't enjoy making your own decisions, you're never going to be much of a collector anyway. But that hasn't stopped the growing army of art advisers building "portfolio" collections for their clients.

On the right price to pay

I never think too much about the market. I don't mind paying three or four times the

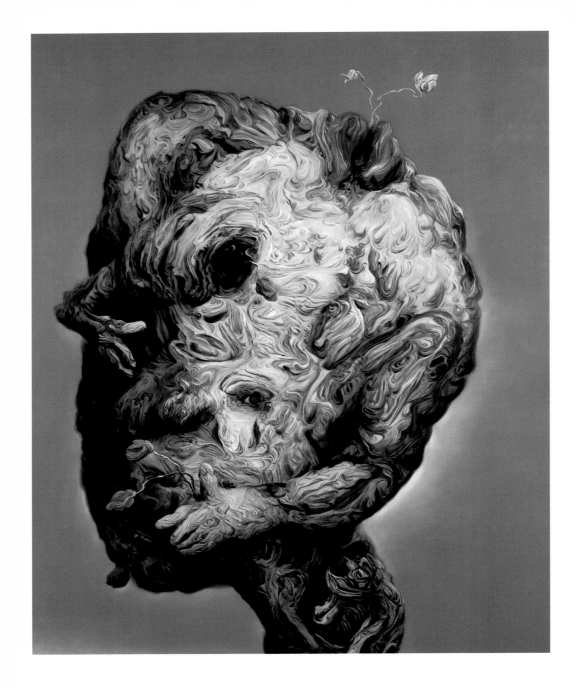

Glenn Brown
The Hinterland, 2006, oil on wood,
58 ¼ x 48 ¼ in. (148 x 122.5 cm)

market value of a work that I really want. Just ask the auction houses. As far as taste is concerned, as I stated earlier, I primarily buy art in order to show it off. So it's important for me that the public respond to it and Contemporary Art in general.

What and when to sell

There is no logic or pattern I can rely on. I don't have a romantic attachment to what could have been. If I had kept all the work I had ever bought, it would feel like Kane sitting in Xanadu surrounded by his loot. It's enough to know that I have owned and shown so many masterpieces of modern times.

> "I don't buy art in order to leave a mark or to be remembered; clutching at immortality is of zero interest to anyone sane."

Buying art that is not "commercial"

Lots of ambitious work by young artists ends up in a dumpster after its warehouse debut. So an unknown artist's big glass vitrine holding a rotting cow's head covered by maggots and swarms of buzzing flies may be pretty unsellable – until the artist becomes a star. Then he can sell anything he touches.

But mostly, the answer is that installation art like Richard Wilson's oil room [purchased by Saatchi in 1990] is only buyable if you've got somewhere to exhibit it. I was always in awe of the Dia Center for the Arts for making so many earthworks and site-specific installations possible. That is the exception: a collector whose significance survives.

In short, sometimes you have to buy art that will have no value to anyone but you, because you like it and believe in it. The collector I have always admired most, Count Panza di Biumo, was commissioning large installations by Carl Andre, Donald Judd and Dan Flavin at a time when nobody but a few other oddballs were interested.

On painting

It's true that Contemporary painting responds to the work of video-makers and photographers. But it's also true that Contemporary painting is influenced by music, writing, MTV, Picasso, Hollywood, newspapers, Old Masters. But, unlike many of the art-world heavy-hitters and deep thinkers, I don't believe painting is middle-class and bourgeois, incapable of saying anything meaningful anymore, too impotent to hold much sway. For me, and for people with good eyes who actually enjoy looking at art, nothing is as uplifting as standing before a great painting, whether it was painted in 1505 or last Tuesday.

Art as investment

There are no rules about investment. Sharks can be good. Artist's dung can be good. Oil on canvas can be good. There's a squad of conservators out there to look after anything an artist decides is art.

Museums versus galleries

I like everything that helps Contemporary Art reach a wider audience. However, some-

times a show is so dismal it puts people off. Many curators, and even the odd Turner Prize jury, produce shows that lack much visual appeal, wearing their oh-so-deep impenetrability like a badge of honour. They undermine all efforts to encourage more people to respond to new art. So although I didn't adore *In-A-Gadda-Da-Vida* [a 2004 show at the Tate Modern featuring Damien Hirst, Sarah Lucas and Angus Fairhurst], it was nice to see something in the Tate that was fresh from the artists' studio. It helped make the Tate more relevant to today's artists. Of course the work had to come direct from the artists' dealers – it was brand new. Anyway, what's wrong with Jay Jopling getting just a little richer?

Art collecting for posterity

I don't buy art in order to leave a mark or to be remembered; clutching at immortality is of zero interest to anyone sane.

The greatest artists of the twentieth century

General art books dated 2105 will be as brutal about editing the late twentieth century as they are about almost all other centuries. Every artist other than Jackson Pollock, Andy Warhol, Donald Judd and Damien Hirst will be a footnote.

> "If you don't enjoy making your own decisions, you're never going to be much of a collector anyway."

On dealers

An occupational hazard of some of my art-collector friends' infatuation with art is their encounter with a certain type of art dealer. Pompous, power-hungry and patronizing, these doyens of good taste would seem to be better suited to manning the door of a nightclub, approving who will be allowed through the velvet ropes. Their behaviour alienates many fledgling collectors from any real involvement with the artist's vision.

These dealers like to feel that they "control" the market. But of course, by definition, once an artist has a vibrant market, it can't be controlled. For example, one prominent New York dealer recently said that he disapproved of the strong auction market, because it allowed collectors to jump the queue of his "waiting list". So instead of celebrating an artist's economic success, they feel castrated by any loss to their power base. And then there are visionary dealers, without whom many great artists of our century would have slipped by unheralded.

Critics

The art critics on some of Britain's newspapers could as easily have been assigned gardening or travel, and been cheerfully employed for life. This is because many newspaper editors don't themselves have much time to study their "Review" section, or have much interest in art. So we now enjoy the spectacle of critics swooning with delight about an artist's work when its respectability has been confirmed by consensus and

Damien Hirst
The Physical Impossibility of Death in the Mind of Someone Living, 1991, glass, steel, silicone, shark, formaldehyde solution, 84 x 252 x 84 in. (213 x 640 x 213 cm)

a top-drawer show – the same artist's work that ten years earlier they ignored or ridiculed. They must live in dread of some mean sod bringing out their old cuttings. However, when a critic knows what she or he is looking at and writes revealingly about it, it's sublime.

On collectors

However suspect their motivation, however social-climbing their agenda, however vacuous their interest in decorating their walls, I am beguiled by the fact that rich folk everywhere now choose to collect Contemporary Art rather than racehorses, vintage cars, jewellery or yachts.

Without them, the art world would be run by the State, in a utopian world of apparatchik-approved, Culture-Ministry-sanctioned art. So if I had to choose between Mr. and Mrs. Goldfarb's choice of art or some bureaucrat who would otherwise be producing VAT forms, I'd take the Goldfarbs.

Anyway, some collectors I've met are just plain delightful, abounding with enough energy and enthusiasm to brighten your day.

Artists

If you study a great work of art, you'll probably find the artist was a kind of genius. And geniuses are different to you and me. So let's have no talk of temperamental, self-absorbed and petulant babies. Being a good artist is the toughest job you could pick, and you have to be a little nuts to take it on. I love them all.

Note: *This interview was first published in* The Art Newspaper.

THE AU HOUSE

Little in an auction house is what it appears to be. Sotheby's, Christie's, and Phillips sound and look glamorous, but the reality is that they are struggling and competing with each other and with all the dealers. Why don't they make more money? Well, it's the glamour factor; all those catalogues and cocktail parties in lavish offices all over the world, as well as the cost of insurance and installation, add up, not to mention the fact that the business has become fiercely competitive. The auction houses obtain many of their prize works for sale by giving the consignors a "guarantee". Often, important or super-hot artworks (valued at over $ 1 million) will be guaranteed by the auction house for the low end of the estimate. This means that when the work is estimated at $ 1 million to $ 1.5 million, the consignor (the seller) has already received a cheque from the auction house of an amount in the vicinity of the low estimate, and probably will receive only a portion of the gain over the guaranteed figure.

What happens if the piece is "bought in", meaning it doesn't reach the guaranteed or "reserve" price? Theoretically, the auction house gets stuck with it, but not really: they've been shopping for months to find a "third party" who will take the piece at the guaranteed price. This third-party guarantor is usually a mega-dealer or mega-collector, who wants to make sure that the de Kooning, the

CTION EXPERT

Amy Cappellazzo (220)
Simon de Pury (226)
Tobias Meyer (232)

Warhol, or the Koons in question sells and doesn't get "bought in". So now you see that auction prices can be deceiving. True collectors do their own homework and understand a work's value before the bidding starts.

Armed with a healthy dose of caution, we are now ready to meet the three heads of Contemporary Art at the auction houses. But not so fast: these people are busy, they are running two sales a year in New York, and possibly another one or two in London. They spend their time scouring the world searching for enough good work to sustain a blockbuster auction. They don't really have much time to go to galleries, and they are primarily focused on the works they are selling. How could it be any other way? Selling that $10 million Mark Rothko to a little old lady in Miami is a lot more important than understanding the work of a newcomer like Barry McGee, and why his folk-art derived graffiti images earned him a major show at the Fondazione Prada.

Now let's ask some questions, and probe the depths of their insiders' knowledge, keeping in mind that this information is not enough, you will always need more.

Amy Cappellazzo

*International Co-Head
of Post-War and Contemporary Art,
Christie's,* New York

Amy Cappellazzo is currently the International Co-Head of Post-War and Contemporary Art for Christie's, where she has worked since 2001. Before holding this post, she was an art adviser in Miami. She also worked as a curator for the renowned Rubell Family Collection & Foundation, and has curated several museum shows and exhibitions.

Separating Contemporary and Post-War art

When I got to Christie's there was a distinctly separate Contemporary department from what was called Post-War. The idea, at the time, in creating two distinct departments was that there was a whole area of cutting-edge, young Contemporary Art that needed to be singled out and developed on its own. There was a really defining moment when Christie's sold the Jeff Koons *Woman in Tub* (1988) for the second time, in May 2001, for over $2.5 million. It had sold for $1.7 million the year before. In a very short period of time, there had been this big run up in the Koons market, and it felt like there was no separate treatment of cutting-edge art. And when Koons made that enormous price it felt like there was this coming together of those two areas and departments. Actually, the real decision was made after 9/11.

On selling works made in the last ten years at auction

It is often said that Contemporary is the only area of the auction house that has a growing inventory. Every season, there's a new artist who has a deep enough market to come to auction and sell well and, maybe eventually, become a night-sale artist and sell at a higher price point.

For example, all the hot Contemporary artists: Takashi Murakami, Damien Hirst, Jeff Koons etc., when they make new work every year, the market absorbs them. I might not see them at auction right away, but I will see them at some point. The nostalgia loop of holding something gets shorter and shorter. So it's not uncommon for me to see something a year or two after it was made.

In taking charge of that new area of the market, you have to really do an extraordinary amount of homework to understand: How deep is the market? Where are things buried? How well are the other works placed? Are they likely to come up to auction, given the

demand on the primary market? Who were all those people standing in line who never got a painting by that artist? Would they be buying at auction, and if so at what price point? Are they true auction buyers or are they the kind of collectors who only buy on primary market because they get things inexpensively offered to them? You have to really study the market forces.

I probably dedicate more time than I should to watching the younger markets; I'm always interested in the younger artists because they're the future of the market. You need them to keep growing and emerging and you have to watch them very closely, and therefore it can be very time-consuming.

I am conscious of the fact that you can burn a whole career on a failed sale. For example, if you put a young artist on a very big stage and they can't keep the stage, you run the risk of tanking the market and burning a career. I'm not sitting here in this ethical position claiming that I have to take care of young artists; it's more a question of burning my own inventory out, too, by running it up too high.

The auction's effect on an artist's career

Jeff Koons was completely born and raised at auction, although his gallery, Sonnabend, does a good job in the primary market of selling his work, but the strength of his market owes everything to auction, truthfully. There are also other examples, like Richard Prince, Cindy Sherman, Takashi Murakami etc.

On Jean-Michel Basquiat's *Profit* selling for $5.5 million

Sure. That's another one. That set the bar for a great Basquiat. What was essentially missing in the Basquiat market was that one price that happened at Christie's – it felt a little unusual for the market because there were still so many run-of-the-mill Basquiats trading for $400 000 or $500 000. That was really an extraordinary reach at the time.

In Richard Prince's own words, I think he at one time said that he owes more to auction houses than he does to museums for the success of his career. That's another great example.

An Andreas Gursky photograph versus a Prince photograph

With the Gursky photos that tend to make the top prices, out of the edition of six, maybe four are in museum collections. Richard's market is a little bit different. There are certain museums that own a lot of his work, like the Whitney Museum of American Art, for example, but Richard was not as heavily and broadly collected by museums right from the get-go. With Gursky, a huge price for a certain image is possible because it is the only example not in a museum, whereas the other five examples are in museum collections.

Buying at auction

People like depth in markets. Basically, auctions bring transparency and democracy to this market. It's an unregulated market so there are still lots of other things that remain undisclosed. In auction, you might not know who is bidding or whether it is a dealer or a private collector, but you can count the number of telephone bidders on it, you can count the number of paddles, and you can assess the depth of the market.

Jean-Michel Basquiat
Profit I, 1982, acrylic and spray paint on canvas,
86 ½ x 157 ½ in. (219.7 x 400 cm)

On whether the market is manipulated by someone with inventory or a vested interest

I have a few stocks that I follow very closely, personally. I'm positive there are people with much more information than I have, so how do I manage to be successful in what I do in the stock market, despite the fact that I'm not getting the best inside information? I pose that same question in other markets that are supposedly regulated and transparent. Some markets, such as art, are thinly traded; a fabulous object in the many millions of dollars may never find twenty bidders. In the end, like a stock, you have to believe in the inherent quality of something.

We sold the Jackson Pollock from the Museum of Modern Art for a stunning price – $11 million and change. That was a fabulously

> " ... Contemporary is the only area of the auction house that has a growing inventory."

strong price. There were actually a number of bidders for a while, but in the end, it was essentially two people, and that's what one can expect. It's usually down to two, even at a lower price point, but certainly, the higher you get, the thinner it gets.

Collectors who do "well" at auction

They are the ones who are focused and disciplined; the ones who are really searching for quality; the ones who can see and feel and smell an artist's importance before the rest of the world does. Someone with a good eye; somebody who is very impulsive and will bid to the end – that's the kind of person who is successful. They buy a lot because they don't always buy with value in mind, but they're certainly good buyers.

On the value of a life-sized taxidermy horse hanging from the ceiling
[Maurizio Cattelan's *The Ballad of Trotsky* (1996)]

It is a very difficult piece. That happened to be an outstanding price ($2 million) and an excellent example of the artist's work. But the thing to consider also is that it's a two-bidder situation, there were really two people fighting for it [reportedly Dakis Joannou and Bernard Arnault]. And that's what auction is all about. It's getting those people in the ring to fight, to spar with one another and really see who the winner is. But it was not a piece for everyone. A different Maurizio piece, maybe one a little bit less difficult to house or a little less challenging in subject matter – there are a few equally strong as the horse – could have done just as well, better maybe, more bidders, perhaps.

There are always advantages and disadvantages to auctions. There is a risk that one takes when they put something up at auction – you hope that it was estimated properly, you hope that the specialist you were working with gave you the right information about the market, and that you were consulted in advance and lowered the reserve, if needed. There are a lot of factors involved, but offering something privately can be just as risky.

Richard Prince
Untitled (Cowboy), 1999, ektacolour photograph,
edition of 3 + 1 AP, image: 61 x 32 ½ in. (154.9 x 82.6 cm)

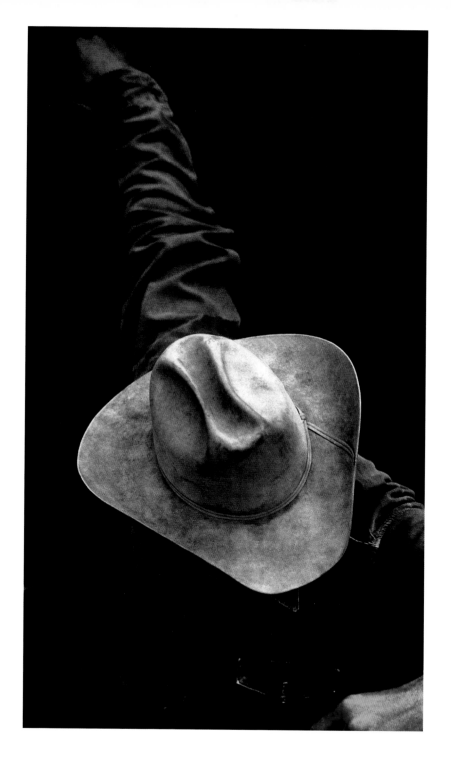

Simon de Pury

Chairman, Phillips de Pury & Company, New York

Born in Basel, Switzerland, Simon de Pury was chairman of Sotheby's Europe and also its star auctioneer. In 2001, with Daniella Luxembourg, he merged de Pury & Luxembourg Art into LVMH's Phillips Auctioneers to create the third major international art auction house. Although both LVMH and then Luxembourg subsequently dropped out, Simon persevered. Based in the heart of Chelsea, New York City's busiest art district, Phillips de Pury continues to sell challenging Contemporary Art for record prices, much to the chagrin of its two entrenched competitors, Sotheby's and Christie's.

Changes in the Contemporary Art market over the last ten years

The market for Contemporary Art has totally changed over the last few years. The Contemporary Art market used to consist only of American and Western European artists until recently, and it's only now that it has become a totally global market. You now have artists from every continent, from every part of the world, who have a market. You have biennials in Havana, São Paulo, Shanghai, Seville, and of course Venice and Istanbul, so you have a lot of surveys that show you what is being done around the world, and the audience for Contemporary Art has widened in an extraordinary way.

The primary market has a key importance in creating the market for the artists because it determines, for instance, how wide the geographic spread will be and in which collections the works will go. You have certain artists who are so sought after that it's not a question of money to be able to get those works; it's a question of being in the good books of the dealer who's handling them. There are long waiting lists that develop for certain artists, and certain buyers who cannot, irrespective of money, have access to works by those artists. Whereas the minute a work by one of these artists comes up at auction, it's simply whoever will pay the highest price will get it.

It's fascinating to see how rapidly taste evolves. Taste evolves all the time, in all areas of the art market, but there is an acceleration in the change of tastes, particularly in the Contemporary Art market. You look at artists who have been active for many, many years, like Richard Prince, his market has multiplied several times just over the last two years. I think this

Richard Prince
A Nurse Involved, 2002, ink jet print and acrylic
on canvas, 72 x 45 in. (182.9 x 114.3 cm)

Luc Tuymans
Within, 2001, oil on canvas,
87 ¾ x 95 ⅝ in. (222.9 x 242.9 cm)

is just the beginning, his market will strengthen further due to the great quality of his most recent work, because very often, if the recent work of an artist is weak, it does damage to the market of his earlier work, even if his early work was much stronger. We obtained the highest price for any of his photographs with the "Cowboy", and also the highest price for any of his "Joke" paintings with *My Name* (1987), which sold for $750 000.

On selling Contemporary works at auction

At Phillips, over the last few years, we have introduced into our evening sales one, two, or three artists who have not been tried yet at auction, but where there are long waiting lists. Such artists as Ugo Rondinone, Neo Rauch, Daniel Richter, Noble and Webster, Luc Tuymans or Jack Pierson, I could go on and on providing artists for whom we have been, in a way, the pioneers in selling them at auction. What has normally happened is that

those works have sold far in excess of what they were available for in the galleries. Now this can be a mixed blessing. If that increase is too steep and too quick, it can backfire as well. A market has to be sustained in the long term and something that may rapidly obtain very high prices, unless you can sustain it, is not necessarily a good thing. We try never to have too many works by the same artist in the auction. We try not to have works that compete with each other in the same auction. We try to put these auctions together like curating an exhibition – really putting together exciting shows of what has been done in the art field over the last twenty to twenty-five years.

I believe that as an auction company, we do have a responsibility to the marketplace, to the market and to the artist, and so it is in our interest not to flood the market with works by a certain artist, to act responsibly, and to have as good a relationship as possible with the artist and with the dealers representing these artists, because the relationship between the gallery and the auction house does not need to be antagonistic. On the contrary, as I said earlier, both need each other. When you have a healthy auction market for an artist, it helps the primary market for that same artist, and vice versa.

"That's the true adventure, to then choose and follow your own instinct of what is good."

Contemporary Art and risk

In a way, younger *is* riskier, yes. Let's say you buy ten paintings by ten different artists for $10 000 each. Now, the likelihood that all of those will be worth much more is not that great. You may have one that is going to be worth $100 000 in the foreseeable future, but the others may not be worth more than $10 000. In fact, they may be worth only $5000 or zero, if you resell them. Whereas, if you buy a blue chip or something of a mid-career artist at $100 000, it's much easier because you can already look back at the career of the artist, you have a way of gauging how much he paints, in which collections his work has gone, does he have international or a local audience, etc. In the end, it is cheaper to spend $100 000 for a mid-career artist than to spend $10 000 on an artist who is just starting. On the other hand, that is the most exciting part of the market – when you don't know how an artist is going to develop, what he's going to do, what is going to happen to him. You don't have any points of comparison. That's the true adventure, to then choose and follow your own instinct for what is good.

On buying at auction and primary

As a private collector, you always want to have a point of reference when you are offered something at a given price. You want a) to have a feeling whether that price is justified or whether it's just taken out of the air, and b) to know that you have an outlet to be able to sell it. I mean, it's legitimate, if you spend a lot of money on something that you may wish to resell it at some stage. It is very important to know that there is, besides the possibility of giving it back to the dealer who has sold it to you, a possibility of putting it onto the public marketplace. In most cases, dealers, when they sell something, justify

the prices of what they sell by comparing it to the prices obtained by that given artist on the open marketplace. And while, ten years ago, market prices were really something only accessible to the professional in the market, now anybody can just click into *Artnet* and see what prices have been obtained for any artist at auction. So that information is available to everybody. There's a much greater transparency in the market and, ultimately, everybody benefits from that greater transparency.

The collectors who buy with passion, with guts, with their hearts, and don't think primarily of the investment, are those who make the best investment. Whereas those people who think primarily of the investment when they buy, in most cases, fall flat on their nose. To buy particularly well at auction, you must follow, very, very closely. Don't listen to the buzz. Because sometimes people say, before an auction, that a certain work will go through the roof, and that may discourage a lot of people from bidding in the first place. The key is to follow it closely – if you can't be there in person, be at the end of a phone line and really get the feel of the temperature and get your own feel of how things are doing.

On auction-house estimates

There is a rule that a conservative estimate is much more likely to get high prices than a stiff estimate. Let's say you have seven potential bidders for a lot. If the estimate is too high, out of the seven maybe five won't even get into bidding. Whereas if you have a conservative estimate, all seven will start bidding and that creates the excitement in the room, and then the competition, and then you are more likely to get a high price.

When you put together an auction, it's like putting on a play. You must have changes of rhythm, you must have your high moments, you must have less exciting moments, and you must orchestrate it so that each work is sold in the context where it will sell the best. So you do not do it in a chronological way, you do not put the most important lot at the end, on the contrary, you're more likely to put it in the first third of the auction. You can't have two *very* important works following each other, one after the other, because if you have just had a very strong price for something, people are not yet focusing when the next lot is being sold. Then, of course, the auctioneer is very, very important. I think you could sell the same work through four different auctioneers four times, and you would probably get four different prices. Auctioneers are like artists. They may have their good days, but they also have their bad days.

> "Auctioneers are like artists. They may have their good days, but they also have their bad days."

Advising for a collection

It is as part of the advisory work at Phillips that we have been involved in building collections. We buy a lot on behalf of clients at galleries, but also from our competitors, so we buy from other auction houses. The Pisces Collection was a collector who approached me in the late Nineties, who wanted to build a collection of art focusing on the last twenty years.

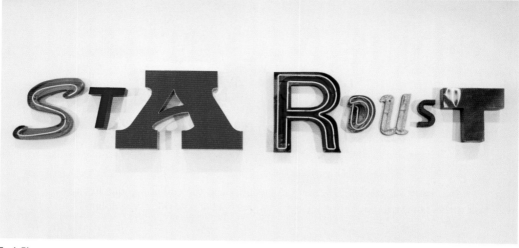

Jack Pierson
Stardust, 1995, found metal and plastic objects,
30¾ x 192 in. (78 x 487.7 cm)

It is somebody who had never collected any art, who had the means to collect, and who liked the intellectual challenge of seeing how a collection could be developed. This person is very private, and did not want us to mention sex, age, nationality, nothing except the sign of the zodiac, so this person is a Pisces and hence the name. We bought very actively for several years and then the owner of the Pisces Collection wanted to see whether there was the reality of the market behind it. So between November 2003 and November 2004 we sold a number of works from the Pisces Collection. I think we have sold around thirty to forty percent of the works.

What makes a great collector

Collecting is a disease. It's the most wonderful disease and a totally incurable disease, and it has as many forms as there are collectors. The best collectors I have encountered in my life are the most passionate, and that passion takes over every other aspect of their lives. There are three or four collectors around, living today, who are utterly obsessed and they are, at the same time, the greatest collectors.

> "Collecting is a disease. It's the most wonderful disease and a totally incurable disease ..."

Most collectors of Contemporary Art who have made good collections have a very good sense for artists of their own generation, and then they have not shown that same sense for artists of the next generation, or even for the one after that. But I have also seen some exceptions.

Tobias Meyer

Deputy Chairman, Sotheby's Europe
Worldwide Head of Contemporary Art, New York

Viennese-born Tobias Meyer has been Sotheby's stylish Worldwide Head of Contemporary Art since 1997. In addition to running the powerful auction house's Contemporary business in a manner that spans from humorous to formal and remote, he also plays the role of principal auctioneer for sales of Contemporary and Impressionist Art. He has overseen several record prices, including the blockbuster $17.4 million for Mark Rothko's *No. 6* **and the staggering $104.2 million for Pablo Picasso's** *Garçon à la pipe.*

Changes in the art market

We are seeing an accelerating trend today in the need to buy the art of our time. Contemporary Art is being bought by a group of people who are basically my age (41) and younger. Increasingly, those who have made money in the financial markets want to buy young art, and they also want to buy status art. They want to buy Warhol, Jean-Michel Basquiat, Andreas Gursky and Willem de Kooning.

It also seems to me that these new buyers love the auction process. They love the idea of buying at auction because they think that *that* is the real market and there is no hidden agenda. So, they know what they buy, they know how much they wish to spend, and they know how much the auction house gets. It's a very clear and transparent transaction for them. They are very comfortable because they made their money in financial markets and they understand demand, supply and competitive bidding.

There's a new informality about our life. People buy young art – it is all much less formal, but it is *informed*. These people want to be part of a community of informed people and the last thing they want to do is buy the wrong picture. People thrive on information. This community has access to a lot of information, including websites such as *Artnet*, as well as the catalogues from all the sales, and they inform themselves before they buy. Twenty years ago you could sell somebody a second-rate painting, perhaps a lesser Monet or even an inferior Morris Louis, but it was good enough for them. They didn't know any better and they just wanted to buy some art. Now they don't buy second-rate art because they have access to information; they can talk to people, and they are a smart group of people. Just as they were smart enough to buy the right stock,

Matthew Barney
Cremaster 3, 2002, production still

Mike Kelley
Ethernal Circle
(from: *Plato's Cave, Rothko's Chapel,*
Lincoln's Profile), 1985, acrylic on paper,
75 x 63¼ in. (191 x 160.5 cm)

or they were smart enough to buy the right company, or they were smart enough to invest in the right currency, they want to be smart enough to buy the right object. For us, it is a challenge to supply the right property to this very informed market.

Selling Contemporary at auction

The funny thing is that I have that reputation for selling blue chip. In fact, my first sale at Sotheby's in 1997 was for the Boston Children's Hospital, and I put all the young material in the beginning of the sale. Just prior to the sale, I was actually told by my CEO at the time that she didn't know why I had done this and that it would not sell. It ended up making world-record prices. So actually I started off with the young market.

In response to this success, Christie's divided their sales into Post-War and Contemporary. I did not. I kept the Rothkos and the works by younger artists together. Then Christie's went back to my formula. So I have the reputation because of these high-level sales. I can sell a Warhol for $17 million. I just decided that these two markets are inseparable. I believe that you have a great sense of cross-fertilization. If you separate the post-1980s works into a separate auction, you shoot yourself in the foot because the young buyer – who will buy a Gursky for $50 000 and then ultimately, it will be worth $600 000 – is also looking at a Warhol *Soup Can*. The high-end market can be as young and energetic as the young market. The money that is being made in the financial community is so strong that a million dollars is just the beginning. So, I want them to look at not only a late de Kooning, a Basquiat, a Gursky, but a Martin Kippenberger, a Robert Gober and a Jeff Koons as well. When I started selling Koons in 1997, he was considered young. Now he is iconic. He is a grand master of the twentieth century. You know, the *Balloon Dog* gets compared to Bernini.

The value of *Balloon Dog*

Eight million dollars, nine million, ten million.

I think Koons is a total genius, and there are fewer works by Koons on the market than you might think. If you wait to buy another one you may suddenly realize that you cannot. The demand suddenly rises and it flips. Things can become very expensive very quickly, that is, if the art is good enough and interest is maintained. An artist such as Koons has the substance and discipline to continuously produce interesting works, resulting in a very strong market.

> "I think that to expect a return from it, like you expect from a stock or from a bank, is the wrong attitude."

Art as an asset

Art has proven to be a fantastic investment. Of course, even when I buy art, I buy with the idea that if I have to sell it, I will get my money out, or I will make some money. Clearly, if you spend a million dollars on something, you want to know that you're not going to lose a million dollars. I think that to expect a return from it, like you expect from a stock or from a bank, is the wrong attitude. A work of art should primarily excite you visually and excite you spiritually. Yes, it

should be a good investment. As we said, more and more people want to buy good art. More and more people want to participate in this market and there are fewer and fewer works of great quality available. So, if you buy well, you have a pretty safe bet for a good investment.

The motivations for buyers are so different. If you really want something, all I can tell you is to buy it and don't be discouraged by other bidders. We do have clients like that and they have always been happy. However, most collectors do have a ceiling and not everyone has unlimited funds. Very often I ear, "I should have bought it, I regret that I didn't buy it." So the happiest buyers are the ones who ended up buying the piece.

The auction process

At auction, ten bidders on one work by an artist is a very solid market. Sellers who do the best at auction are those who trust the process. They allow us to price the art the way we think it should be priced. Providing an attractive estimate and marketing the work well is a successful formula. The people who do poorly at auction are those who try to interfere with the process, asking for high guarantees and demanding higher estimates than the work is worth.

> "Just as they were smart enough to buy the right stock, or they were smart enough to buy the right company, or they were smart enough to invest in the right currency, they want to be smart enough to buy the right object."

On obtaining a "guarantee" from the auction house

Very often, the process of winning consignments is very competitive, and clients often initiate the discussion of guarantees. Therefore, you have two houses wanting the property for their business, and they will push the guarantee as high as they can without losing money. A guarantee is something for somebody who, ultimately, doesn't really believe in the auction process for his or her work of art.

On a painting bought for $65 000 selling for $624 000 two years later

Yes. Well, the problem there is access. The original buyer was privileged enough to be able to buy that painting at a time when the artist was already interesting, but little known. It is very hard to enter a market early, because you must be very informed and you must have access to the primary dealers who control the material, because these returns don't happen all the time. So, the piece sells for $600 000 plus premium, and that's the function of the market – that's an amount of money that somebody will pay for a great John Currin, for a great Murakami, for a Matthew Barney, for things that have proven to be very good art.

The hottest Contemporary artists today

Cattelan, Koons, Hirst, Barney, Currin, Murakami, Peyton, Wool, Prince, that's a group. What is interesting about these artists is that they are like athletes. How long can they run? How much discipline and stamina do they have to continue producing good art? That's the challenge for all of these guys. I don't know where the markets for these artists will be in ten years. I know that all markets are cyclical. I also know that there will always be new stars as well. The cruel prediction is that some of these artists will continue to make great art and continue to be collected, and some will fade out and decide to do something else with their lives, or make bad art. Then a new crop of artists will come up underneath them.

Impact of auction on an artist's career

Gursky, in a way, is the ultimate auction success story, because, first of all, Gursky's imagery is an agitated imagery. I think the good Gurskys – the *Tokyo Stock Exchange* (1990) or *May Day IV* (2000) – have some kind of energy underneath them. There is a movement. Also when you walk out of a Gursky exhibition, suddenly everything looks like Gursky to you. He has that kind of vision that you suddenly take on and then compare his vision to your own.

Then, what also works with Gursky, because it's always one of six editions or multiples, you can actually buy one identical to the one that's in MoMA, or the one that was just in this important exhibition. So you have curatorial approval for the same image, not a similar one. It's not possible that the one that you are going to buy is going to be worse than the one that's in the exhibition. I think multiples help the desirability. It is a very smart marketing tool for that work of art.

I remember when I started to look at Gursky, they were $40 000, but when those prices exploded at auction [$600 000 in 2001], you couldn't get them. They spoke the language of that time as well, and they spoke the language that these collectors liked. That is when his career really took off. He was in everybody's mind and on everybody's tongue. The material was also a little bit available, so that agitated the market, but it only really works if the artist continues to provide great works of art.

THE MUS
PROFESS
DIRECTO
AND CU

Do we really need to talk to these people? Aren't they rather didactic and boring? Can they really be in touch with the art market, and are their opinions relevant? Truth is, some of the shows organized by these museum directors and curators will change the course of an artist's career, and museum activity will ultimately stimulate the artist's market. They are also a great resource for insight and discussion about art and artists.

There is no doubt that the Paul McCarthy retrospective organized by Lisa Phillips and Dan Cameron a few years ago at the New Museum helped confirm that this seminal but long under-appreciated artist was finally going to develop a real commercial market. I remember the moment when I walked into the Cartier Foundation's Murakami show in Paris, I could feel the energy that

EUM IONAL: RS RATORS

would propel his prices into the seven-figure range. Recently, Matthew Barney's *The Cremaster Cycle* at the Guggenheim cemented his position as *the* American artist of the Nineties.

Museum shows, even major ones, guarantee nothing, but they can often serve as a launch pad for an artist's commercial success, or as confirmation of an artist's place in recent history. As you become a true collector, and not just someone who buys art, reading the tea-leaves of the museum shows and the curators' comments becomes absolutely essential, even if somewhat frustrating. Just like everyone else in the art world, they think they know better, and keep in mind that their natural bias will be against work that they view as "commercial" or "dealer-hyped". Don't rely on them for pricing or market-timing hints; generally, they are comfortable talking about the art, not the art market.

Lisa Dennison

Director, Solomon R. Guggenheim Museum, New York

Lisa Dennison is Director and Chief Curator of the Solomon R. Guggenheim Museum in New York City. She serves as chief curator of all the Guggenheim's branches in the United States and abroad – Las Vegas, Bilbao, Venice and Berlin. She is responsible for the museum's collections, its exhibition programme and development. In addition to organising exhibitions, Lisa Dennison has played a key role in building the museum's permanent collections in New York and Bilbao.

Presenting and collecting Contemporary Art at the Guggenheim

The Guggenheim is a young institution. It began specifically with the vision of Solomon Guggenheim, who was a wealthy Jewish philanthropist at the turn of the century, and came late into the game of collecting art.

Solomon Guggenheim recognized that he was building a mediocre collection that had no real focus: some tapestries, some Audubon prints, some nineteenth-century stuff. His wife, Irene Rothschild, commissioned Hilla Rebay von Ehrenwiesen, a young German baroness, to paint his portrait. Then in 1927, when Rebay got her hooks into him, she said, "Let's collect the art of our time, and that will be an important collection." It was to be a Contemporary collection, and it was a brave move at the time. Rebay, the first director, had a very specific aesthetic goal, which was to collect "non-objective" art. She convinced him, a) to collect Contemporary Art, b) to collect art that was non-objective, that was made through the necessity of the inner spirit rather than based on the external world. Eventually, the collection outgrew the walls of his apartment, and they said, "We need a museum." The idea for incorporating the collection and making it into a foundation was born in 1937.

All great museums are really nothing more than collections of collections. What museums do, ultimately, is absorb private collections that are fully formed into their holdings, and that's what gives them their identity. So the Guggenheim Museum is really a collection of collections, from Solomon Guggenheim's to Peggy Guggenheim's to Justin Thannhauser's, to the recent acquisition of the Panza di Biumo collection, etc.

I think a great collector buys not with his or her dealers, which some of the collectors do today, but is intuitively committed to the art no matter what the fashion of the time is,

Matthew Barney
Cremaster 4, 1994, production still

Francesco Clemente
Scissors and Butterflies, 1999, oil on linen,
82 x 82 in. (208.4 x 208.4 cm)

has an enduring commitment to the art, doesn't sell the art, doesn't horde the art for investment purposes, believes in the art, lives with the art, lends the art, supports the artists, supports institutions, has it all in balance.

A curator building a collection has to make choices. The Guggenheim merit has always been to select a few artists and collect in depth. As a museum curator I think that is the obligation – to believe in several artists and confirm your belief or demonstrate your belief by buying and showing their work.

Monographic exhibitions and the market

We did Robert Rauschenberg, Claes Oldenburg, two Roy Lichtenstein retrospectives; we've done Warhol (so has MoMA), and we've done James Rosenquist. We've distinguished ourselves most in terms of the one-person exhibitions of Pop Art. In the Seventies, we did mid-career shows, like the Whitney did in the Eighties, including Carl

Andre, Robert Ryman, Brice Marden, Donald Judd, Dan Flavin – all of the Minimalist artists, before they were as known as they are today.

On mid-career surveys hurting the market of an artist

You're taking a big risk. As an artist, you put your work out there for everybody to see and you're under tremendous pressure. First of all, if a critic comes in and says, "Oh, this is not a good artist, his work looks terrible," or, "The artist didn't deserve to be seen retrospectively," then people panic. It's like selling stocks on bad news. That can hurt your market, but it can also help an artist's market, with all the speculation before a show. Often there's a rush to buy, believing that the show may increase the artist's value, and then afterwards, it sort of dies. You say, "Okay, there's going to be no momentum for another fifteen years because now the artist is not going to have a show at another major museum." It is also sometimes very hard, after you've had a retrospective and laid out your work for the world to see, to move it to the next level. That is *pressure*.

When you see a Roy Lichtenstein retrospective and you see forty, fifty years of his work, you say, "Okay, so maybe this period was great, that period wasn't great, this period was really great, this period wasn't so good." It all balances out within the course of that career. It's natural for an artist to have peaks and valleys, and it puts a lot of pressure on the artist in his or her next commercial gallery show to come up with something really great. The museum show doesn't guarantee the artist, it can hurt the artist, particularly the younger ones, as much as help them, in terms of career and market.

On putting together an exhibition and selecting "great" works

Professionals bring a different set of criteria when putting together an exhibition because we don't have to worry about the market. Let's say I'm putting together a Francesco Clemente show and MoMA has a painting (which they do). Now let's say hypothetically that MoMA's painting might not be the best Clemente from a particular series. However, if you don't put a MoMA painting in the show, is that bad for the artist, because you want your lenders to be important institutions? There is an effort, when

"There aren't that many great artists in the world, in the end, when you look in the history books."

you're an artist in that situation, or even a curator, to try and validate your choices by showing that Francesco Clemente is an artist who is in the collection of the Museum of Modern Art in New York and the San Francisco Museum of Modern Art, and so on.

What do you do, when you're a curator, if it's really not the best painting? Those are the kinds of choices museum curators have to confront. You want to build a case for the artist, but on the other hand, you really want the show to be powerful, and you want to have only the best paintings selected with the proper criteria. You get pressure from the artist's dealer, you get pressure from the artist and, certainly, when you're putting together a show, you get a hundred phone calls from someone saying, "I'm Mr. X and I have a Clemente and I know you're doing a Clemente exhibition, do you want to borrow it?"

The greatest artists of our time

If you think about the thousands of artists in the world, there are the ones who have risen to the surface and resonate, for whom there's universal consensus that this is a great artist, like Picasso. But there are not many of those. I think, in this fast-paced world, every once in a while a genius like that can emerge, who can just overcome the boundaries of this age of rapid information. There aren't that many great artists in the world, in the end, when you look in the history books. It's such a finite group.

When David Sylvester was alive, I used to have dinner with him from time to time, and all he wanted to do was play the game: Who are the

> "The museum show doesn't guarantee the artist; it can hurt the artist, particularly the younger ones, as much as help them, in terms of career and market."

top ten greatest artists of our time, or of the nineteenth century, or of the twentieth century? And he would just sit at dinner and go, "Manet – is Manet one? Well, why is Manet one, why isn't Manet one?"

The top artists of the 1990s

I don't know. We don't have enough historical distance yet. First of all, there are boundary problems. Is Matthew Barney an artist of the Eighties or of the Nineties? It's not even clear. I don't think Matthew Barney is the only artist of the Eighties and Nineties, and I'm delighted that we've made as much of a commitment to him as we have, and I wouldn't want to stop that commitment. On the other hand, I wouldn't want to say, to the exclusion of everybody else, we're only going to invest in Matthew Barney. Looking back at the Nineties, you have Takashi Murakami and Damien Hirst, you see they're certainly going to withstand the test of time. They may not be the equivalent of Picasso, but they're going to be there. The only way I would collect Murakami or Damien now is to get a really great work. I don't want something insignificant. I want something really important, something defining.

You can collect in one of two ways: You can decide you're really going to collect an artist in depth, and there you might get some drawings, you might get some sculpture, you might get a print, you might get a video, you might get a painting, whatever. You put together a basket of great things that represent the artist. Or you can say, "We don't have a lot of money for Contemporary acquisitions, so I'm going to buy, for example, a Mike Kelley, but it has to be a great Mike Kelley." It has to be a Mike Kelley that stands for Mike Kelley, one that can stand alone in the collection as an ambitious installation.

Robert Gober
Untitled, 1989–1990, wax, cotton, wood, leather, human hair,
11⅜ x 7¾ x 20 in. (28.9 x 19.7 x 50.8 cm)

Tom Eccles

Former Director, Public Art Fund
Now Executive Director, Center for Curatorial Studies,
Bard College, Annandale-on-Hudson, New York

Tom Eccles took over the Public Art Fund in 1997 and successfully brought the provocative world of Contemporary sculpture to the outdoor spaces of New York City. A sharp-witted Scotsman, Tom succeeded in the daunting tasks of exhibiting both Jeff Koons' *Puppy* **and Takashi Murakami's** *Mr. Pointy* **at Rockefeller Center. Having curated eighty major exhibitions throughout the city, he recently left The Public Art Fund to head up Bard College's programme at the Center for Curatorial Studies.**

What is the Public Art Fund?

The Public Art Fund's exhibitions are is absolutely contrary to the kind of thing one normally expects of public art. I think it's clear that I don't really like public art and I don't really like so-called "public artists". I feel some passion about the works that we create, or the works we show, or how we show them, it's not purely a matter of commissioning.

Your aim is to be Contemporary

Absolutely, almost all Contemporary. Or at least the exhibition must have some currency that suggests a new way of thinking. When Robert Storr was curating the Tony Smith retrospective at the Museum of Modern Art, he asked me to join him to expand the exhibition outdoors. I liked that project because it really challenged one of the paradigms of what you shouldn't do in public space, which was to take large, abstract sculpture and plop it down in front of large, Modernist buildings – you know, the absolute antithesis of good practice. The Tony Smith show was enormously successful because what it said was: if you actually show first-rate sculpture of that period that has a real dynamic with the built environment and the architectural environment, then it can be as exhilarating as, say, skating on an assume vivid astro focus (Eli Sudbrack) floor. It's not necessarily the *type* of work, it's the *quality* of the work. That's why, in the context of collecting, I think it's perfectly feasible for someone to own a Tony Smith work and to own a piece by assume vivid astro focus. Diversity is a good thing, after all. What we're trying to do is to allow people to get an exposure to the gamut of Contemporary Art in a way that's interesting to look at and think about.

As to cutting edge, I think that's found when you challenge people's expectations. You

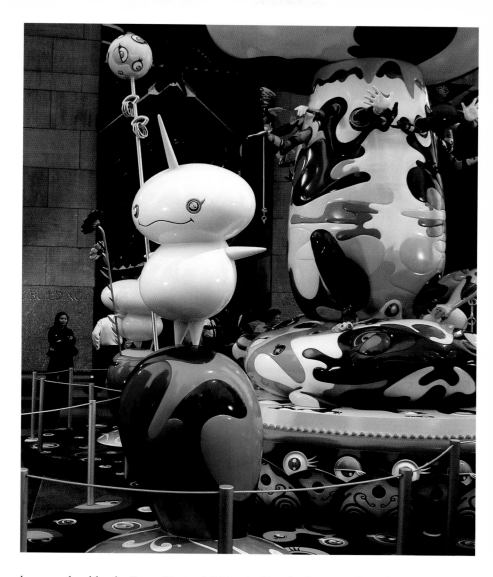

know, rather like the Franz West exhibition in Lincoln Center – when they came to us to do a show there, my first reaction was: the *last* thing you want is a lot of sculpture at Lincoln Center. But it's always been a passion of mine to work with Franz West. The context of Lincoln Center provided exactly the backdrop where you might just get away with a Franz West show in a public space. Also you could show a number of works so that people could actually see a whole body of work, rather than a single work on a platform. His work is really very critical of sculpture itself, although it sits on the very platform that one expects of traditional sculpture.

Takashi Murakami
Reversed Double Helix, 2003, at Rockefeller Center, organized by Public Art Fund and Tishman Speyer Properties. Presented by Target Stores

On selling works that are exhibited

We go to the artists and commission the work, or show the work, just like any museum. The Public Art Fund is a private, not-for-profit organization, and we raise money to show these works. I can't help it if the artist is represented by a dealer in New York. We've set a fairly strict policy that none of our decisions are made on the basis that a dealer is willing to fabricate the work. I certainly feel completely scrupulous in those decision-making processes. In fact, the financial commitments of the Public Art Fund, and the way projects are supported, are more or less transparent – *unlike* the museums. My primary relationship, as a curator and director of an organization, is not with dealers, but with artists. Though it is certainly true that galleries provide the gateway to artists, and that can also be a positive thing.

How exhibitions affect the art market

Well, I think I do affect an artist's market, but if our exhibition does not affect the artist's market, it doesn't bother me, and it certainly doesn't bother our organization. When you reach a certain level in terms of the kind of attention that your organization is getting and the kind of artists you're working with, and the synergy of the two, your imprimatur or the kind of project you do *does* lead to a certain kind of attention that the artist gets. I mean, nowhere was it clearer than when we showed Jeff Koons' *Puppy* (1992/2000) at Rockefeller Center, and then weeks later, Jeff's auction market went through the roof. The visibility that an artist is given at that moment is important to what ultimately happens in the marketplace.

We're slightly unique in the museum, or not-for-profit world, in that our board is not primarily made up of collectors. We don't have a collectors circle, or a young collectors group. Also, the kinds of works that we commission are rather hard to collect. So there's a unique group of people who have both the financial commitment to the art, but also are helpful in gaining access to the public and private property on which to show these kinds of works.

His five top exhibitions

Highest impact would probably be Koons, Murakami, Rachel Whiteread, Tony Oursler. I also think Ilya Kabakov's *Palace of Projects* made a very large impact at the time. People look at these extremely high-profile projects and don't realize that almost half the projects of the Public Art Fund are with emerging and relatively unknown artists. We were working with Paul Pfeiffer on a project at the World Trade Center, which ultimately happened, just before 9/11, before anybody really knew who Paul Pfeiffer was. We were working with Eli Sudbrack before this burst of interest at the Whitney Biennial. We have a programme for putting emerging artists before the public, where we commission three major projects a year, and they have a huge impact on the artist's career. We put as much energy into those commissions as we do into these major projects at Rockefeller Center and elsewhere.

I think there has to be some intellectual honesty in the art business, in curating, and certainly in the world that I'm in, which is commissioning

Jeff Koons
Puppy, 1992, stainless steel, soil, geotextile fabric, internal irrigation system and live flowering plants, 486 x 486 x 256 in. (12 x 12 x 6.50 m), organized by Rockefeller Center in association with Public Art Fund, 2000

artists. You have to have a level of commitment to those artists. That's why, with most of the artists we work with, on some level I remain in discussions, in dialogues, to this day – so, maybe in ten years' time, I would work with them again, in a very different kind of capacity.

On recent changes in the Contemporary Art world

I think there's been an accelerated awareness of the concept of an art market, per se. I'm not a collector, I am not part of that kind of collecting world, but there's an intensity to the collecting world and an immediacy that has rarely been seen before. The pinnacle of that was the Whitney Biennial 2004, where you had a lot of young artists, and what was being sold in Chelsea mirrored what was happening at the Whitney Biennial itself. I don't know if I have ever seen that. It's almost as if what's in the museum is also available very quickly on the market, at a very high price.

There are certain dealers who are, I think, clever, and have said they're not going to inflate young artists' prices early on. So, certain collectors get certain works by certain artists at the right level. There are other collectors who feel they've been, quite frankly, taken for a ride. I don't think that's particularly good for the artists themselves. There were a number of young artists who were in the Whitney Biennial,

assume vivid astro focus
avaf 8 (detail of *Phoenix* at the Skate Circle), 2004, part of *Public Art Fund Projects in Central Park – A collaboration with the Whitney Biennial*, New York

Franz West
Dorit, 2002, lacquered aluminium, 236 x 59 x 59 in. (6 x 1.50 x 1.50 m), part of *Franz West: Recent Sculptures*, organized by Public Art Fund at Lincoln Center and Doris C. Freedman Plaza, New York

whose works were priced in six-digit amounts, and that's a dangerous kind of precedent. It's dangerous for the artist, it's extremely dangerous for the collector, and it's not very good for the art market itself, because the lie is told a couple of years down the road. I also think it was probably quite difficult for the Whitney to acquire the work of these younger artists as well, because the prices were somewhat out of their reach.

On today's prices

My opinion is that one million dollars is quite a lot of money, and it is probably too much to spend on anything other than your house. Obviously, to some people it's not a lot of money. When people collect work, they should feel passionate about it. It might be naïve to think that you should have some kind of direct response to what it is that you own in terms of art, and have almost a transcendental kind of relationship to it. That's obviously not what's happening in the Contemporary Art world. In fact, works have been flipped at a rather expedited rate.

I think the amount of money there is in the art world right now and the expectations that are in the art world *do* bring people in. Obviously, being a donor and being a collector in New York go hand-in-hand. Being a donor also allows one much closer access into the art world itself. It provides insider knowledge. It provides foresight in terms of what kind of shows are coming up. On the other hand, the world of collecting is somewhat removed from my purview, because the organization is not actively collecting work, and isn't reliant upon collectors in terms of getting gifts of work. We're somewhat liberated from a system that has become quite overheated.

> "It's almost as if what's in the museum is also available very quickly on the market, at a very high price."

There's also a great demand for artists to make work now, so I think a number of strong artists can actually be weakened by this, because they're forced to make work after work after work. Artists have to perform at a faster rate and they become art stars quickly, at young ages. I've talked to a number of extremely famous, extremely high-profile young artists, one in particular, who said he didn't know whether he had another good idea. It's also true that artists move up very quickly, and then get on this international treadmill, where they're doing so many international shows in such a short period. You know, a successful artist can probably do an almost unlimited number of shows a year, which can be a terrible burden in some ways. There are benefits to the more factory-based approach to making art, where artists have very large studios with huge numbers of assistants. So you now have essentially a whole slew of artists who work via a kind of productive model that comes out of Andy Warhol, not necessarily because they are conceptually driven by that model, but because that model can feed the market.

Rachel Whiteread
Water Tower, 1998, translucent cast resin, height 12 feet 2 in. x Ø 9 feet (396 x 275 cm), installed at West Broadway and Grand Street, New York, organized by Public Art Fund

Alanna Heiss

*Founder and Director, P. S. 1 Contemporary Art
Center, a MoMA Affiliate,* New York

**Alanna Heiss was born in Louisville, Kentucky, and moved to New York City in the late
Sixties. By the Seventies, she had transformed, first, the Clocktower (near City Hall) and
eventually P. S. 1 in Long Island City, Queens, into significant alternative art spaces, with the
belief that traditional museums were not providing adequate exhibition opportunities for
site-specific art. P. S. 1 is the largest centre for Contemporary Art in the United States, and it
continues to show innovative and experimental art within its vast spaces, and on a shoe-
string budget. In 1999, the museum was partially underwritten by the Museum of Modern Art
and is now referred to as P. S. 1, a MoMA affiliate. It functions as an exhibition space and
maintains no permanent collection.**

An affair with art and artists

The Clocktower [Heiss' first art space in Tribeca] was a little bit like collecting; I'd spent
a lot of time with collectors and had a sense of how they were able to look at art in the
privacy of their own homes. The Clocktower was a search for a tower in the sky that had
no relationship to earth and, in the Clocktower, my original dream was to have one work
of art or a couple of works of art. This way people could come and be in the Clocktower,
usually alone, and be with art in the same way that a collector could be with art, home
alone, at night.

In the Seventies and the early Eighties, the Clocktower was a kind of symbol of idealism
and purity, because we were not a gallery; we didn't have a stable of artists. We would
only show an artist one time.

When you're a museum or an art centre you have an intense relationship with an artist,
but you don't have a *continuing* relationship with an artist, which is one reason why
friends of mine who are dealers have chosen to be dealers – because they want continu-
ing, developing relationships with producing artists. As a museum, you're almost forced
by the necessity of public funding *not* to have such a relationship. You wouldn't be
involved in their promotional activities, you wouldn't be involved with their dealers, and
you certainly wouldn't do more than one show every five years. So I would compare it to
a series of brief, intense affairs, as opposed to a stable marriage. The relationship with
the artist, whether you're a museum curator or a critic, a collector or a gallerist, is some-

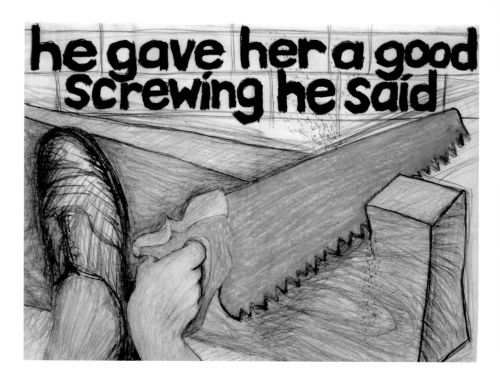

thing that involves a kind of passion. If the passion isn't there, then I really doubt whether the collector can be a good collector.

On choosing exhibitions, the 2004 Lee Lozano show, for example

Lee Lozano was a very eccentric and indomitable person who had an exciting and tumultuous ten years of production between the early Sixties and the early Seventies. She was a woman who was highly disturbed and almost impossible to work with. She developed an increasing obsession in which she felt all women were enemies, and if they were around her she would actually walk away. When I did the first show – which was not the first Lee Lozano show, but the first show that I did of her work – she asked me not to let women in to see the show. This was easy to agree to, but she herself then refused to come and see the show, due to the presence of a woman guard.

I learned last year, from Bob Nickas, that after her death, her estate was collecting all the works. I knew that this would be an extraordinarily interesting show for the art community, both national and international. I knew that we wouldn't be able to do it again, because the works would be sold and dispersed. It also would have been financially unfeasible to put together such an immense drawing show with only five or six paintings. I assembled the exhibition knowing that two years from now I wouldn't be able to do so because all the works would be sold to private collections.

Other decisions were really influenced by the questions: Where is my audience within the

Lee Lozano

No title, ca. 1962, coloured pencil and crayon on paper, 18¾ x 23⅞ in. (47.6 x 60.5 cm)

international community of people who are involved in Contemporary Art? What would they find interesting to review at this time? A woman who made work in the Sixties, who was conceptual, left painting, became minimal, and identified with a certain aesthetic. Never, never, though, did I think that she would be a money-winner.

I bet on horses, but I would never bet on art. There's a difference between being smart and being quick. I hope that I'm both, but I know I'm quick. I have a lot of experience and I'm no spring chicken, and I also spend a lot of time asking people for advice. I really

depend on listening as a key factor – listening and looking. The other major influence on my career in its entirety has been information that comes from artists, because artists talk about artists, and I try to sift that out. As a non-dealer, I can be a trusted informant because I am not going to have any influence on artist A's bank account. So artist A can freely tell me

Tim Noble and Sue Webster
The Undesirables, 2000, trash, electric fan, 3 light projectors, coloured gels and smoke machine, 78 ¾ x 236 ¼ x 196 ⅞ in. (200 x 600 x 500 cm) Installation view, *Apocalypse*, Royal Academy of Art, London, 2000

about artist B, and say, "You should really look at this work," or "Artist C is no good," or whatever.

On exhibitions affecting the art market

We try to ignore that, because it influences the process of selection. It's idealistic and it's non-functional. It's dysfunctional. If I were running a place with a collection, I would be tempted to do certain shows knowing that I could get a piece out of the show, and once you do that, you start evaluating shows in a different way.

I'm very competitive about the museums, of course – the Tim Noble and Sue Webster exhibition we did would have been a very smart show for a collecting institution, because a collecting institution would have had a chance, perhaps, to produce the piece with them and then have that for its very own.

Showing Noble and Webster

Several people had recommended them, a very young and enthusiastic collector saying, "I really love the work," and mature and very wise collectors saying, "I love this work." I asked my colleague Klaus Biesenbach about it and he said, "I'm really interested. If we do the show right now, it's going to be an important time to do it," because with a lot of our shows, we not only do the right artist, but we do the right artist at the right time.

Depending on how close your ear is to the ground, you hear this sort of little tremble, whether it's a train approaching or it's an earthquake or it's just nothing at all but a couple of horses running away. You hear the noise. Sometimes you just see the work and you wonder: Why isn't anyone else interested in this? At times I go ahead with something on my own, and at other times I wait to see if anybody else is reacting to it. It's not a question of picking winners. It's a question of picking people who are making interesting contributions, because what you see is *not* what you get; what you see is what you *learn*. What you see is what helps you see the next thing. I'm involved with what you, as a viewer, see – making what I see accessible to the viewer, not to buy, but to look at. Then I hope that what they see today helps or interests that person in seeing something else tomorrow. So there's the idealism I've got – not in owning, not in listening to the auction records; my job is to keep all that static out of my head.

On collectors and collecting

At no point in my life have I ever bought a piece of work, at no point in my life have I ever sold a piece of art. I'm a hard case, because for me, money and art have never matched up in a significant way. I don't regard money for art as immoral, I just have never been able to make these two quality-of-judgment assessments line up. I have no register in my mind that equates the cost of the work with the value of the work.

You know when the Count in Sesame Street says, "Let's all learn to count, one … two … three … four …" That's a dangerous thing for collectors. Because then you're thinking quantitatively – to me that destroys the purpose of why you would own something. You own something because you're protecting it, or because it is mysterious. You own a piece of your culture, you own a piece of your heart, and you own a piece of your generation or your society. You own something that means something to you in an indefinable way. So the very fact of ownership is usually not really possible.

A good collector

Being a collector should be something that makes you want to get up in the morning. It should bring you happiness. If you want one thing and you love it and you're happy, you don't have to have another thing. However, you might want to change once a year. You might want something in every room. What I mean is, owning art should be a way of investing in yourself and your own happiness. It shouldn't be about other people, because it's an intimate, special relationship between yourself and the artist, with the work of art as the vehicle, the intermediary, the spokesperson.

Changes in the Contemporary Art world

When I started working in the arts, people only collected things that were on the wall, or discernibly on the pedestal. Then artists like Richard Serra took art off the pedestal, putting it directly on the floor or, in some cases, throwing it against the wall. The next stage was the attempt to collect Land Art, where you didn't see the work at all, but it was performed. Or performance art, where you only saw it once and maybe there was some sort of documentation. Then the Minimal artist ruled and insisted that to see a piece correctly, you have to turn over your home, and put your wife or husband out in the street, and put your children in hotels, and then turn your house into one shining work of art.

> "... I would compare being a museum curator to a series of brief, intense affairs, as opposed to a stable marriage."

Conceptual art has been a very strong influence on my life: You buy an idea by Lawrence Weiner rather than a work of art, which he conveniently puts on your wall in terms of a phrase. Then we went back to painting in the Eighties, and then we went more into political art in the Nineties. All of this is just an investment in society and the cultural products that it makes. It is no longer a drawing or a photograph or a videotape or an installation. It's all of those things. Those are the changes, and the collectors have adjusted to them.

Taking the temperature of today's market

It's cyclical. The collectors have shifted and changed according to the art they love. Some people will only ever want photographs – it's not that they're bad, that's just what they want. A lot of people will buy things that are only in their imaginations, and the idea of buying imagination is quite special. It's like being a collector of abstract mathematics. I am actually behind the experiments in abstract mathematics. It's not even sexy, it's not ever going to take us to the moon, it's just going to be a scientist working on something and I'm going to back him for the year. Isn't that an interesting idea? This is what we're talking about.

Glenn Lowry

Director, Museum of Modern Art, New York

Glenn Lowry, an Islamic art scholar by training, became Director of New York's Museum of Modern Art in 1995, where he leads a staff of 550 and directs exhibitions, acquisitions, and publications, and oversees the finest collection of twentieth-century art in the world. He has successfully raised over $850 million, and the new MoMA is now housed in an expanded structure designed by Yoshio Taniguchi. Despite its "merger" with P. S. 1 Contemporary Art Center in 1999 and the inclusion of several Contemporary works in its recent exhibitions and acquisitions, MoMA has generally shied away from exhibiting or acquiring works by art-market favourites like Andy Warhol, Jeff Koons or Damien Hirst, and does not even own a single work by Jean-Michel Basquiat. With the 1996 bequest of the late Elaine Dannheisser, MoMA did finally move, albeit cautiously, into the art of the previous decade, acquiring works by Anselm Kiefer, Robert Gober, Felix Gonzalez-Torres and Jeff Koons.

Collecting Contemporary

I don't think there's any question that the traditional stance of most museums towards Contemporary Art has been to try to be a little bit removed, to be able to make measured judgments. Several factors have altered that. One, there are so many other museums now in the game besides us, so that to be competitive one has to make faster and more risky judgments. Secondly, the number of artists who are making art has so multiplied, not just here in the United States but around the world. To talk about Contemporary art-making and *not* think about what's going on in Latin America, what's going on in Asia, what's going on in Eastern and Central Europe, and even Africa now, is to miss an enormous amount.

It's impossible to stay current with everything, so you end up having to make judicious moves that you hope can bring to your audience enough of what's happening to engage them. Maybe it allowed us to take fewer risks a decade ago, but if we want to stay involved, if we want to be able to work with major artists and think about their work and present it intelligently, we have to act, sometimes a little faster than we are used to. That's why we merged with P. S. 1, a much less hierarchical institution than ours, but one that is able to make decisions in a minute and has a much closer beat to the ground, one that can react faster. I realized we could never transform the Museum of Modern Art to

react with the same speed as P. S. 1. Nor was it even desirable, because the level of research we can bring to an exhibition, the level of consideration that we can bring to a project, is just simply greater by virtue of the scale of our staff and the resources we have. There is no question that the meteoric rise of prices in the art world has made it increasingly difficult for institutions like the Museum of Modern Art to remain active. We've always relied on donations. Even fifty years ago, the majority of works of art we acquired were bought by people on our behalf who subsequently donated them. That hasn't changed. At the same time, to stay current you need to have your own resources and not always rely on other people's generosity. We created an acquisition fund for the twenty-first century that is designed to allow us to acquire the works of younger artists or artists relatively early in their careers, regardless of their age. We've collected works by Shirazeh Houshiary, Fang Lijun, Christian Marclay, Kutlug Ataman, Zwelethu Mthethwa, Walid Ra'ad/The Atlas Group, Lindy Roy, Eve Sussman, Trenton Doyle Hancock, Tim Lee, Julie Mehretu, Manfred Pernice, Nick Relph and Oliver Payne, really interesting young artists. We think there are a number of artists who are early in their careers whom we are prepared to take a

Kutlug Ataman
The Four Seasons of Veronica Read, 2002,
4 DVDs, 4 screen video installation,
each approx. 1 hour

risk on. If it turns out in twenty years that one or two of the artists that we've been able to acquire become really important, we'll be thrilled. If it's more than that, even better, but we recognize that many of our efforts won't pan out.

There are fantastic drawings out there for $1000 – I mean *really* fantastic, and terrific photographs and great prints that are relatively inexpensive. If you want a horizon line that lets you go after works on paper as well as digitally-based media and paintings, you're going to have to have a figure that lets you do that. I think you can pick any figure you want, you can pick $5000 and still build an interesting collection, if you want to put the effort into looking. If you wanted to spend $100000, you could change your field of vision. The figure isn't important, it's the energy you're going to put into it and where you want to locate yourself on a risk spectrum. You know, the less you pay, the greater the risk, ultimately, in terms of significance.

If you're spending one million to buy the work of an established artist, somebody whose career is now pretty well defined, I think your risk is significantly less than if you spent one million on an artist that neither of us has heard of. Now, will your million go to zero? No, that's not going to happen. Will your $2000 investment in an artist that no one has yet heard of potentially go to $100? It's possible.

A good collector is ...

Someone who's passionate, knowledgeable, thoughtful, who has a clear sense of what he or she wants to do, has a clear sense of the artists that interest them, and who is dedicated to the effort.

Julie Mehretu
Congress, 2003, ink and acrylic on canvas,
70⅞ x 102⅜ in. (180 x 260 cm)

The only advice that I can think of is that old Army adage that time spent in reconnaissance is never wasted. You know, this is not an avocation. To buy art seriously, to build a collection that's going to have integrity, that's going to be grounded in quality, that's going to be meaningful, that will bring satisfaction and pleasure, takes an enormous amount of hard work. It's not something that you can delegate to a third party to do for you – not that third parties can't provide great advice. But if it's going to have a personality, if it's going to reflect the issues and the ideas that you are deeply interested in, it's going to take a great deal of work, and it's going to entail making lots of mistakes along the way.

I think the greatest mistake is to think that all art is equal, that it's just a matter of picking what you like. Art is inherently undemocratic in that respect. Some works of art are just much more important and significant than other works of art. Figuring that out, understanding it, believing in the artists that you acquire, takes a lot of conviction, a lot of courage, and a tremendous amount of research. When I look at the collections that I think are really impressive, in almost every instance, it's the result of someone who has dedicated at least as much time to building their collection as they dedicated to building their businesses. I don't think there are any shortcuts to that.

With collecting, a great deal of what has to happen is finding the comfort level at which you want to work. The kinds of artists who interest you, the kinds of work that appeal to you, and the kind of money you're prepared to spend. If certain works of art intrigue you, if you think about them and they get you excited and you like looking and you want to learn more, then follow that vein. You can always branch out at a later date. But follow the vein that really appeals to you. I think staying focused is helpful. It gives clarity and definition to what you're doing. Staying really focused on an issue, an artist, an idea, a moment, lets you develop real knowledge about that.

Then, you know, the money issue is a matter of comfort. You can spend three or four million dollars a year and build an incredible collection, but you can also spend a tenth of that a year and build an incredible collection. It just depends on what you want to focus on, on whether your insight is greater than anybody else's, because building a collection is highly competitive. You're competing not only with other collectors, but you're competing with other possible choices you could have made.

Art as investment

I think that anyone who collects as an investment is taking a huge risk. It's really difficult to do. If you look at the recent sales, in London, of Impressionist and Post-Impressionist work, there were a number of works that came on the market that had been bought for nine, ten, eleven million dollars that were being sold a decade later for two or three million dollars *less*. There's no guarantee that prices are going to go up in the art world. From my perspective, and that's the perspective of the museum world, looking at art as an investment is *highly* risky, and *very* difficult to make work.

It's fascinating that now there is a whole host of new collectors who are prepared to make serious purchases, to collect with a real intensity of focus, and who are not looking at what happened yesterday, but are really focused on what's happening today. I still am of the school that one million dollars is a lot of money. I think if you're buying a Takashi Murakami because you really believe in Murakami and you really like the work, it's something you want to live with, it's something that profoundly moves you, then one

million isn't a lot of risk because the work will end up satisfying you. If you're putting one million into Murakami because you think it's going to be worth three million in five years, then I think there could be real risk in that, because there's no guarantee.

Promised gifts and priority for museum donors

First of all, this is a new move on the galleries' part. In the past, there were always galleries that would reserve what they believed to be an artist's most important picture, to try to place it in a museum through a donor, but this has now become almost commonplace. This is a real shift, this notion that almost every work that an artist now makes needs to be promised to a museum. I have to say, on the museum's side, this is troubling, because it puts collectors, at a very early stage in an artist's career, already in negotiations with a museum over whether or not the museum wants that work of art – perhaps before we've had a chance to really decide whether or not that's an artist we want to follow, or if it *is* an artist we want to follow, whether that's the right work.

The beauty of a promised and fractional gift from the donor's point of view is the following: You give ten percent of a work of art that you own; theoretically, you are entitled to have that work in your home for ninety percent of the time. The institution is entitled to have it for ten percent of the time. Usually, you measure this over cycles of years. Nobody wants to be disrupted, so if you have a major exhibition, obviously the institution has a call on being able to include the work, but most of the time, you're going to see the work at home. The ten percent that you give is at current market value, so if you spend $100000 on a work and you give ten percent, you're entitled to a ten-percent tax deduction. Over time, the value of the work of art will increase, potentially.

> "I think the greatest mistake is to think that all art is equal, that it's just a matter of picking what you like."

As for who is responsible for insuring and maintaining the work, what happens is this: When we take a fractional ownership in a work, we agree with the donor that we are going to have the right to inspect that work periodically, to make sure that its condition isn't deteriorating. We agree with the donor on a plan to insure that work; whether we take responsibility or the donor takes responsibility depends on the donor, depends on the work of art, depends on the amount of the fractional donation. But there's a discussion that ensues to insure that the work of art is properly cared for.

I also think that it is quite normal for works of art to move around. If you look at the history of a fourteenth-century Renaissance altarpiece, it will have moved around many times in its life. It may have only ended up in a museum in the last fifty years. It's normal for works of art to change hands, to move around. It's wonderful when they come to museums, but that's not the only place a work of art is necessarily happy or should be.

De-accessioning

We are fairly active in the de-accessioning world. It's one of the ways in which we can

stay competitive in terms of acquisitions. We approach it from a very particular position. First of all, when we were founded in 1929 and subsequently began a collection in 1931, the inaugural gift was given to us with the understanding that we would sell from that collection to buy more significant and important works of art. We always understood, from that moment on, that we had a double responsibility – to build a collection and *refine* the collection, which meant that when we *do* accept gifts, they're always unconditional, for a reason.

We're very explicit with donors, because it is possible that at some point in the future the museum may feel it's important to sell a work of art in order to acquire another one. We always credit the original donor, and if the donor is still living, we always let that donor know and talk to that donor about it, because we don't want any surprises – even though, up-front, we've already been explicit that we won't accept any conditions on gifts. We've lost works of art that have gone to other institutions that were prepared to accept restrictions on a gift that we were not. We try to be as transparent as possible, but there are certain works of art that are simply not going to do as well at auction as other works of art, and we have at the same time a fiduciary responsibility to make sure we don't sell a work of art at less than its fair market value.

Exhibitions and the market influence

We just had a big Thomas Demand show, and we have upcoming shows of Elizabeth Murray, Brice Marden, Richard Serra – all interesting artists at different points in their careers. We make our decisions *entirely* based on curatorial interest. We spend a lot of time thinking about who to show, when to show them, what to show. But we rarely think about, if at all, the marketplace as an indicator, factor, or even an issue in the kind of decisions we make.

We were stunned by the response to the Andreas Gursky show. We did that show because we think his work is important. Did we think that was going to be a wildly popular show? Absolutely not. If you had asked me, in my wildest dreams, whether we would bring in five hundred thousand people to Gursky, I would have said, "You're out of your mind." His prices were already soaring. The reality with Gursky, as it is with a number of photographers of his generation, is that the auction prices were far outpacing the gallery prices. The reverse is always true in any event, which is that a major museum show can *negatively* affect an artist, just as it can positively affect him. I think artists get overexposed. And putting artists through the scrutiny of a retrospective can have a really debilitating effect on their work. Think of Bridget Riley or Lee Bontecou: it was not until quite recently that people really started looking at their work again, and they had continued to make superb work that we can now all recognize.

Julia Peyton-Jones

Director, Serpentine Gallery, London

Julia Peyton-Jones has been director of the Serpentine Gallery since 1991, where she has commissioned groundbreaking exhibitions and initiated inventive programmes in architecture and education. Under the patronage of Diana, Princess of Wales, the Serpentine completed a £4 million renovation in 1998. Since then, visitor numbers have increased almost threefold. The Serpentine is well known for holding solo shows of mid-career artists like John Currin, Takashi Murakami, Glenn Brown, Gabriel Orozco and many more. Exhibitions of this kind have contributed to heating up the market for these artists.

The Serpentine

Interestingly, the character of the Serpentine's exhibitions used to include, you might say, Modern Masters, artists like Giacometti and Jasper Johns, with young emerging artists, usually in group shows, principally from Britain. It had a tradition of annually doing something called the Serpentine Summer Show – where young British artists' works were presented to the public, probably for the first time in an exhibition. I thought that the strength of the Serpentine's programme was its breadth, and to a degree it differentiated us from our colleagues in other organizations. So that was something I very much kept. When we programme the work of Modern artists like Piero Manzoni, it has to be because they relate to the art of today. That's a very strong guiding principal when we do those shows.

When I started, the work of Contemporary artists was less known in the U. K. than it is now; people travelled less, they saw less. So it felt very important to show to a British audience – since we're publicly funded – artists who were under discussion internationally, and whose work hadn't been seen here. Now we've changed significantly, and people are better informed with a tremendous appetite for Contemporary Art and, indeed, it's covered considerably in the media.

Deciding on the next show

Obviously we get exhibition proposals. And Rochelle Steiner, my curator, and I devise the programme together. It's a pooling of resources

Glenn Brown
Dali Christ, 1992, oil on canvas,
107 ⅞ x 72 in. (274 x 183 cm)

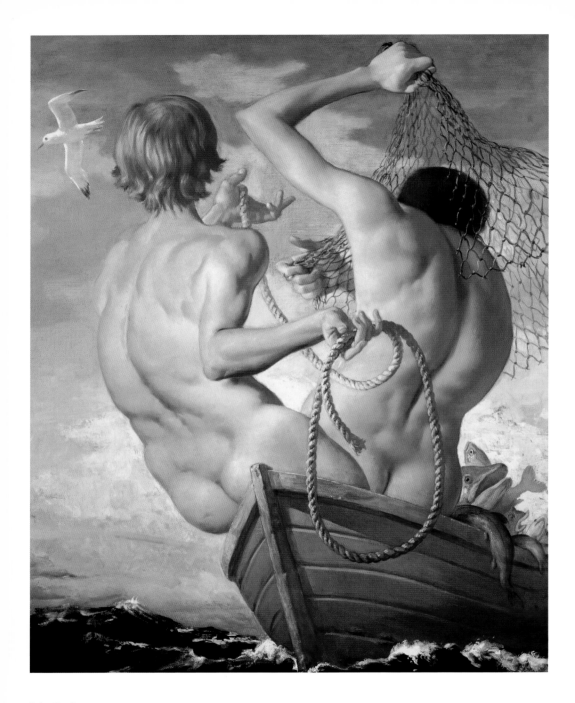

John Currin
Fishermen, 2002, oil on canvas,
50 x 41 in. (127 x 104.1 cm)

and also a balance, from time to time, doing what I call a Modern Master and also wanting to introduce younger artists whose work, perhaps, has not been seen in a public space, like Monika Sosnowska, a young Eastern European artist who is doing a special commission in the Gallery. Another example is Tomoko Takahashi, who is known; she is a past Turner Prize nominee, but has had relatively little exposure since then.

On choosing to show Glenn Brown

It is very important that we show British artists. I think this will be the third time Glenn's been shown here. He's been in two group shows. He was ploughing his own terrain then and continues to do so now. His artistic language is really so particular to him – it's figurative, but he references historical figures and also other painters of today, coupled with an incredibly interesting technique. He's the same age as the group that became known as the Young British Artists (YBAs), but absolutely set apart from that. He's

> "I come from a tradition, or an age, where a celebrity artist is a contradiction in terms."

somebody for whom there hasn't really been an opportunity to survey his work, and I think he's just remarkably good.

The artist as celebrity

I come from a tradition, or an age, where a celebrity artist is a contradiction in terms: I mean, it didn't exist, certainly not in Britain. In fact, the whole point about being an artist, when I was a student, was that you needed to be incredibly responsible about your work. That's what you lived for; it was very, very serious. You know, the idea of celebrity shows – if five people came, it was considered to be a big success. We live in a time of celebrity. If the question was, "Do you think the celebrity culture is a good thing," that's another discussion.

The market really doesn't influence us at all, except insofar as it is an element of the whole art world. If the art market suffers, then the value of people's collections goes down, and, psychologically, they might have mixed feelings about supporting institutions like ours. You know, it *is* a very fragile house of cards. However, the prices of works of art really are not a consideration for us. For example, I don't go to the sales. If we had a collection, I would definitely go because then that would be part of the job. I don't collect privately, and we don't have a permanent collection.

Luckily, commerce is sitting across the table, and the voice of reason, the non-commercial view, is sitting on the other side. Do I like the idea of people, dealers, selling art from a show that's at the Serpentine? No, I hate it. Because it's an affront. Mostly I don't know about it, 99.9 percent of the time I don't know about it.

The thing about an exhibition is that it gives collectors, and the public alike, an opportunity to review the contribution that an artist has made. As a result, it may therefore be possible for people to say, "My God, this artist is incredibly better than I thought he was." And therefore, as a result, the prices go up. Alternatively, and there are all sorts of examples of this, an exhibition can really *not* enhance an artist's reputation.

I think the Turner Prize experience has, for some artists, really not been such a product-ive thing for them. There is some sort of public exposure. I mean, it's easy to mention the Turner Prize, but you know, there are lots of examples of an artist whose work you go and see in an exhibition, and you go full of expectation, and it's disappoint-ing. That's what criticism is all about. That's what talking with your peers is all about.

Changes in the Contemporary Art market in the past five years

There really is an appetite. We experi-ence this particularly through people who are "Benefactors" to the Serpen-tine. Some of them come knowing nothing and they're slightly embar-rassed about it, and so quickly, they develop this appetite for knowledge. They go and see shows independently, they say, "Have you seen this, have you seen that," and it feels as though Contemporary Art now is something that people need to be informed about, just as they need to read the newspapers and need to know about current affairs. It's a really signifi-cant change.

> "In America, particularly, the wealth of collectors – I don't mean the richness of them, I mean the number of collectors – is absolutely phenomenal. It's fantastic and remarkable, and we don't have that here."

On collectors

Collectors are certainly as well informed as, if not better informed than, some of the pro-fessionals in the art world; they've seen shows all over the world, they're travelling …
In this country, as you know, in the U. K., there is a dearth of collectors out of the virtual circle that we have called the art world here. It's still relatively new, the interest in Con-temporary Art; and the embracing of the contemporary is also relatively new. In Amer-ica, particularly, the wealth of collectors – I don't mean the richness of them, I mean the *number* of collectors – is absolutely phenomenal. It's fantastic and remarkable, and we don't have that here.

What makes a good collector?

Knowledge. Somebody who is prepared to be serious and focused about what he or she does – I think it's fantastic. I mean, I don't live with Contemporary Art, I work with it. I live with it professionally, but I don't own any. I'm fascinated, particularly, because as I've said, here it's less usual. I'm fascinated by people who buy to own, and that whole idea of ownership. I don't have that. I think it's a special gene, this desire for ownership. I'm fascinated by it as a principle, because it's foreign to me.

Gabriel Orozco
Black Kites, 1997, graphite on skull,
8 ½ x 5 x 6 ¼ in.
(21.6 x 12.7 x 15.9 cm)

MORE
USEFUL
INFORM

By now you've heard a lot, much of it true, some of it coloured by each person's role in the art world: the dealer needs you to buy, the auctioneer wants you to buy and sell, the museum wants you to buy and give, and the collector is balancing all of these influences while exerting his own agenda. As a new collector, you will face several dilemmas, which boil down to whether you will buy primary, secondary, at auction, or in the context of an art fair. For this reason I have included a conversation

MATION

with Samuel Keller, the director of the two largest Contemporary Art fairs, who clearly explains the benefits and the differences between the gallery, the auction house and the art fair. Next comes *A Year in art collecting*; this is simply a calendar of what art events you'll want to attend if you intend to keep abreast of the market. Last but not least, the glossary provides a few terms that will make you feel like you are equipped with enough to understand what "they" are talking about. Happy hunting!

A Conversation with Samuel Keller

Former Director, Art Basel and *Art Basel Miami Beach*, Basel, *Head of Beyeler Foundation*, Riehen/Basel

Number of booths in Art Basel

In Basel we select 270 galleries to be in the gallery section, and the number of booths is determined by the size we think the show should have to be manageable for the collector. We do get about 900 applications. Galleries are paying to apply to Art Basel, and we try to select only the best of them.

The fair's total sales in dollars

I think *The New York Times*, years ago, estimated them to be a couple hundred million, around $200 to $300 million. The way Art Basel works is that certain sales are made before the fair. People get the catalogue, which we print six weeks in advance, so some people already buy, some call the galleries to find out what they're going to put on reserve. There are sales during the fair and there are sales that go on after the show – they can take several months, sometimes up to a year, especially if they need to be approved by a museum board, so you can't really measure by what is sold only at the fair. Also, as Art Basel is truly international, a global art event, you have American dealers selling to American collectors, German dealers selling to Germans, Japanese to Japanese. They may conclude the deal with a handshake. At the end, the transaction is then going to be made in their own city and also wherever taxes are most favourable.

Attendance

We have about 55 000 in Basel and 33 000 visitors in Miami. Visitors of Art Basel are, in large part, private collectors. There are museum directors and curators, galleries and dealers, there are artists who come in, and we do get the critics. We had 840 journalists and critics who came to Miami, and we had 1780 last year in Basel. We do also get a lot of art enthusiasts and people who may not call themselves collectors; they may buy every now and then.

The scene

One part of Art Basel is the art fair, that's the core of it, the buying and selling, but the whole thing has other aspects to it which are important – the whole networking, the edu-

Art Basel Miami Beach
Overall view of Art Positions, 2005

cational aspect, and also the whole social aspect. We work together with museums to have receptions, we work with collectors to open their collections so that collectors who come to town can actually see and experience how they collect. We do, for example, a film programme as well as public art works.

About Art Basel Miami Beach

The idea to do a second art fair came through the need of the galleries to have their artists represented in both markets – in Europe and the United States. Not all galleries used to do art fairs, many of the major galleries didn't need to do art fairs. Now they do. Their most important clients are there. Big buyers go to art fairs and there is a lot of business done, and apart from the business, they can expose their artists to an audience that can't get into the galleries. There are museum people there, many of whom you don't get into your gallery. Exposing, especially, younger artists in a fair like Art Basel can do great things for their careers. Other galleries may pick them up, they may go into important collections, museums may give them shows, etc., etc. That's something that art fairs can do for you, so it's not just about sales. You can sell the work but you can also create a client base that can take the work of the artist to a higher level. That's what an art fair can do.

Buying at a fair versus buying in a gallery

In the gallery, you have a lot more time with the dealers, to talk about the work and so on. An ideal situation is to buy art at the gallery, but you need to have the relationship with the gallerist and the gallerist needs to have time for you. When you go to the other

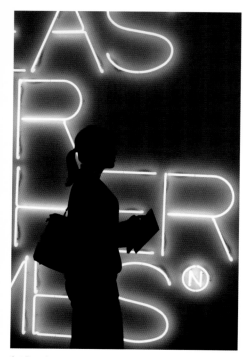

Art Basel

side and go to an auction, you need to have a lot of the information beforehand. If you want to do the right thing and buy at the right price, an auction offers a very limited scope of works—the works that sell. You have to make up your mind in a judicious way and then sometimes with limited information. The art fair is something in between: you have less time than in the gallery but you have more time than at an auction. You have time to make your decision. You have the key people there, you can get information from different sources, you can ask advisors and curators, you can ask other collectors, friends. It's not only about the buying, it's also about learning. You also have the largest selection at one time. For instance, you have several galleries showing the same artist so you can compare the works as well as the prices. At the Art Basel shows, you have from Modern Art to the very cutting edge Contemporary, so when you go to buy something by a young artist and you have a certain price, you can compare: "Well what can I buy from a different period from other artists? Is it worth it to pay that price for somebody I'm not sure is going to have a career, and not sure will hold its value, compared to something by an artist who is in museums?" So it gives you a better selection than you have in other places.

The quality of material at the art fair

The calibre of an art fair is the quality the dealers bring. It's the quality of the dealers but they also need to bring good works. Art Basel has established the best art fair, and with its tradition every dealer knows there are two or three behind him who are waiting to get his place. The selection committee goes every morning and visits the booths at the art fair to criticize them, take notes, and then probably takes into consideration if the gallery should be re-admitted next year. We drop between five and ten percent of the galleries every year, and in some cases it can be a well-known gallery that didn't bring exciting works or works that are fresh to the market. The competition is very important in order to get the quality.

On collecting

There is no wrong way to collect. There are so many different ways to collect and collecting is something personal. It reflects your personality. Of course, you should learn the ABCs. It's not only buying the works that are going to end up at MoMA that makes

you a collector, you can make a very small, intimate collection of something that is important only to a few people. You can also buy very eclectic, you can buy because you like the artist, you can also buy it because it makes you like your home better and because it looks good. I think it's important to learn about how other collectors collect, it can actually help you to have a greater freedom. Also, getting the right information gives you the freedom to make your own decisions. Making your own decisions does not mean not taking anybody's advice, it means to take as much advice and information as you can; this in turn makes your decision

"The art fair is something in-between: you have less time than in the gallery but you have more time than at an auction."

more personal, by knowing the most about the work and knowing the most about the market. The other side is, many people don't have the time to collect and to have a professional life. If you really do it seriously, some of the collectors travel more than many of the art critics or dealers can afford to travel and they do serious research. Other people enjoy having their kids and their career and can dedicate a small amount of time to it, and it's not important to know each and every artist and know the market value. One of the things we are trying to tell people is to be confident in collecting without imitating.

Art Basel
The Art Unlimited exhibition space for unusual
and outsized projects, 2005

A Year in
art collecting

early December

Art Basel, Miami Beach, Miami, Florida
The American sister event of the summer's Art Basel in Switzerland. Art Basel Miami Beach is a new type of cultural event with special exhibitions, parties, music, film, architecture and design. Exhibition sites are located in the city's beautiful Art Deco district within walking distance of the beach and most hotels and restaurants. It has also become a major social event.

early February

Christie's, London
Phillips de Pury, London
Sotheby's, London
Contemporary Art sales
The major London evening sales are traditionally held in February and June. There are "mid-season" sales for art of lesser value that are usually held in September or October.

mid-February

ARCO, Madrid
This is Spain's largest art fair. Located at the Parque Ferial Juan Carlos I, each year the galleries from one country are invited to participate as guests of ARCO, as well as curators and art critics from around the globe to discuss the current art scene.

late February

ADAA Art Show, New York
Each year, seventy or more of the nation's most prominent art dealers exhibit paintings, sculpture, drawings, prints and photographs (by artists of all periods) at this exhibition, which is held at the Seventh Regiment Armory in New York City. It is organized by the Art Dealers Association of America (ADAA) and all proceeds go to the Henry Street Settlement, one of the city's oldest social service agencies.

early March

Whitney Biennial, New York

The Whitney Biennial is the museum's signature survey of contemporary American art and "reaffirmation of its commitment to American artists" and their future. The show spanned painting, drawing, printmaking, sculpture, installation, video, filmmaking, photography, performance and digital art, as well as some outdoor projects. Many of the works conveyed an underlying sense of anxiety and uncertainty about the world today.

mid-March

Armory Show, New York

The Armory Show, the International Fair of New Art, is one of the world's leading art fairs devoted exclusively to Contemporary art. The most recent show brought together 148 international galleries presenting new art from around the globe. Now in a new, spacious location at Piers 90 and 92, it was formerly held at the 69th Street Regiment Armory, the site for which the show is named.

mid-May

Sotheby's, New York

Contemporary Art sale ... a must.

mid-May

Christie's, New York

Post-War and Contemporary Art sale ... ditto.

mid-May

Phillips de Pury, New York

Contemporary Art sale ... you have to go.

New York City's major Contemporary art auctions are traditionally held in May and November. Sotheby's, Christie's and Phillips each provide comprehensive and detailed information on their websites (www.sothebys.com; www.christies.com; www.phillipsdepury.com) about their services and the workings of their auction houses. Prospective collectors, buyers, or anyone interested can browse the auction calendars, see images and details on the lots being offered, look over catalogues, get auction results, not to mention helpful tips on buying and selling.

June

Carnegie International, Pittsburgh, Pennsylvania

Held every three to four years, this is one of the programmes of the Carnegie Museum of Art, which describes it as "the premier North American showcase for the best new art and new artists from around the globe". The exhibition features a diverse array of established and emerging artists, all at the forefront of Contemporary Art, with a broad selection of painting, drawing, sculpture, photography, film, and video.

mid-June

Berlin Biennial, Berlin

The Berlin Biennial takes normally place in summer – from mid-June to August. Berlin is one of the most exciting cities for Contemporary Art for geographic, political and economic reasons. Berlin also boasts several of

Europe's top Contemporary galleries including CFA Berlin, EIGEN + ART, Galerie Max Hetzler, neugerriemschneider, as well as Galerie Guido W. Baudach among others. A visit to Berlin has become *de rigueur* for any serious collector.

mid-June
Venice Biennale, Venice, Italy
The Venice Biennale has been called the "largest and longest-running art spectacle in the universe". Ever since it was founded in 1895, it has presented new artistic trends on the scale of a world's fair with exhibitions and pavilions in the visual arts, architecture, film, dance, music, etc. The Biennale di Venezia expects about 400 000 visitors from mid-June to mid-November. There will be international pavilions representing some sixty countries, plus the key group exhibitions, outdoor installations and other events, often held off-site. And it is also the non plus ultra of art-world party scenes.

mid-June
Art Basel, Basel, Switzerland
Dubbed "The Olympics of the art world" by *The New York Times*, this event is acknowledged as the world's leading art fair, drawing about 50 000 art collectors annually from every continent. It brings together painting, drawing, sculptures, installations, photography, video, multi-media art, and performances, with some 260 galleries from around the world displaying works by over a thousand artists. Art Basel is a must for anyone who wants to survey the crème de la crème of twentieth- and twenty-first-century art. It is held annually and runs for six days.

mid-June
documenta, Kassel, Germany
documenta takes visitors on a ride through all artistic genres: photography, painting, sculpture, installations, architecture and performances. This show has been held in the beginning every four, now every five years since 1955. The exhibition prides itself on showcasing non-Western art alongside works from Europe and North America.
Many critics, art historians and curators regard this exhibition as the most consistently "serious" or highbrow of the international shows.

late June
Christie's, London
Phillips de Pury, London
Sotheby's, London
Contemporary Art sales. There is a lot of European only art, but key pieces inevitably come up.

mid-September
International Istanbul Biennial, Istanbul
At first glance, it would appear there are just too many biennials, but this art exhibit in Istanbul (mid September until November) is very well

attended, includes many great artists, and provides you with a good excuse to travel to Turkey!

October	## São Paulo Biennial, São Paulo

The São Paulo Art Biennial founded in 1951, is the second oldest art biennial in the world after Venice. This Brazilian event (October 8 to December 17, 2006) is both international and highly political, another possible stop on your global tour.

late October	## Frieze Art Fair, London

The Frieze Art Fair, the brainchild of Matthew Slotover and Amanda Sharpe, founders and publishers of the British art magazine *frieze*, takes place every October in Regent's Park and features over 140 of the most exciting Contemporary Art galleries in the world. It also includes commissioned artists' projects and an ambitious programme of talks. Frieze was the first-ever international Contemporary Art fair to be staged in London. When it was launched in 2003 it featured over a thousand artists, including Tracey Emin, Ed Ruscha, Andy Warhol, Sarah Lucas, Takashi Murakami, Maurizio Cattelan, Damien Hirst and Gerhard Richter. Like Art Basel Miami Beach – but to a much lesser degree – it has also become a lively social event.

late October	## FIAC, Paris

FIAC (Foire Internationale d'Art Contemporain), France's annual art fair, is usually held the last week in October, and has lagged behind the Basel art fairs and Frieze in London, but with over hundred international galleries exhibiting, this may continue to grow and develop into another stop on the global pilgrimage.

mid-November	## Christie's, New York ## Phillips de Pury, New York ## Sotheby's, New York

Contemporary Art sales

Once again, the New York sales will give you an opportunity to bid on lots of work and gauge the temperature of the overall market.

Partial glossary of terms you need to know

Abstract art – Art that is not representational. Art as a cultural commentary.

Anime – Japanese cartoon films whose two-dimensional figures and action movie plots are based on Japanese manga comics. They are part of Japanese contemporary popular culture and were not generally recognized as an art form.

Anthological collection – a collection that seeks to include a single and representative example of the work of a large number of artists. This style is the opposite of collecting "in depth", where several works of a single artist are accumulated.

Appropriation art – Objects, images and texts are taken out of their traditional cultural context and dropped, unaltered, into a new and seemingly paradoxical one. The new meaning is created by this art of seminal disruption.

Art fair – A convention where art dealers set up booths in order to exhibit and sell. These fairs have been expanding in importance, allowing collectors to shop at hundreds of galleries in a few hours.

Assemblage – From the French, a use of several different materials to create a work of art.

Auction – A method of selling that requires a minimum of three participants: two who bid against each other in a competitive process and a third who selects the winner and typically charges a commission to the seller, also known as the consignor.

Bought in (see "Reserve") – what happens when the minimum price that the auction house is authorized to sell a work for is not met. For example: "The piece was bought in, it didn't make the reserve."

Catalogue raisonné – Annotated catalogue of an artist's work, with a claim to completeness and historical accuracy.

Collage – From the French, a work of art made up of a variety of unconnected objects or fragments that were not created by the artist and are typically glued together on a given surface.

Conceptual art – Conceptual Art emerged in the 1960s. Its premise is that an idea alone, as presented in a recitation or text, is sufficient to create a work of art. This term refers to art that is driven by an idea, not an image.

Condition report – Typically requested by the potential purchaser of a work, this report identifies any damage or

condition issues which may affect the price of a work of art.

Connoisseurship – From the French, it is the result of careful study and self-education in a given field. In art collecting it is the opposite of simply "buying what you like".

Curator – Whether museum employee or visiting staff, this individual or group selects the works exhibited in a given show. Some shows have been viewed as breakthrough moments and acquired historical status, thereby endowing the curator with "star status".

Deconstruction – An idea often connected with the late, great French philosopher Jacques Derrida, it is an attempt to use semantics (the study of language) to create an archeology of meaning. Language is viewed as an effort to construct meaning out of chaos. Typically, deconstruction is used to show that words can have several different meanings, in addition to what may have been originally intended.

Digital art – Art that makes use of computers.

Environment – An interior or exterior space designed by an artist to surround the viewer in an aesthetic experience.

Figurative painting – Painting which is representational as opposed to abstract, usually depicting some version of the human figure.

Flip/To Flip – Wall Street stock traders' term for buying and selling in rapid succession. For example: "The piece was flipped in less than a week!"

Flog (at auction) – The act of selling something, often in haste, without any regard to possible consequences or repercussions.

Fluxus – From "to flow", a radical experimental art movement embracing a variety of forms including happenings, poetry, music, and the plastic arts, whose ephemeral nature removed art from its accepted museum context. Examples of artists associated with Fluxus are Joseph Beuys, John Cage and Yoko Ono.

Fractional gifts – A tax-saving ruse used by dealers to get collectors to donate artists' work to museums. When the work is purchased, a "fraction", often 10 percent, is given to a museum at inflated values. Subsequently 10 percent slices are given over the next several years. A painting bought for $50 000 may allow the "donor" to write off a gift of $250 000 or more. The collector effectively gets to enjoy the piece for several years for free, and benefits from being a museum patron.

Free market price – The theoretical price a work of art would command without the manipulations of third parties like speculators, dealers or other interested parties.

Grey market – In the Contemporary art world, this would refer to works not shown by a dealer or sold through an auction house. The works trade without any public record.

Happening – An artistic action in front of a public that normally becomes engaged or provoked.

I. C. A. – Institute for Contemporary Art, a place that puts on exhibitions but does not maintain a collection, a.k.a. Kunsthalle.

Icon – A religious image, representation, or symbol.

Iconography – The language of images or forms and the study of their cultural context. One can study the iconography of advertising, the Western, postmodern architecture, or medieval religious icons.

Installation – The act of an artist placing works in a specific space to create a

desired effect. Can also refer to a curator or dealer's placement of work in a museum or gallery.

Liquid/Liquidity – The ability to turn a work of art into cash. Historically, art has been an illiquid investment. Recently, the Contemporary Art market has offered remarkable "liquidity", especially for fashionable artists like Warhol, Kippenberger, Basquiat, Koons and others.

Manga – Japanese comics depicting action, violence and sometimes, sex.

Memento mori – An event or object reminding one of death.

Minimal art – Art trend of the 1960s that traces sculptures and pictures back to clear basic geometric forms. Leading minimalists include Donald Judd, Agnes Martin, Dan Flavin and Carl Andre.

Modern art – This term is used to distinguish older art of the 40s, 50s and 60s from Contemporary Art of the 80s and 90s.

Momentum – Momentum investing: a Wall Street term for buying individual stocks or groups of stocks based on their increase in price, not on their fundamentals.

Monographic exhibition – A show whose goal is to give an anthological view of an artist's entire body of work, from beginning to end.

Multiple – Works of art which are produced in quantity, that is, as "multiples".

Neo-Geo – A 1980s art concept drawing and going beyond on minimalism, seen in the work of such artists as Peter Halley, Ashley Bickerton, etc.

Non-Objective art – The guiding principle of the Guggenheim Museum's original curator and Solomon R. Guggenheim's adviser, Baroness Hilla Rebay. It is art based on abstraction with no rela-

tion to the empirical world (does this mean anything today?). Artists of this school include Vassily Kandinsky, Franz Mark and Frantisek Kupka.

Op art – A type of 1960s abstract art that plays with optical effects.

Performance art – Artistic work performed in public, often memorialized by photographs, film or surviving props.

Phenomenology – A branch of philosophy which examines the way external reality appears to humans.

Photorealism – Hyper-realistic painting and sculpture using exaggerated photographic sharpness to take a critical look at the details of reality.

Pop art – Artistic movement of the 1960s which transformed the popular iconography of film, music and commerce into art. Famous proponents include Andy Warhol and Roy Lichtenstein among others.

Postmodernism – A vague term used to describe Contemporary Art which does not fit into any easily identified "school" or art movement.

Post-War art – A term used to describe works created after the Second World War, but which are not considered Modern Art. Chronologically, the order is "postwar", "modern" and then "contemporary", although their actual boundaries are often blurred.

Primary (market) – The first sale of a work of art, usually from the artist's "primary" dealer. It means this work has never been offered for sale before.

Provenance – The ownership history of a work of art. In historical art fields like African Art, it is significant to the value of the piece if it was part of known, documented and respected collections. Even in Contemporary Art, provenance is important; a painting is worth more money if it comes from a great collection.

Pump and dump – A Wall Street term for a stock trader's manipulation. A given stock is "bid-up" in small amounts and then a large block is sold at the higher price. This happens in the art world as well, where dealers hold inventory and try to raise prices before liquidating their holdings.

Readymade – An everyday article which the artist declares to be an artwork and exhibits without major alterations. The idea derives from the French artist Marcel Duchamp, who displayed the first readymades in New York in 1913, e.g. an ordinary urinal from sanitary porcelain signed R. Mutt 1917.

Resale agreement – A dealer's attempt to bind the purchaser of a work of art to offer it back to the gallery before selling elsewhere. It is effectively a way of retaining a right of first refusal on an artist's work.

Reserve/Reserve price – The minimum price at auction below which a consignor/seller of an art work would rather not sell the piece. Often, pieces which don't make the "reserve" are referred to as "bought in". Many times, dealers will call the auction house and make after-market lowball offers.

Retrospective – A show that "looks back" at an artist's career from a historical perspective.

Secondary (market) – A resale of a work of art. Every time the work is sold after its initial sale (primary), it is a secondary market sale.

Surrealism – Art and literature movement formed in the 1920s around the writer André Breton and his followers. The suspension of conscious control in creating art was intended to create an art based on dreams and the unconscious. Salvador Dalí is one of the classic surrealist artists.

Video art – Art that consists of film shorts, usually lacking a traditional narrative. An entire tradition of video art includes the work of artists like Bruce Nauman all the way up to Paul Pfeiffer.

Sweet spot – The center of a tennis racquet. Also refers to an opportune time or place, e.g., the "sweet spot" in the market is the place where one can make the most money.

Viennese actionism – Art form based around happenings of a ritualistic, bloodthirsty and apparently painful nature. Actionists often used sadomasochism and orgies for their systematic attack on the apparent moral and religious hypocrisy of Austrian society in the early 1960s.

White cube – The neutral white exhibition room which, in modern times, has succeeded older forms of presenting art. The white cube is supposed to facilitate the concentrated and undisturbed perception of the work of art.

Young British Artists (YBA) – The catchword for a group of British artists collected, promoted and exhibited by Charles Saatchi in the mid-90s. He succeeded in taking much of the Contemporary Art limelight which had rested on the shoulders of the New York art scene since the 50s and focused it on British artists in shows he toured like the famous *Sensation* show. These artists include Damien Hirst, Chris Ofili, Sarah Lucas, Tracey Emin, Rachael Whiteread, Gary Hume, Mark Quinn and Glenn Brown among others.

Magazines and Websites

MAGAZINES

Art + Auction (New York) – Focuses on market information, news stories, reviews and auction news; includes calendar of events. **www.artandauction.com**

art – das Kunstmagazin (Hamburg) – In this art magazine, which has appeared monthly since 1979, known and unknown artists are presented together with their works, the focus being on Modern Art in all media (sculpture, painting, photography, video-art etc.). **www.art-magazin.de**

Art in America (New York) – Provides news and trends in the art world for artists, dealers and collectors; wide-range coverage of painting, sculpture, photography and prints. **www.artinamericamagazine.com**

The Art Newspaper (London) – Reports on art personalities, issues and events. Daily updates are available online on auction house prices and news on big name Contemporary artists. **www.theartnewspaper.com**

Art Review (London) – International Contemporary art and style magazine; covers artists, private collections, analysis of art market, news of exhibitions, sales and events. **www.art-review.com**

Artforum (New York) – Major international Contemporary art journal; offers daily news from the art world, museum shows, articles, interviews, "critics' picks" and reviews. **www.artforum.com**

ARTnews (New York) – Magazine reporting on the art, personalities, issues, trends and events shaping the international art world; wide coverage of museums, galleries and artists. **www.artnews.com**

art press (Paris) – This bilingual magazine (French/English) provides information and analyses in every field of contemporary art and also on current events in literature, film, theatre and dance. **www.artpress.com**

Connaissance des Arts (Paris) – Introduces Contemporary and Classical art with exhibition tips, studio visits, travel reports, private collections and discussions of works. **No website of its own**

Flash Art (Milan) – Features information on the current market in Contemporary art plus articles on new and unknown artists. Online edition offers reviews, profiles, news and archives. **www.flashartonline.com**

frieze (London) – Europe's leading magazine of Contemporary arts and culture,

offers features, columns and reviews. Organizer of the Frieze Art Fair which is held every October in London.
www.frieze.com

kunstbulletin (Zurich) – Small-format magazine with short reports on the current art-scene focusing on Switzerland, in addition news, listings, index of artists and exhibition calendar.
www.kunstbulletin.ch

Kunstforum International (Ruppichteroth) – Quarterly in book format with essays on Contemporary art, design, photography, new media, etc. Also interviews, exhibition reports, news from the art world (fairs, art-markets, symposia, festivals, prizes and competition invitations), as well as an annotated international exhibition calender.
www.kunstforum.de

Lapiz (Madrid) – Spain's most influential magazine on international Contemporary art with information on young upcoming artists and analyses of current artistic phenomena. Appears in Spanish and English. **www.revistalapiz.com**

Monopol (Berlin) – Art and lifestyle magazine with large pictorial section on Contemporary art and photography, entertaining reports on design, architecture, fashion and film, detailed artist portraits etc. **www.monopol-magazin.com**

Parkett (Zurich) – Contemporary art journal of art and ideas, published in direct collaboration with major international Contemporary artists.
www.parkettart.com

Tema Celeste (Milan) – Appears every two months in Italian and English. With interviews, reports and international exhibition critiques on young as well as established artists. **www.temaceleste.com**

Texte zur Kunst (Berlin) – Art-theoretical essays on a superordinate theme (from the visual arts through performances to media art) related to Contemporary art. Also interviews, exhibition reports, book reviews and news.
www.textezurkunst.de

WEBSITES

Art Resource – The "world's largest" archive of fine art images allows web searches of any artist free. License to reproduce pictures requires payment of fees based on image/project. **www.artres.com**

Artnet – The *sine qua non* source for auction data, also includes an online magazine with news of artists and reviews. **www.arnet.com**

Artprice.com – Another leader in art market information. **www.artprice.com**

The Baer Faxt – Newsletter by email or fax. Worth subscribing to for weekly and sometimes daily bulletins on Contemporary art news as well as Josh Baer's personal insights. **www.baerfaxt.com**

e-flux.com (electronic flux corporation) – A New York-based information bureau dedicated to world wide distribution of information for Contemporary visual arts institutions via the internet. The selected informations are distributed via email, subscription is free. **www.e-flux.com**

In addition, almost all good galleries have their own websites/home page that show their roster of artists and provide information as well as images on current and future exhibitions. Also every major museum has a website.

Auction houses offer previews of their upcoming auctions plus online catalogues which you can browse:
Christie's – **www.christies.com**
Phillips de Pury – **www.phillipsdepury.com**
Sotheby's – **www.sothebys.com**

Index

Page references in *italics* refer
to illustrations.

Photo credits

p. 2 → Courtesy of Galerie Max Hetzler, Berlin. Estate of Martin Kippenberger. Galerie Gisela Capitain, Cologne **p. 4** → Estate of Andy Warhol PA 30.037. Courtesy of Sotheby's © 2010 Andy Warhol Foundation for the Visual Arts/ARS, New York **p. 9 / p. 11 / p. 12p.** → Private Collection **p. 15** → Courtesy of James Cohen Gallery, New York **p. 18** → Courtesy of Gagosian Gallery, New York **p. 29** → Courtesy of Galerie Eva Presenhuber, Zurich **p. 33** → Courtesy of Galerie Emmanuel Perrotin, Paris © 2002 Takashi Murakami/Kaikai Kiki Co., Ltd. All Rights Reserved **p. 34** → © 2004 Takashi Murakami/Kaikai Kiki Co., Ltd. All Rights Reserved **p. 36** → Collection of the author. Courtesy of Marianne Boesky Gallery, New York **p. 39** → Private collection, Berlin. Photo Jochen Littkemann, Berlin. Courtesy of Contemporary Fine Arts, Berlin **p. 40** → Private collection, South Korea. Photo Jochen Littkemann, Berlin. Courtesy of Contemporary Fine Arts, Berlin **p. 41** → Photo Jochen Littkemann, Berlin. Courtesy of the artist, Afroco and Contemporary Fine Arts, Berlin **p. 43** → Collection of the author. Photo Jochen Littkemann, Berlin. Courtesy of Contemporary Fine Arts, Berlin **p. 45** → Courtesy of Sadie Coles HQ, London © Sarah Lucas **p. 46** → *The Kinks*, Collection of the author. Courtesy of Sadie Coles HQ, London, and The Modern Institute, Glasgow © Jim Lambie **p. 49** → Courtesy of Sadie Coles HQ, London © Urs Fischer **p. 51** → Courtesy of the artist and Deitch Projects, New York **p. 52/53** → Courtesy of the artist and Deitch Projects, New York **p. 56** → Courtesy of the artist **p. 59** → Photo Eduardo Ortega. Courtesy of Galeria Fortes Vilaça, São Paulo **p. 60/61** → Courtesy of Galerie Max Hetzler, Berlin **p. 62** → Collection Rose and Alfredo Setúbal, São Paulo. Photo Eduardo Ortega. Courtesy of Galeria Fortes Vilaça, São Paulo **p. 65** → Photo Robert McKeever. Courtesy of Gagosian Gallery, New York **p. 66/67** → Estate of Martin Kippenberger. Galerie Gisela Capitain, Cologne **p. 68** → Collection Dia Art Foundation. Photo Allen Glatter © VG Bild-Kunst, Bonn 2010 **p. 69** → Photo Robert McKeever. Courtesy of Gagosian Gallery, New York © 2003 Chris Burden **p. 71** → Photo Michael James O'Brien. Courtesy of Barbara Gladstone Gallery, New York © 1997 Matthew Barney **p. 72** → Photo David Regen. Courtesy of Barbara Gladstone Gallery, New York © Richard Prince 1993 **p. 75** → Courtesy of Sodie Coles HQ, London © Sarah Lucas **p. 77** → Courtesy of PaceWildenstein Gallery, New York **p. 78** → Courtesy of PaceWildenstein Gallery, New York **p. 83** → Courtesy of PaceWildenstein Gallery, New York **p. 85** → Courtesy of Galerie Max Hetzler, Berlin. Estate of Martin Kippenberger. Galerie Gisela Capitain, Cologne **p. 86** → Courtesy of Galerie Max Hetzler, Berlin **p. 89** → Private Collection. Courtesy of Galerie Max Hetzler, Berlin **p. 90/91** → Courtesy of Galerie Max Hetzler, Berlin **p. 93** → Courtesy of Galerie EIGEN + ART Leipzig/Berlin © 2010 Artists Rights Society (ARS), New York/VG Bild-Kunst, Bonn **p. 94** → Courtesy of Galerie EIGEN + ART Leipzig/Berlin © 2010 Artists Rights Society (ARS), New York/VG Bild-Kunst, Bonn **p. 98/99** → Courtesy of Galerie EIGEN + ART Leipzig/Berlin and David Zwirner, New York © 2010 Artists Rights Society (ARS), New York/VG Bild-Kunst, Bonn **p. 101** → Courtesy of Galerie Emmanuel Perrotin, Paris **p. 102** → Photo André Morin. Courtesy of Galerie Emmanuel Perrotin, Paris **p. 105** → Photo Goswin Schwendinger. Courtesy of the artist, Hauser & Wirth, Zurich London, and Luhring Augustine, New York **p. 107** → Collection of the author. Photo Oren Slor. Image Courtesy of Andrea Rosen Gallery, New York © David Altmejd **p. 109** → Courtesy of the artist and Gagosian Gallery, New York © 1993 John Currin **p. 110** → Courtesy of Andrea Rosen Gallery, New York © The Felix Gonzalez-Torres Foundation **p. 113** → Image Courtesy of Stuart Shave | Modern Art, London © Nigel Cooke **p. 114** → Collection of the author. Courtesy of Stuart Shave | Modern Art, London © Tim Noble and Sue Webster **p. 117** → Courtesy of Stuart Shave | Modern Art, London © Tim Noble and Sue Webster **p. 119** → Photo John Berens. Courtesy of Hauser & Wirth, Zurich London **p. 121** → Courtesy of Hauser & Wirth, Zurich London **p.**

Biography of the author
Acknowledgements

DEDICATION
To Helen, Charlotte and Frances

Adam Lindemann started collecting Tribal Art as well as works of artists of the Eighties before turning to Contemporary Art, which has been his passion for the past several years. This book was conceived as a short handbook of information and advice for new collectors, but Lindemann's research eventually led him to an international tour of the art world and personal interviews with some of its leading figures. The results are shared with the reader on these pages – along with images of over one hundred art works which help define the Contemporary Art market today.

My heartfelt thanks to all the interviewees in this two-year adventure who gave their time to share their thoughts and expertise with me. I would like to thank Iris Chekenian for her help through every step of the way in putting it all together. My special appreciation to Simon de Pury for introducing me to Benedikt Taschen who had the insight and courage to make this project a reality. Thanks as well to Christian Domínguez and Sabine Bleßmann of the Taschen staff for their input during the production process, and to Ali Subotnick and David Rimanelli for their contribution in the early stages. Last but not least, I would like to thank all the artists who have personally given me permission to reproduce their work on the pages of this book.

Imprint

To stay informed about upcoming TASCHEN titles, please request our magazine at www.taschen.com/magazine or write to TASCHEN America, 6671 Sunset Boulevard, Suite 1508, Los Angeles, CA 90028, USA; contact-us@taschen.com; Fax: +1-323-463-4442. We will be happy to send you a free copy of our magazine, which is filled with information about all of our books.

© **2010 TASCHEN GmbH**
Hohenzollernring 53, 50672 Köln
www.taschen.com

Original edition: © 2006 TASCHEN GmbH
Design: Sense/Net, Andy Disl and Birgit Eichwede, Cologne
Production: Ute Wachendorf, Cologne

Printed in South Korea
ISBN: 978–3–8365–2308–0

100 Artists Who Epitomize the Contemporary Art Scene

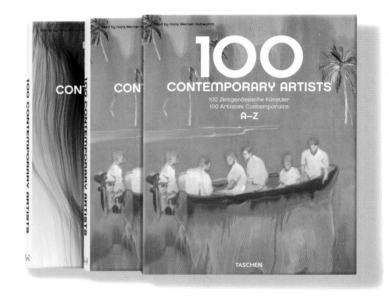

100 CONTEMPORARY ARTISTS

Ed. Hans Werner Holzwarth
Hardcover, 2 vol. in a slipcase,
format: 24 x 30.5 cm (9.4 x 12 in.), 696 pp.

ONLY € 39.99/$ 59.99
£ 34.99/¥ 7.900

This special two-volume edition features 100 of the most exciting artists from TASCHEN's seminal *Art at the Turn of the Millennium* and the renowned *Art Now!* series – gathered in a comprehensive survey of contemporary art at the start of the 21st century. The selection includes a wide variety of works by pioneering artists like Jean-Michel Basquiat, Marlene Dumas, Damien Hirst, Mike Kelley, Jeff Koons, Albert Oehlen, Richard Prince, Charles Ray, Cindy Sherman, and Christopher Wool – alongside a younger generation including Glenn Brown, Natalie Djurberg, Tom Friedman, Mark Grotjahn and Terence Koh.

The editor: **Hans Werner Holzwarth** was a photographer before launching a corporate design firm. He has collaborated on book designs with Robert Frank, Nan Goldin, Albert Oehlen, Richard Prince, Kiki Smith, and John Waters. For TASCHEN, he edited *Jeff Koons*, *Christopher Wool*, and *Art Now! Vol 3*.